Using Your Meter

VOM and DVM Multitesters

by
Alvis J. Evans

introduction by
Jack Hudson, W9MU

Third Edition

Master Publishing, Inc.

This book was developed and published by:
Master Publishing, Inc.
Niles, Illinois

Editing by:
Gerald Luecke, Pete Trotter, KB9SMG, Jack Hudson, W9MU

Acknowledgements:
The publisher wishes to thank Jack Hudson, W9MU, retired Coordinator of the
Electronics Technology Program at College of Lake County, Grayslake, IL, for his
review of the book and for writing the new Introduction for this 3rd Edition of *Using
Your Meter*.
Thanks also to Greg Gilleran, a long-time instructor of electronics technicians, for his
review of the book.
All photos are courtesy of RadioShack and Master Publishing, unless otherwise noted.

Trademarks:
RadioShack® is the registered trademark of RadioShack Corporation.
Sears™ is a trademark of the Sears Holding Corp.
Delco™ is a trademark of the Delco Division of General Motors Corporation.

Printing by:
Arby Graphic Service, Inc.
Niles, Illinois

Visit Master Publishing
on the Internet at:
www.masterpublishing.com

Third Edition
10 9 8 7 6 5 4 3 2 1

Table of Contents

Preface

Making basic electrical measurements of voltage, current, or resistance with a meter can help significantly in understanding an electrical circuit to determine whether it is operating properly or if repair or maintenance is required to restore its operation.

Using Your Meter has been written to help you understand how meters work and how to use them to make basic electrical measurements. This book strongly emphasizes "how to do" the various measurements. In addition, it provides an understanding of basic concepts and fundamentals so that you will have a greater insight into what is actually happening in the electrical circuit being measured. The book is fully-illustrated to visually enhance your learning.

The book begins by explaining the basic concepts of VOM and DVM meters, relating how the analog and digital meters differ, and discussing the advantages and disadvantages of each. Following a discussion about multitester measurements, where polarity, reference point, and meter loading are the topics, basic dc and ac measurements are discussed with actual step-by-step procedures defined for voltage, current and resistance measurements. These principles are then applied to measuring electrical components – resistors, capacitors, inductors, semiconductor devices – both individually and in circuits.

The next four chapters show you how to make electrical measurements on common systems found around the home and office. Home appliances – including heating and air conditioning systems – are discussed, as are power distribution and lighting systems. Measurements on automotive circuits are explained. Finally, measurements on tool control circuits are discussed.

After reading *Using Your Meter* and following its suggested procedures you should be able to make circuit measurements and detect improper circuit operation. Our goal is to teach you enough different measurement applications to make you a competent user of a VOM or DVM.

Alvis J. Evans

Introduction

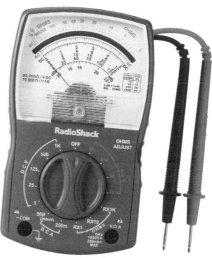

Electricity seems so elusive, so mysterious. We know it is used to operate most of the equipment around the home and office. Home lighting, appliances, heating and air conditioning, televisions, stereos, workshop tools, video games and computers, copiers and fax machines all depend upon electricity for their operation. Although we can see and feel the effects of electricity, it would benefit one a great deal to understand the effects if one could measure it. That is the purpose of meters – voltmeters, ammeters, and ohmmeters: to measure basic electrical quantities such as voltage, current and resistance.

This book has been written to help you understand how such meters work and how they can be used to make basic electrical measurements – in the home, in the workshop, at the office, on the job. It discusses both analog and digital multimeters and their application in electrical maintenance. The basic VOM and DVM are generally used in maintenance and engineering applications and are usually small and portable. The multimeter is a versatile, powerful tool for troubleshooting electrical and electronic systems.

The basic, inexpensive instrument is referred to as a VOM (Volt Ohm Meter) for analog meters, and a DVM (Digital Volt Meter) for digital meters. These instruments are generally called multimeters, indicating that they have the ability to measure several different quantities. Typically, they measure voltage (voltage), current (amperes) and resistance (ohms) over several ranges. Some meters also have additional, special measuring features, such as measurement of certain semiconductor parameters, or temperature.

There are some general principals of measurement that should be followed, which are fully developed in later chapters. These fundamental principals apply regardless of the type of meter being used. However, each meter will have its limitation and the user should carefully read the instruction manual supplied with the meter to understand the instrument's capabilities. Most multimeters also require some setup, and care should be taken to make sure the meter is setup properly.

THE NATURE OF ELECTRICITY – OHM'S LAW

Before beginning our exploration of meters, we want to provide a brief review of some of the fundamentals of electricity to provide you with an understanding of what it is you are measuring when you use a multimeter. What are current, voltage, and resistance?

- Current (I) is the flow of electrons, which are negatively-charged particles that are free to move in many materials. Materials that allow the free flow of electrons are referred to as conductors (usually metals, such as copper). Materials where electrons do not flow easily are called insulators. Between conductors and insulators you find semi-conductors. Current is the flow of many electrons, in fact there are so many that they look like a continuous flow rather than individual electrons. The basic unit of current is the ampere.

- Voltage (V) is a measure of the electromotive force (like a pressure) that pushes the electrons. A voltage rise like that provided by a battery will produce an electric field that will attract or repel electrons. Voltage sources add energy to the electrons, causing net current flow. As electrons flow they lose energy when they encounter a resistance that causes a voltage drop. In any closed circuit the voltage drops will equal the voltage rises. When measuring voltage it may either be a rise or a drop, the meter can't tell the difference since the meter measures potential difference. Voltage is measured in volts.

- Resistance (R) is that feature that sets the ratio between current and voltage in a resistive element and is one form of impedance. As current flows through a resistor energy is lost as heat and a voltage drop occurs. In a resistive element the resistance is defined as the ratio between the voltage drop and current in the element. The unit of measurement for resistance is ohms.

The relationship of current, voltage, and resistance are described by Ohm's Law, which states that the rate of the follow of current (amps) is equal to the electromotive force (volts) divided by the resistance (ohms):

$$I = \frac{V}{R}$$

CURRENT AND POLARITY – MEASURING DIRECT CURRENT

When current was first defined, it was thought that the electrons were positively charged particles. Thus the definition of current flow was based on the assumption that current flowed from the positive (+) terminal to the negative (−) terminal, and this is called conventional current flow. It turns out that electrons really flow in the opposite direction – from negative to positive, and this is called electron current.

In the schematic diagrams in this book, the direction of current flow is indicated by solid and dotted lines. The direction of conventional current is indicated by the solid line directions; the direction of electron current is indicated by the dotted line directions. (If you would like to learn more about the fundamentals of electricity, read *Basic Electronics* by Alvis J. Evans and Gene McWhorter, available at Radio Shack.)

The direction of current flow is closely related to the polarity of voltage rises and drops in a circuit, and it is generally assumed that conventional current into an element has a positive sign where it enters the element. Meter polarity is generally set up as if current was defined as conventional current. This is especially important when making dc measurements with a VOM (analog meter). As you will learn in the next chapter, analog meters use a mechanical movement. If the polarity is reversed when making a measurement, the needle will want

to move backwards, and if too much force is applied to the movement the meter can be damaged or destroyed.

In the case of a DVM (digital meter) polarity usually is indicated by a plus (+) or minus (−) sign appearing on the meter reading. Having reverse polarity on a DVM will not damage the meter.

The bottom line is that it makes no difference what direction current flows as long as you are consistent throughout your analysis and measurement. When doing measurements you will encounter polarity for voltage drops and rises. Generally meters will indicate positive deflection for analog meters, when the red (positive) lead is on a more positive voltage than the black (negative) lead. Some digital meters are auto-ranging and will show a negative sign when the red lead is more negative. You should refer to your meter manual to determine the consequence of reverse polarity connections for voltage measurements.

Since current has direction, meter systems will indicate a positive value when current flows into the red lead.

MEASURING ALTERNATING CURRENT – RMS

How about those pesky AC (Alternating Current) voltages and currents? Most commonly we think of AC waveforms as being sine waves. This is often the case, especially in power circuits where the power line normally gives us sine waveforms. However, in power circuitry (such as a power supply) the input voltage may be a sine wave but the current is not, especially when the load is not a linear load. Thus, you get waveforms that are something other than a pure sine wave.

When making measurements you should be aware of the type of voltage or current being measured. DC (direct current) voltages are steady and unvarying, while AC (alternating current) voltages will often be changing with a sine wave form. The terms DC and AC contain the word current, but they refer to the nature of both voltage and current. Most simple meters are set up to read the average value of AC waveforms only for sine waves.

When measuring AC waveforms since the actual voltage or current varies with time we need a single number to describe the value of the waveform. Normally, especially with sine waves, this value is called the RMS value. RMS stands for root-mean-square, which is the mathematical definition of the value. The RMS value of an AC voltage produces the same heating in a resistor as a DC voltage of the same value. This is true of any wave form. In signal processing circuits there are many "strange" wave forms that are described not by RMS but by peak values and a geometric description.

Peak, Peak-to-Peak and RMS Voltages

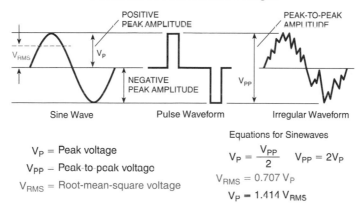

V_P = Peak voltage

V_{PP} – Peak-to-peak voltage

V_{RMS} = Root-mean-square voltage

Equations for Sinewaves

$$V_P = \frac{V_{PP}}{2} \qquad V_{PP} = 2V_P$$

$$V_{RMS} = 0.707\,V_P$$

$$V_P = 1.414\,V_{RMS}$$

However most of the time in maintenance situations you will have sine waves and RMS values can be read using your multi-meter. In less expensive multi-meters the peak value of the wave form is determined and the scale is calibrated for "RMS," but this is really the effective value. This is not particularly accurate, but most of the time works well enough in a maintenance situation. More expensive TRUE RMS meters are available that employ special electronic circuits to "calculate" true RMS values.

Whether or not you need the more expensive meter depends upon the application. Even with TRUE RMS meters care should be used in measurements when the frequency is other than 60 Hz and the wave form is not sinusoidal. The meter manual should be consulted and the manufacturer's recommendation followed.

FUNDAMENTAL MEASUREMENTS

Here is a brief introduction showing how to use your multimeter to make fundamental measurements. Detailed, step-by-step instructions are included in later chapters.

Voltage Measurements: The meter should be set up according to the meter manual. Voltage is measured _across an element or many elements such as resistors_. In all cases, voltage is measured between two points in a circuit. With many measurements the voltage is measure between some energized point in the circuit and a ground reference point. With voltage measurements the circuit is not disturbed; that is, nothing is opened or shorted and the measurement must be done with the circuit energized.

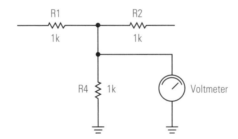

Current Measurements: Once again the meter should be set up according to the meter manual. Current measurements will require special setup since current *flows through elements*. The circuit must be broken and the ammeter inserted to complete the circuit. In some circumstances, in AC circuits, indirect methods are used with special purpose Amprobes. Once again, as in voltage measurements, the circuit should be energized. In DC measurements polarity is important since the current will have direction.

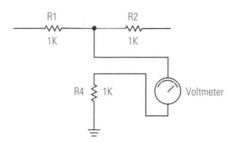

Resistance Measurements: With the meter properly setup to measure ohms, resistance is measured between two points in the circuit. *The circuit must be de-energized* since a resistance measurement cannot be made with voltage or current present in the circuit. If the circuit is energized the meter maybe damaged. The necessary energy for the measurement is provided by the battery in the meter.

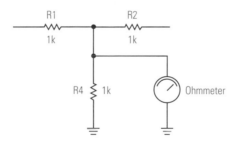

You are now ready to learn about meters and their use. Go carefully and enjoy your new skills and ability. **Always keep safety in mind when working with equipment with high voltages**!

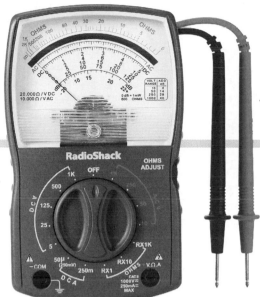

VOM -
The Basic Concepts

There are two basic types of meters used to make electrical measurements. One type has a needle that deflects along a scale and indicates the value of a quantity by the position of the needle on the scale. This is an analog meter, and is commonly called a voltmeter, ammeter, ohmmeter, VOM, multimeter, or multitester depending on the quantities that it measures. The meter mechanism is generally of the D'Arsonal type, which will be detailed later.

Figure 1-1. Analog Meter

Figure 1-1 shows a typical analog meter. The main meter parts are the meter movement (behind the scales) that contains the needle that deflects to the right along a scale, the switches that select which quantity the meter is set to measure and determine the full-scale range of the meter for the measurement, and several adjusting controls and jacks that accept plug-in test leads to connect the meter to a component or circuit for measurement. A set of test leads is shown in *Figure 1-2*.

First, let's look at the analog VOM (Volt-Ohm Milliammeter). When you understand how this type of meter works, you'll have a good foundation to understand how the digital meter works. We'll study digital meters in the next chapter.

THE BASIC METER MOVEMENT

The VOM, with its needle that moves on a scale, is basically a small electric motor. To understand electrical motor action it is necessary to understand two very simple electrical principles: 1. What happens when there is current in a wire or other type conductor of electricity; and 2. magnetism and magnetic fields. Let's take a look at magnetism first.

Figure 1-2. Test Leads

Figure 1-3 shows a coil of wire with many turns mounted on a pivot between the north and south poles of a magnet. There is a magnetic field running from the north pole to the south pole. The field is invisible, but if it were visible, it would appear as lines starting at the north pole and stopping at the south pole, a shown in *Figure 1-3*. The field lines leave and enter the magnet's surface perpendicular (at right angles) to the surface. The pole pieces have a special shape so that the magnetic field is very uniform throughout the air gap between the pole pieces and the meter movement coil. The purpose of such a uniform field between pole pieces will not be apparent until we look at the second simple principle of motor action – current in a wire or conductor.

CURRENT IN A WIRE

In 1819, Danish physicist Hans Christian Oersted discovered that a magnetic field surrounds a wire or conductor in which there is current. The effect is shown in *Figure 1-4*. A current in the wire in the direction shown will produce a magnetic field counter-clockwise around the wire as shown – the larger the current, the larger the magnetic field. In this book, those of you who are familiar with electron current use the dotted line directions for current, and those familiar with conventional current use the solid line directions. (If you would like to learn more about the fundamentals of electricity, read **Basic Electronics** by Alvis J. Evans.)

Figure 1-5 is a cross-section through the pole pieces and one loop of the coil of wire shown in *Figure 1-3*. It shows the motor action. As an example, let's look at Leg A of the loop of wire in *Figure 1-6*. Electron current is out of the page; therefore, the magnetic field produced is clockwise around the wire. At the top of Leg A, the current magnetic field adds to the uniform magnetic field; at the bottom of Leg A it subtracts. As a result, a force is developed that pushes on the loop of wire and causes it to rotate. The stronger magnetic field at the top forces Leg A of the loop down.

Figure 1-3. Meter Coil in Magnetic Field Between Pole Pieces of Magnet

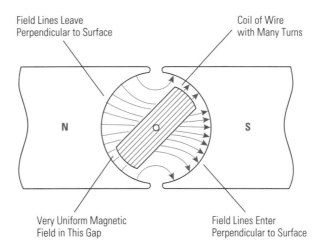

Field Lines Leave Perpendicular to Surface

Coil of Wire with Many Turns

N

S

Very Uniform Magnetic Field in This Gap

Field Lines Enter Perpendicular to Surface

The continuous current in the loop goes into the page in Leg B. The current magnetic field now is in a direction to force Leg B up as shown, thus aiding the force on Leg A to cause the loop of wire to rotate clockwise. This simple explanation is the basis for all electrical motor action, and the basis for the meter movements of the analog meter we will be discussing.

Figure 1-4. Magnetic Field Around a Wire Carrying Current

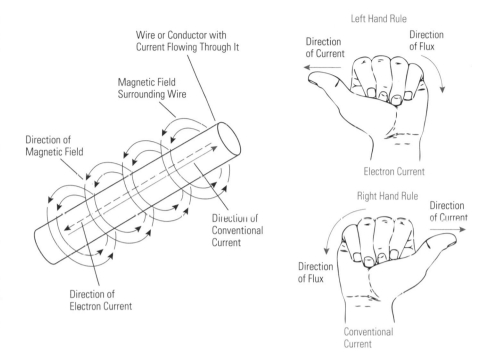

Figure 1-5. Motor Action – Wire Carrying Current in a Magnetic Field

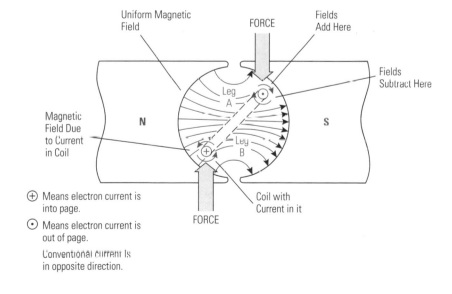

⊕ Means electron current is into page.

⊙ Means electron current is out of page.

Conventional current is in opposite direction.

OPERATION OF THE BASIC METER MOVEMENT

Let's look further at the basic construction and operation of the analog type meter called a D'Arsonval meter (*Figure 1-6*). The moveable coil with many turns, called an armature, has a needle attached to it, and is located within the strong magnetic field of the permanent magnet (PM), which is hidden under the scale plate. The uniform radial field about the moving coil is required to make the torque produced by the current in the coil result in a linear movement of the meter needle along the calibrated scale. As current increases, deflection increases.

Figure 1-6. D'Arsonval Moving Coil Meter Movement

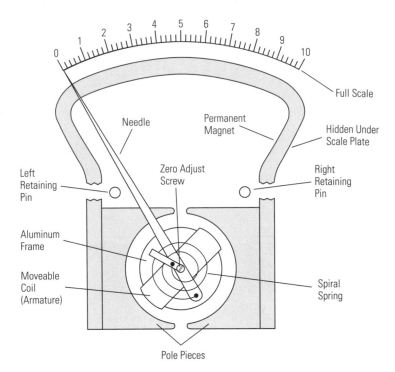

One end of the needle is attached to a spiral spring so the needle will be returned to an initial position when the current in the coil is removed. The spring is calibrated and the coil and needle are balanced so that the total assembly produces a linear deflection on the meter scale as the current in the coils is increased linearly.

The other end of the spiral spring is attached to a ZERO ADJUST screw located on the core of the moving coil. Using the ZERO ADJUST, the initial static position of the meter movement is adjusted mechanically to zero on the scale by varying the position of the end of the spiral spring. Care must be taken in making this adjustment because of the delicate construction of the spiral spring.

The complete needle assembly usually is constructed around an aluminum frame so that the assembly is very sturdy. The aluminum frame also serves a purpose for damping, which will be discussed a bit later.

Since the radial magnetic field is produced by a permanent magnet, the direction of the force of this field is always in one direction. Thus, the current must pass through the coil in

one direction only to cause an upscale deflection of the needle. If current passes through the meter movement coil in the other direction, the needle deflects backwards against the meter's left retaining pin. This is one of the most common ways of damaging or burning out a meter – *passing too much current through the coil in the wrong direction.*

DAMPING

To prevent overshoot when the meter coil and needle assembly moves, it must be damped. As mentioned, the aluminum frame accomplishes the damping. In effect, the aluminum frame serves as a short-circuited single-turn loop within the meter's magnetic field. A loop of wire moving in a magnetic field will have a voltage induced in the loop. Any movement of the meter armature moves the frame, and the induced voltage causes a current in the frame. As with any current in a conductor, the frame current develops a magnetic field which interacts with the strong magnetic field of the permanent magnet and offers a slight opposition to the movement of the coil. This method of damping the moving coil movement is an application of a law developed by Heinrich Lenz, a German physicist. The law states that the resultant current in a wire moving in a magnetic field produces a magnetic field that opposes the original magnetic field that generates the voltage that produced the current.

BASIC CHARACTERISTICS

METER MOVEMENT SENSITIVITY

The sensitivity of the meter movement depends upon the current required for full-scale deflection. It varies inversely with the current; that is, the most sensitive meter requires the least current for full-scale deflection. The amount of current required to deflect the needle full scale depends upon the number of turns of wire on the moving coil. When more turns are added, usually by using smaller and smaller wire, a stronger magnetic field is created to react with the permanent magnetic field. Smaller wire also keeps the mass of the meter movement low.

INTERNAL RESISTANCE

The meter sensitivity and the internal dc resistance of a meter movement are fixed by the design; definite characteristics that cannot be altered unless the physical construction of the meter movement is changed. To measure a meter's internal resistance, with the full-scale current through a meter indicated by the standard current meter, a voltmeter is connected across the unknown meter to measure the voltage drop across its internal resistance, as shown in *Figure 1-7*. The unknown meter's internal resistance may then be obtained by Ohm's Law:

$$R_M = \frac{V_M}{I_M}$$

where V_M is the voltage across the meter and I_M is the current through the meter for a full-scale reading. A meter that is designed to have full-scale deflection with a very low current will have high sensitivity and high internal resistance.

CAUTION: A sensitive meter movement can easily be destroyed by connecting an ohmmeter across it in an attempt to measure its internal resistance. The ohmmeter has an internal battery and can supply current. The current from the ohmmeter may be 100 times that required to deflect the meter full scale.

• *Measuring Sensitivity*

The sensitivity of a meter can be determined by measuring the current required to produce full-scale deflection. To do this, a standard current meter is placed in series with the unknown meter and a source of current is applied to the meter, as shown in *Figure 1-8*. Since the current is the same in all parts of a series circuit, the amount of current to produce full-scale deflection on the unknown meter can be read directly from the standard meter. Meter sensitivities range from a few microamperes for very sensitive movements to 50 to 1,000 microamperes for average movements used for multitesters that measure voltage, current and resistance.

Figure 1-7. Measuring a Meter's Sensitivity and Internal Resistance

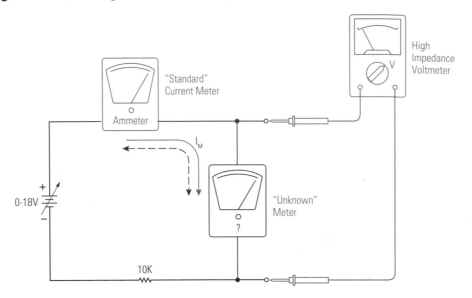

METER ACCURACY

There are many factors that affect a meter's accuracy: the design of the meter, the quality of its parts, the care in its manufacture, the accuracy of its calibration, the environment in which it is used, and the care it has received since being put into service.

The accuracy of a meter that is used in everyday applications (not under controlled environmental conditions) usually is between 0.01% and 3%. The accuracy of meters that have D'Arsonval movements (*Figure 1-6*) that are commonly used in all types of measuring instruments is about 1% of the full scale reading. If a voltmeter has a 10-volt scale and it has a 1% accuracy, any reading is going to be accurate to ±0.1 volt. The stated accuracy of the meter in percent refers to the percent of full-scale reading on any range.

Let's look at *Figure 1-8*. The accuracy of a voltage reading for a meter that has a stated accuracy of 1% is plotted against the voltage to be read for three full-scale ranges – 10 volt, 5 volt, and 2.5 volt. If a voltage of 2 volts is measured, it will be accurate to ±0.1V (5%) if measured on the 10 volt range; ±0.05V (2.5%) if measured on the 5 volt range; and ±0.025V (1.25%) if measured on the 2.5 volt range.

As a result, a meter reading taken at the low end of the scale (using the 10 Volt Range) is going to have a greater percent of absolute error than a reading near full scale (the 2.5 Volt Range). The closer the reading of the meter to full scale, the less the absolute error.

Figure 1-8. Accuracy Range of 1% Meter on Various Full-Scale Ranges

AMMETERS

The simplest ammeter contains only the basic meter movement. It can measure values of current up to its sensitivity rating (full-scale deflection). Meter movements that require a large current for full-scale deflection are not practical because of the large wire that would be required on their coils and thus, a large mass. Therefore, highly sensitive meter movements are desensitized by placing low-value resistors called "shunts" in parallel with the meter movement to extend their current-handling range. If a meter movement requires 100 microamperes for full-scale deflection and the meter is to have a 10 milliampere (10,000 microampere) scale, a shunt across the meter must have a resistance value to carry 9900 microamperes. First, we will look at how a shunt is used to adjust the range of a simple ammeter. Then we will describe how shunts are used to manufacture multirange ammeters.

SIMPLE AMMETERS

Figure 1-9 shows a single shunt across a basic meter movement to extend the range of the movement. Shunts are easily calculated by applying Ohm' Law ($V = IR$) and the principles of a parallel circuit, if the meter movement's internal resistance, R_M, is known. The derivation of the equation for the ammeter shunt resistor, R_S, is as follows:

The voltage across the shunt, V_S, is equal to the voltage across the meter, V_M. Therefore:

$$V_S = V_M$$

V_S is equal to the current through the shunt, I_S, times the shunt resistance, R_S. V_M is equal to the current through the meter movement, I_M, times the meter resistance, R_M. Therefore:

$$I_S \times R_S = I_M \times R_M$$

Solving for R_S gives,

$$R_S = \frac{(I_M \times R_M)}{I_S}$$

Substituting $I_T - I_M$ for I_S gives,

$$R_S = \frac{(I_M \times R_M)}{(I_T - I_M)}$$

The use of this meter shunt equation will provide the correct value of resistance to be added in parallel with the meter movement to increase the current handling capability of the meter.

Figure 1-9. Using a Single Shunt to Extend the Range of a Basic Meter Movement

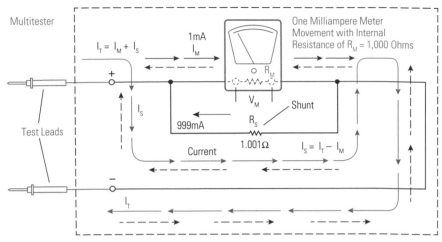

Example: If I_M = 1 milliampere, R_M = 1000 ohms, and I_T is to be a full-scale range of 1 ampere, the shunt resistance is:

$$R_S = \frac{0.001A \times 1000 \text{ ohms}}{(1000-1) \text{ mA}}$$

$$R_S = \frac{1V}{999mA}$$

$$R_S = \frac{1}{0.999A}$$

$$R_S = 1.001 \text{ ohms}$$

MULTIRANGE AMMETERS

• Simple Shunts

As we have said, a basic meter movement has a given sensitivity – a given amount of current must pass through it to produce full-scale deflection. By using suitable shunts, the range of current that a given movement can measure is increased. Essentially, this is the process used in the construction of multi-range ammeters. *Figure 1-10* shows the shunt circuitry of a four-range ammeter. The test leads are used to connect the meter to the circuit to be tested to measure a current. Note that the lowest range (position 1) uses the meter's basic sensitivity of 1 milliampere (1 mA) with no shunt. The values of the shunts – and the resulting test ranges – are given in the illustration. These values may be verified using the equation for R_S that was just discussed. Position 5 on the switch is marked SHORT, which takes the meter out of the circuit without physically disconnecting the test leads.

• Ring Shunts

Another type of shunt commonly used in multimeters or multitesters is shown in *Figure 1-11*. It is called a ring-type shunt or Ayrton "universal" shunt. In the circuit, resistors R_2, R_3, R_4, R_5 and R_6 are used as shunts. They are all connected in series and, in turn, are connected in parallel across R_1 and the basic meter movement. R_1 is always in series with the meter movement.

Figure 1-10. A Multi-Range Ammeter

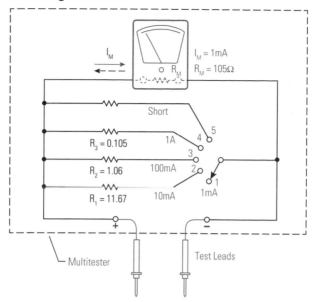

Figure 1-11. Ring Shunt

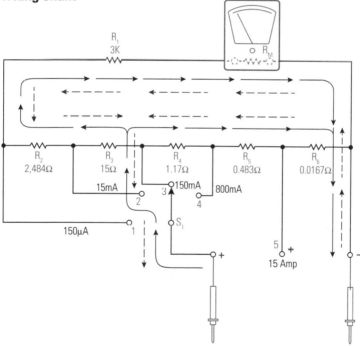

The position of the switch, S_1, determines which of the resistors R_2 through R_5 also are placed in series with the basic meter movement. The remaining resistors form the shunt to increase the current range. The resistance needed for each current range is calculated in the same way as in the simple shunt circuit, except that the resistance in series with the meter is added to R_M.

For example, S_1 in *Figure 1-11* is in position 3, the 150 milliampere (150mA) scale. For this full-scale value, series resistors R_4, R_5 and R_6 are in shunt with the total series represented by R_1, R_2, R_3 and the internal resistance of the meter, R_M. Because of the number of unknowns in this circuit, it is impossible to use the previous equation for calculating R_S. Rather, an equation based upon Ohm's Law and the laws for parallel circuits can be derived. We will not show the derivation because of its length, but just offer the equation here for your use. It is:

$$R_S = \frac{(R_{SUM} \times I_M)}{I_T}$$

where R_S equals the total value of the shunt, R_{SUM} equals the sum of the resistances in the ring of the ring-type shunt, I_M equals the maximum current through the meter movement (its sensitivity), and I_T equals the new full-scale value of the current. In *Figure 1-11*, R_{SUM} would be equal to resistors $R_1 + R_2 + R_3 + R_4 + R_5 + R_6$.

The ring-type shunt eliminates the problem of high contact resistance, which can cause errors in simple shunt meters. It also eliminates the need for a special type of make-before-break type switch on the range switch of the ammeter of *Figure 1-10*. The make-before-break switch protects the basic movement from high currents as the selector switch of *Figure 1-10* is switched to different ranges. Examining the circuit of *Figure 1-10* will show that a full measured current could pass through the basic movement if the selector switch opens the shunt circuit on switching.

BASIC VOLTMETERS

Using Ohm's Law ($V = IR$) again where V is the voltage applied, I is the circuit current, and R is the total circuit resistance, the product of the meter movement's sensitivity, I_M, and the meter movement internal resistance, R_M, equals the voltage across the meter movement, V_M, for full-scale deflection. When additional series resistance is added, it converts the basic meter movement into a direct current (dc) voltmeter. The series resistor is called a multiplier. The basic circuit is shown in *Figure 1-12*. The value of the multiplier resistor, R_X, determines the voltage range for full-scale deflection. By changing the value of the multiplier resistor, the full-scale voltage range can be change.

Figure 1-12. The Basic Circuit for a DC Voltmeter

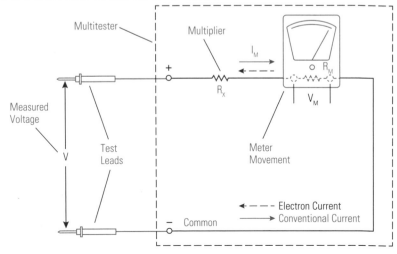

MULTIPLIER RESISTANCE

The value of the multiplier may be found by using Ohm's Law and the rules of a series circuit. Let's look again at *Figure 1-12*. Since the multiplier resistor, R_X, is in series with the basic meter movement, the current, I_M, passes through R_X. If V equals the full-scale voltage of the voltmeter then, according to Ohm's Law:

$$V = I_M (R_X + R_M)$$

Expanding the equation gives:

$$V = I_M R_X + I_M R_M$$

Rearranging:

$$V - I_M R_M = I_M R_X$$

Solving for R_X gives:

$$R_X = \frac{V - I_M R_M}{I_M}$$

Which may be arranged as:

$$R_X = \frac{V}{I_M} - R_M$$

Example: Let's change the basic meter movement of *Figure 1-11* into a dc voltmeter with a 10 volt full-scale range. For this example, V = 10 volts, I_M = 1 milliampere (0.001A), and R_M = 105 ohms. Therefore:

$$R_X = \frac{10 \text{ volts}}{0.001A} - 105 \text{ ohms}$$

$$R_X = (10,000 - 105) \text{ ohms}$$

$$R_X = 9895 \text{ ohms}$$

When 10 volts is applied to the circuit of *Figure 1-12*, with R_X = 9895 ohms and R_M = 105 ohms for the basic meter movement, one milliampere of current will deflect the meter to full scale.

MULTIRANGE VOLTMETERS

The selection of one of a number of multiplier resistors by means of a RANGE switch provides a voltmeter with a number of voltage ranges.

Figure 1-13 shows a multirange voltmeter using a four-position switch and hence four multiplier resistors. The multiplier in each range was calculated using the simple equation for R_X given previously.

A variation of the circuit of *Figure 1-13* is shown in *Figure 1-14*. In this circuit, V_4 is a higher voltage range than V_3; V_3 is higher than V_2; and V_2 is higher than V_1. As a result, the multiplier resistors of the lower ranges can be included as the multiplier for the higher range. An advantage to this circuit is that all multipliers except the first have standard resistance values, which are less expensive and can be obtained commercially in precision tolerances. The first multiplier resistor, R_1, is the only special resistor that must be manufactured to meet the particular requirements of the meter movement.

Figure 1-13. Simple Multirange DC Voltmeter

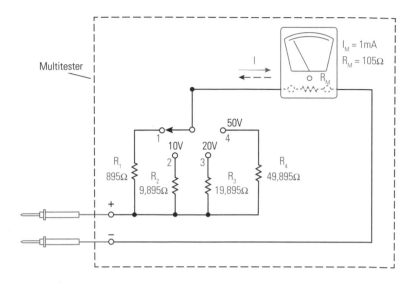

Figure 1-14. Alternate Multirange DC Voltmeter Circuit

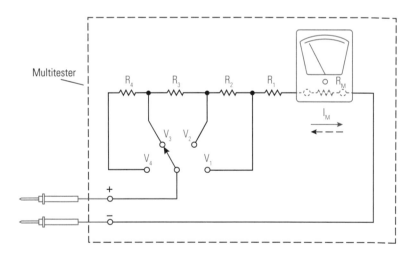

VOLTMETER SENSITIVITY

Figure 1-15 shows the typical way a voltmeter is used to make a voltage measurement – in this case, the voltage across resistor R_2. The voltmeter is connected across or in parallel with the circuit component (R_2) to measure the voltage. The voltmeter must have a current, I_M, through the meter movement to produce the deflection. This current must be supplied by the circuit and reduces the current through R_2 as shown in *Figure 1-15*. It is desirable that the resistance of the voltmeter ($R_X + R_M$) be much higher than the resistance of the device to be measured. This reduces the current drawn from the circuit by the voltmeter and, therefore, increases the accuracy of the voltage measurement.

The value of the voltmeter resistance (referred to as input resistance) depends on the sensitivity of the basic meter movement. The greater the sensitivity of the meter movement, the smaller the current required for full-scale deflection and the higher the input resistance. When expressing the sensitivity of the voltmeter, the term "ohms per volt" is used exclusively. It is referred to as the voltmeter sensitivity.

The sensitivity of the voltmeter, S, is easily calculated by taking the reciprocal of the full-scale deflection current of the basic meter movement, or:

$$S = \frac{1}{I_M}$$

Example: if a meter movement with a sensitivity of 50 microamperes (0.000050A) full-scale current deflection is used to make a voltmeter, the voltmeter has a sensitivity of:

$$S = \frac{1}{50 \times 10^{-6}} = \frac{1}{0.000050A}$$

$$S = 20,000 \text{ ohms per volt}$$

Figure 1-15. Voltage Measurement

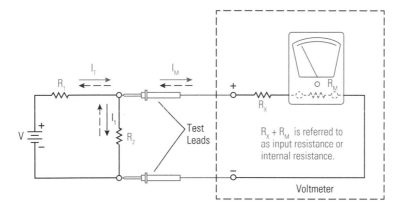

If the full-scale voltage range is set on the 1 volt range, the input resistance is 20,000 ohms; if it is set on the 20 volt range, it is 400,000 ohms.

BASIC OHMMETERS

Since electrical resistance is measured in ohms, a common instrument used to measure resistance is called an ohmmeter. Recall from Ohm's Law that the resistance, R, in a dc circuit can be determined by measuring the current, I, in a circuit as a result of applying a voltage, V. The voltage divided by the current is the resistance value, or:

$$R = \frac{V}{I}$$

The resistance will be one ohm if there is one ampere of current in a circuit when one volt is applied. By applying a known voltage, V, to a circuit and measuring the current, I, the meter scale can be calibrated to read in ohms of resistance. This is the basic principle of an ohmmeter.

BASIC OHMMETER CIRCUIT

The basic ohmmeter circuit is shown in *Figure 1-16*. The ohmmeter circuit applies voltage from a self-contained battery to a series connection consisting of a known resistance (R_K) to the unknown resistance (R_U). The meter movement determines the value of the unknown resistance by measuring the current in the circuit.

Ohmmeters are very useful in servicing electronic equipment by making quick measurements of resistance values. The resistance values that can be measured with the ohmmeter vary from a fraction of an ohm to 100 megohms or more. The accuracy is seldom better than 3%; therefore, they generally are not suitable for measurements that require high accuracy.

Figure 1-16. A Simple Series Ohmmeter

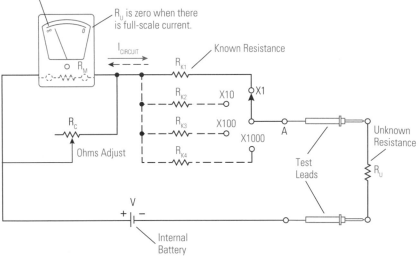

Since ohmmeters contain their own power source and depend on their internal calibrated circuits for accuracy, they should only be used on passive circuits; that is, circuits that are not connect to other power sources. *Connecting an ohmmeter to a circuit with another power source destroys the calibration of the meter and can very easily destroy the ohmmeter.*

SERIES OHMMETER

Let's look again at the basic series-type ohmmeter circuit shown in *Figure 1-16*. Notice that when the test leads are open (R_U equals infinity), there is no current through the meter. The meter needle at rest indicates an infinite resistance.

When the test leads are shorted ($R_U = 0$), there is a full-scale deflection of the needle indicating a zero resistance measurement. The typical meter scale is shown in *Figure 1-16*. The purpose of R_C is to allow adjustment to zero on the scale to compensate for a changing battery potential due to aging, and for lead and fuse

resistance. The purpose of R_K is to limit the current through the meter circuit to full scale when the test leads are shorted.

It is convenient to use a value for R_K in the design of the series ohmmeter such that when an unknown resistance equal to R_K is measured, the meter will deflect to half scale. Therefore, when the leads are shorted together, the meter deflection will be full scale. Using this criteria, multiple ranges for the ohmmeter can be provided by switching to different values of R_K, as shown in *Figure 1-16*. Each R_K would set the half-scale value for the respective resistance range, and provides the scale multiplier.

SHUNT OHMMETER

The shunt-type ohmmeter is often found in laboratories because it is particularly suited to the measurement of very-low-value resistors. The circuit for a shunt-type ohmmeter is shown in *Figure 1-17*. In this circuit, current has two paths, one through the meter and one through R_X, if there is one. If the leads are open from A to B ($R_X = \infty$), then the meter movement reads full scale (adjusted by R_1). This is marked as infinity. If the leads are shorted, the meter current drops to zero and the resistance is marked as 0 ohms. When a value of unknown resistance, R_X, is placed across the terminals A and B, it causes the meter to deflect to some point below full scale. For example, if R_X equals R_M, then the meter movement would read half scale.

Figure 1-17. A Simple Shunt Ohmmeter

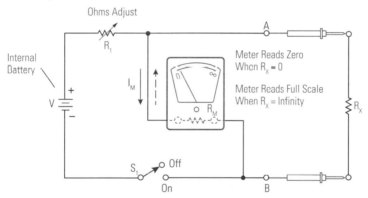

The scales for the two types of ohmmeters are exactly opposite. The series ohmmeter scale has 0 ohms on the right, while the shunt-type has the 0 ohms position on its left. This is a good way to identify the type of ohmmeter you might be using.

AC METERS

The most practical means for measuring commonly-used alternating current (ac) voltages is by combining a highly-sensitive D'Arsonval meter movement with a rectifier.

THE PURPOSE OF THE RECTIFIER

The purpose of the rectifier is to change the alternating current into direct current. The D'Arsonval meter movement is a dc movement because of the permanent magnet, which sets up the field for the moving coil. The method of using a rectifier to convert ac to dc so that the dc movement can be used to measure ac is very attractive because the D'Arsonval meter movement has a much-higher sensitivity than other types of meters used to measure ac, such as an electrodynamometer or the moving iron-vane type of meter.

• Bridge-Type Rectifier

The circuit of *Figure 1-18* makes use of a bridge-type rectifier which provides full-wave rectification. The bridge generally is made of germanium or silicon diodes. A D'Arsonval meter movement provides a deflection that is proportional to the "average" value of the dc current. In practice, most alternating currents and voltages are expressed in effective values. As a result, the meter scale is calibrated in terms of the effective value of a sine wave, even though the meter is responding to the average value. Effective value also is referred to as RMS (Root-Mean-Square) value.

Figure 1-18. AC Voltmeter Using a Bridge Rectifier

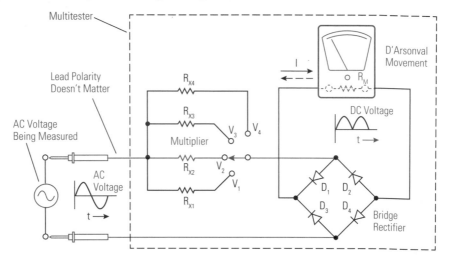

A conversion factor which will relate the average and the RMS values of a sine wave may be found by dividing the RMS value by the average value:

$$\frac{E_{rms}}{E_{avg}} = 1.11$$

This conversion factor is valid only for sinusoidal ac measurements.

MULTIRANGE AC VOLTMETERS

As shown in *Figure 1-18*, just as for dc voltmeters, multiplier resistors can be added to provide multirange ac voltmeters. A more common circuit used for commercial ac voltmeters is shown in *Figure 1-19*. This circuit uses rectifiers to convert the ac voltages to dc in just a little different way. There is current through the meter movement as D_1 conducts on the positive half-cycle, while D_2 conducts on the negative half-cycle to bypass the meter. R_X is connected across the meter movement in order to desensitize the meter causing it to draw more current through diode D_1. This moves the operating point on the diode curve up into a more linear portion of the characteristic curve. Multiple ranges can be provided by having various multiplier resistors for the required ranges. AC meters normally have lower internal resistance than dc meters with the same meter movement.

Figure 1-19. A Practical AC Voltmeter Circuit

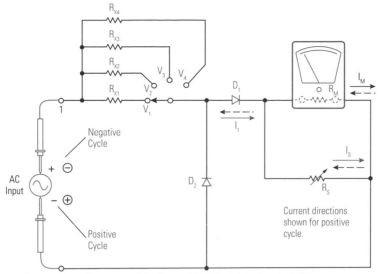

CALIBRATION, PARALLAX, & INTERNAL POWER

Having covered some of the types of analog meters, let's discuss several items that apply generally to the operation of these meters: calibration, parallax, and internal power.

CALIBRATION

The sensitivity of the meter movement may be determined and the meter calibrated as shown in *Figure 1 8*. Calibration requires a standard. In this case, the standard is provided by the current meter used to indicate the current. It is advisable to calibrate the lowest dc current range first, since all ranges of the instrument will be seriously in error if the basic current range is not accurate. Errors on the various scales may be noted so that readings may be adjusted accordingly. If errors are great, shunts and multipliers inside the meter would have to be modified to correct for these errors.

PARALLAX ERROR

Parallax error in reading the position of a meter's needle on the scale is due to the misalignment of the head and eyes over the needle so that you are reading the needle position from the side, not directly above the needle. The most accurate reading is obtained when the head is positioned perpendicular to the scales and directly over the needle. To assure this, many meters have mirrors imbedded in their scales so the needle can be aligned with its image in the mirror. When the head is positioned correctly, the mirror image of the needle disappears, and the correct alignment is accomplished.

INTERNAL POWER

VOM meters rely on internal batteries for their power. A good indicator of battery condition is when the "Ohms Adjust" no longer adjusts the needle to $R = 0$ or $R = \infty$. When this happens, the battery needs to be replaced.

SUMMARY

Now that we know the characteristics of analog meters used to measure current, voltage, and resistance, let's look at their cousins – digital meters.

2

DVM –
The Basic Concepts

BASIC DVM

A typical digital multimeter (DVM) is shown in *Figure 2-1*. It has a single, rotary selector switch that selects whether the meter is to be used as a dc voltmeter, dc ammeter, ac voltmeter, ac ammeter, or ohmmeter. It selects the full-scale range of the measurement at positions within the selected function. It has a digital display, test jacks to accept test leads, and a measurement function selector. Range is selected automatically after the function is selected. The range is determined by the value measured. It measures ac and dc voltage, but only dc current, and does not measure capacitance and transistor h_{FE}.

Figure 2-1. Digital Multimeter

COMPARISON TO ANALOG METERS

Unlike the analog meter that has a needle deflecting along a scale, each of these digital multimeters – as is the case for all digital multimeters – has a digital display. The measurement value is displayed as a number with four digits. On the lowest full-scale range, the measurement is read on the display to an accuracy of three decimal places.

Unlike analog meters, digital multitesters have an ON-OFF power switch. DVMs contain electronic circuits to produce their measurement value rather than an electromechanical meter movement. As a result, they need internal batteries to supply power for the electronics, as well as an energy source to supply current for resistance measurements when the meter is used as an ohmmeter. The ON-OFF switch connects the power source to the circuits. Like the analog meter, the digital multitesters have function selector switches and jacks to accept test leads. They may have range selector switches, or the range may be selected automatically.

DVM CHARACTERISTICS

Several important characteristics result from the fact that digital multitesters are electronic. One characteristic is that they are basically voltmeters and, when used as ammeters or ohmmeters, the circuit arrangement is such that the DVM is used as a voltmeter. A second characteristic is that the DVM has a high internal resistance on all functional ranges. As will be shown in Chapter 3, having a high internal resistance is a very desirable characteristic because circuit loading is usually negligible when using a DVM.

The third and fourth characteristics are due to the digital display. Because the display is digital there is no parallax reading error, or error due to interpolation between scale marks, as on an analog meter. Because the display is digital, the conversion accuracy is within ± one digit on any of the scales used. The accuracy due to the display remains constant over all ranges and doesn't vary. As a result, overall accuracies of DVMs are typically 0.05% to 1.5%, as compared to 3% to 4% for analog meters.

A fifth characteristic relates to the special functions that are available on some DVMs. An audio tone that sounds when measuring circuit continuity is a common example. A special check for semiconductor junctions is another. The meter in *Figure 2-1* only has the feature that checks semiconductor junctions.

HOW A DVM WORKS

A block diagram of a typical digital voltmeter is shown in *Figure 2-2*. Either dc or ac voltages can be measured. Let's look at measuring a dc voltage first.

The test probes connect to the dc voltage, bring it into the DVM through a signal conditioner, and couple it to a circuit called an analog-to-digital (A/D) converter. The A/D converter accepts a voltage and changes it to a digital code that represents the magnitude of the voltage. The digital code is used to generate the numerical digits that show the measured value on the digital display.

DIGITAL DISPLAY

An easy way to understand how a DVM works is to begin at the display. *Figure 2-3a* shows a common way to display a numerical digit. A seven-segment array of elements is used to form the digits. Common displays for portable DVMs used in the laboratory or service shop are light emitting diodes (LEDs) or liquid crystal displays (LCDs). Liquid crystal displays use very little power, but must have ambient light or back illumination to view the display. LED displays use much more power, but are much brighter and not easily washed out in bright sunlight.

Figure 2-2. Block Diagram of a Basic Digital Voltmeter

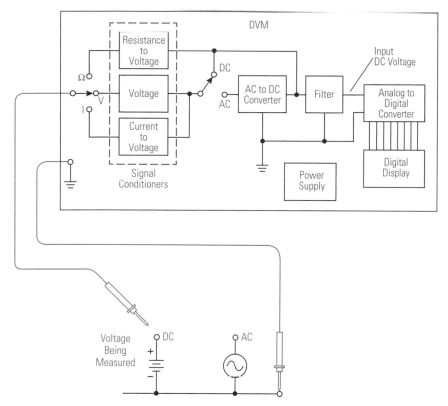

As shown in *Figure 2-3a* – a typical LED display schematic – a power source is connected to each LED segment, and each LED segment is excited by passing current through it. In the example shown, the segments necessary to display a numeral 2 are grounded and current through them causes the segments to emit light. The table shown in *Figure 2-3b* lists the segments that must be excited to display any of the numerals from 0 to 9. As shown in the example of *Figure 2-3a*, a decoder establishes the proper segments that must be grounded. The decoder has an input digital code that represents the numeral required.

• BCD Codes

A very common code used in digital systems to represent numerals is a 4-bit binary coded decimal (BCD) code. The BCD code for the numerals from 0 to 9 is shown in *Figure 2-3b*. This code, if fed into the decoder of *Figure 2-3a*, will cause the decoder to ground the proper segments of the digit display to display the proper numeral for the table of *Figure 2-3b*.

ANALOG-TO-DIGITAL (A/D) CONVERSION

Now that we know how the BCD codes provide the input to display the numerals, let's find out how the codes are generated in the A/D converter. A block diagram is shown in *Figure 2-4*. The table shows the BCD code that is output for each of the four digits when a dc voltage between 0 and 2 volts (1.999 volts) is applied at the input. The resolution of the DVM is one millivolt, which means that a new 4-digit BCD code is generated for each change of one millivolt in the input voltage. *Figure 2-4* does not show each one millivolt

Figure 2-3. 7-Segment Digit Display

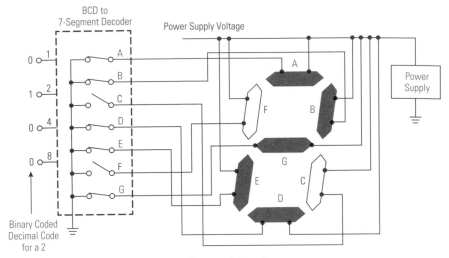

a. Segment Schematic
(The digit 2 being displayed)

Digit	Segment							BCD Code 8421
	A	B	C	D	E	F	G	
0	●	●	●	●	●	●		0000
1		●	●					0001
2	●	●		●	●		●	0010
3	●	●	●	●			●	0011
4		●	●			●	●	0100
5	●		●	●		●	●	0101
6			●	●	●	●	●	0110
7	●	●	●					0111
8	●	●	●	●	●	●	●	1000
9	●	●	●			●	●	1001

● Means segment is grounded

b. Excitation Table for Digits

4-digit code, but lists the codes that would be generated for the four digits for each one-tenth of a volt. In addition, it shows some special example values (0.001, 0.578, 1.234, 1.667, and 1.999) to help understand what the A/D converter output is like. There is a separate 4-digit BCD code for each one millivolt but, for simplicity, they are not all included in *Figure 2-4*.

If the input voltage to the A/D converter is 1.234 volts, the four-digit BCD code that would be generated at the output would be 0001, 0010, 0011, 0100, as shown. Each of the 4-bit BCD codes representing a digit is coupled to a decoder, like the one shown in *Figure 2-3a*, and the proper numeral is displayed for the respective digit. Individual logic gates in the A/D converter control the decimal point. If a logic 1 level is output, the decimal point will be ON. As the scales change, the decimal point that is energized changes.

The display techniques and the outputs of the A/D converter shown in *Figure 2-3* and *Figure 2-4* are not the only way a DVM can produce the conversion and display. There are scanning techniques and multiplexing techniques so that the digit codes are transferred in sequence along fewer bus lines. However, the method described here is the most direct way and was chosen to make it easier to illustrate and explain the basic concepts.

Figure 2-4. A/D Converter with 0-2 Volts Input and 4-Digit Output Codes

A/D Converter

Voltage (in volts)	Digit Code							
	1		2		3		4	
1.999	0001	1	1001	0	1001	0	1001	
1.900	0001	1	1001	0	0000	0	0000	
1.800	0001	1	1000	0	0000	0	0000	
1.700	0001	1	0111	0	0000	0	0000	
1.667	0001	1	0110	0	0110	0	0111	
1.600	0001	1	0110	0	0000	0	0000	
1.500	0001	1	0101	0	0000	0	0000	
1.400	0001	1	0100	0	0000	0	0000	
1.300	0001	1	0011	0	0000	0	0000	
1.234	0001	1	0010	0	0011	0	0100	
1.200	0001	1	0010	0	0000	0	0000	
1.100	0001	1	0001	0	0000	0	0000	
1.000	0001	1	0000	0	0000	0	0000	
0.900	0000	1	1001	0	0000	0	0000	
0.800	0000	1	1000	0	0000	0	0000	
0.700	0000	1	0111	0	0000	0	0000	
0.600	0000	1	0110	0	0000	0	0000	
0.578	0000	1	0101	0	0111	0	1000	
0.500	0000	1	0101	0	0000	0	0000	
0.400	0000	1	0100	0	0000	0	0000	
0.300	0000	1	0011	0	0000	0	0000	
0.200	0000	1	0010	0	0000	0	0000	
0.100	0000	1	0001	0	0000	0	0000	
0.001	0000	1	0000	0	0000	0	0001	
0.000	0000	1	0000	0	0000	0	0000	
Decimal Point Active for Scale Shown	DP_1		DP_2		DP_3			
	2V		20V		200V			

0-2 Volts

1
2
Digit 1
4
8

DP_1
Decimal Pt. 1

1
2
Digit 2
4
8

DP_2
Decimal Pt. 2

1
2
Digit 3
4
8

DP_3
Decimal Pt. 3

1
2
Digit 4
4
8

THE A/D CONVERSION PROCESS

There are a number of techniques used to perform the actual conversion process. Staircase integrating, continuous balance, successive approximations, dual-slope, and voltage-to-frequency converters are the names of some of these techniques. We do not have space to cover all of them, so we will explain the staircase and the dual-slope converter because these demonstrate the basic concepts the best.

STAIRCASE CONVERTER

Figure 2-5 shows the block diagram of a staircase converter. It consists of a comparator, a clock gate, G, a clock generator, a binary counter, and a digital-to-analog (D/A) converter. The output is coupled to a digital display. The D/A converter does the opposite of the analog to digital converter. It takes the digital code output from the stages of the binary counter and converts it to an analog voltage. Each time the binary counter increases its count by one, the output voltage, V_O, increases by one millivolt. V_O is one input to the comparator; the input voltage, V_{IN} is the other input to the comparator.

Figure 2-5. Staircase A/D Converter

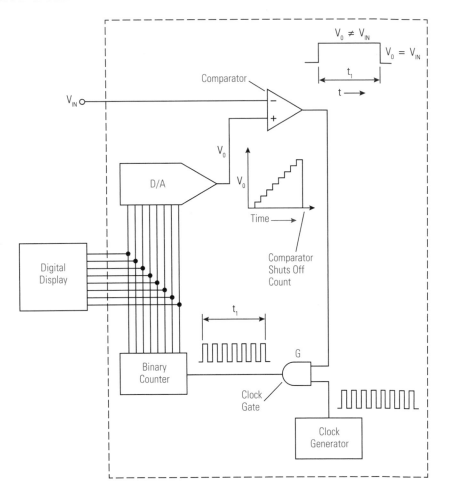

• V_O Not Equal to V_{IN}

When the input voltage, V_{IN}, is first applied to be measured, V_O is zero, and the output of the comparator is at a 1 logic level because V_O is not equal to V_{IN}. Since the comparator 1 output is an input to the AND clock gate, G, the clock signal appearing on the other G input will appear on the gate output and feed into the binary counter. The binary counter counts the clock pulses, and through the D/A converter begins to increase V_O by 1 millivolt per count. Thus the name staircase converter.

• V_O Equal to V_{IN}

When V_O is equal to V_{IN}, the comparator output drops to a 0 logic level, and the clock pulses through G turn off, which stops the count and holds V_O equal to V_{IN}. The digital code at the counter is converted to the necessary code for display of the numerals that represents the value of the voltage V_{IN}. Note that it takes time t_1 to reach the point where $V_O = V_{IN}$; therefore, measurements can be done only at a maximum rate.

DUAL-SLOPE CONVERTER

A block diagram of a dual-slope A/D converter is shown in *Figure 2-6*. It consists of an operational amplifier, A, connected as an integrator, a comparator, a logic gate, G, for gating the clock signal, a counter for counting clock pulses, a reference voltage, and control logic circuitry. The output feeds to a digital display.

Figure 2-6. Dual-Slope A/D Converter

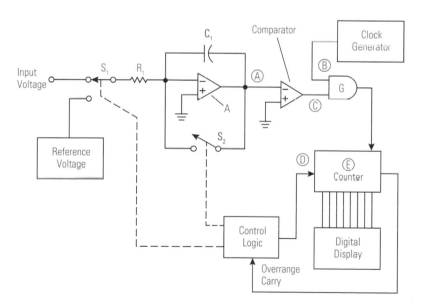

As with the staircase converter, the magnitude of the input voltage measured is determined by the number of clock pulses counted. The resultant counter code is then converted to the appropriate code to display the proper digits on the digital display.

The number of pulses counted is determined by a start count control signal (D) in *Figure 2-6*, which allows the counter to start counting, and a comparator output signal (C), which stops counting by gating off the clock pulses. The timing is shown in *Figure 2-7*.

Figure 2-7. Dual-Slope Converter Operation

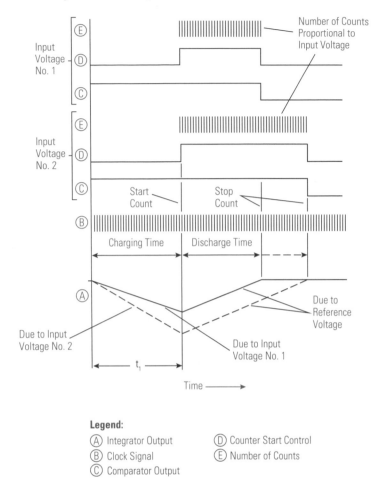

Legend:
- (A) Integrator Output
- (B) Clock Signal
- (C) Comparator Output
- (D) Counter Start Control
- (E) Number of Counts

• Basic Operation

The basic concept of how the dual-slope A/D converter operates is as follows: S_2 is a switch that shorts out capacitor C_1 so that initially there is no charge on C_1. When a measurement is made, S_2 is open and S_1 is connected to the input voltage for a period of time, t_1, as shown in *Figure 2-7*. In time t_1, C_1 charges at a constant rate to a magnitude of voltage determined by the input voltage. At the end of t_1, S_1 is switched to a reference voltage that is opposite in polarity to the input voltage. This reference voltage discharges capacitor C_1 at a constant rate. The time that it takes to discharge C_1 back to the initial zero level (and just a few millivolts more, because the comparator output must switch states) is proportional to the input voltage magnitude. The charging and discharging curves for two different input voltages are shown in *Figure 2-7*.

When the discharge time starts (at the end of t_1), the start control (D) starts the counter. At the end of the discharge time, the comparator output (C) goes to a low logic level, turns off gate G, and stops the counter. *Figure 2-7* shows the number of clock pulses counted for two different input voltages. Note that in each case the count is proportional to the input voltage. As mentioned previously, the counter digital code is decoded to display the proper digits on the digital display.

AC MEASUREMENTS

The A/D converter is designed to accept a dc voltage and convert it to a digital code so the corresponding digits can be displayed. Referring back to *Figure 2-2*, we see that if the input to be measured is an ac voltage, a circuit in the DVM converts the ac voltage to a dc voltage, filters it and couples it to the A/D converter. It isn't absolutely necessary, but the dc voltage also passes through the filter in case there are some noise spikes on the input dc voltage.

SIGNAL CONDITIONERS

Because the A/D converter always needs an input dc voltage, all uses of the DVM as a voltmeter, ammeter, or ohmmeter require that signal conditioners be used to convert the measured quantity into a dc voltage. The three types of signal conditioners are shown in *Figure 2-2*. Let's look at the voltage conditioner first.

VOLTAGE CONDITIONER

Since the range of voltage that the A/D converter can handle is limited by design – 0 to 2 volts in our example – measured voltages greater than 2 volts will need to be attenuated, and voltages less than one-third to one-fifth of a volt will need to be amplified. Therefore, the voltage conditioner, as shown in *Figure 2-8*, is made up of a voltage divider to provide the attenuation and an operational amplifier to provide the amplification. There are five voltage ranges: 0.2V, 2V, 20V, 200V, and 2000V,

The gain of the operational amplifier is set by the equation

$$A = -\frac{R_F}{R_i}$$

where R_i is the input resistance. The minus sign means that the output signal is 180° out of phase from the input signal. R_F and R_i (made up of R_2, R_3, and R_7) are chosen so that A (amplification) equals 1 on the 2V range. With unity gain for the amplifier (A = 1), the input voltage is reproduced directly at the amplifier output and coupled to the A/D converter. On the 20V, 200V, and 2000V ranges, R_3 and R_7 are chosen such that the gain of the amplifier is unity again, just as for the 2V range (R_F does not change). The ratio of R_4, R_5 and R_6 to R_7 is set so that with 20 volts, 200 volts, and 2000 volts, respectively, on the input, the input voltage to the amplifier will be 2 volts. For the 0.2V range, R_1 is chosen so the gain of the amplifier is 10.

Figure 2-8. Voltage Conditioner

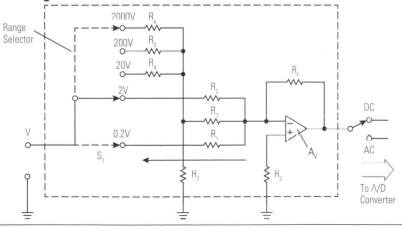

The voltage conditioner will work equally well for dc and ac voltage measurements over the frequency range specified for the DVM as long as the stray capacitance in the circuitry is kept to a minimum. Of course, the ac voltage at the output of the signal conditioner must be converted back to dc before it is coupled to the A/D converter.

AC TO DC CONVERSION

Many VOMs, multitesters, and DVMs that have rectifier type circuits have scales that are calibrated in RMS values for ac measurements, but actually are measuring the average value of the input voltage and are depending on the voltage to be a sine wave. These instruments are in error if the input voltage has some shape other than a sine wave.

There are DVMs that are manufactured that measure the true RMS value of input voltages regardless of the shape of the waveform. They measure the dc and ac component of the input waveforms; therefore, the measured value is the heating power of an ac voltage that is equivalent to the heating power of a dc voltage equal to the RMS value – the definition of an RMS voltage. Check the specifications of a DVM that you are using to determine if it measures true RMS voltages. If it does not, be wary of the measurement if the input voltage is not a sine wave or if it has a dc component.

CURRENT CONDITIONERS

The signal conditioning circuit for measuring current is shown in *Figure 2-9*. The current conditioner changes the current to be measured into a voltage by passing the unknown current through a precision resistance (R_1, R_2, R_3, or R_4) and measuring the voltage developed across the resistor. The range switch determines the resistor used for each range. When the proper current range is selected, the proper resistance is selected so that the voltage out of the current conditioner will be within the range required by the A/D converter. The resistors used are a special type of high power precision resistor used as current shunts.

Figure 2-9. Current Conditioner

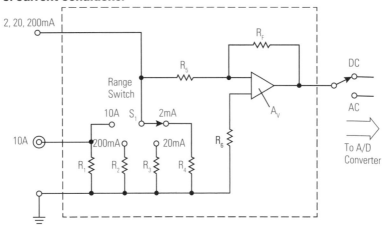

The position of the AC/DC switch determines the route the voltage output from the current conditioner takes to reach the input of the A/D converter. A high current range, such as 10 amps, usually is measured using a special input jack to which a special resistor is connected. An operational amplifier with a fixed gain prevents loading of the current sensing resistors by the A/D converter.

RESISTANCE CONDITIONERS

The basic circuit for the signal conditioner that the DVM uses for resistance measurements is shown in *Figure 2-10a*. The voltage, V, and the resistance, R_s, form a constant current source for the unknown resistor. A constant current through a given resistor will produce a set voltage drop. For example, if the constant current is 1 milliampere (0.001A) through a 1000 ohm resistor, the voltage drop across the 1000 ohm resistor is 1 volt. That's exactly what the DVM does to measure resistance – it measures the voltage across an unknown resistance when there is a known constant current through it. The voltage source, the series resistance, and the voltage range are changed as the full-scale range of resistance to be measured by the DVM is changed. No zero ohms adjustment is necessary.

Figure 2-10. Resistance Conditioner

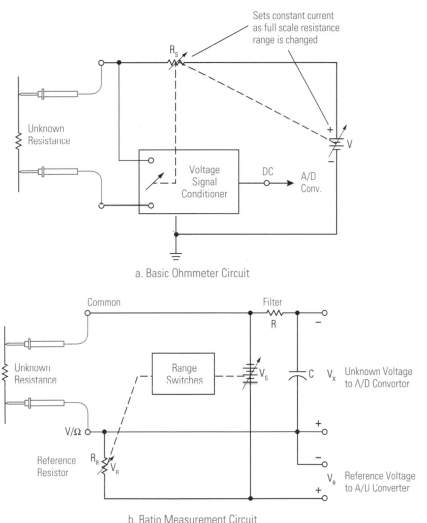

a. Basic Ohmmeter Circuit

b. Ratio Measurement Circuit

An alternate circuit found in some popular DVMs is shown in *Figure 2-10b*. It uses a ratio method to measure the value of the unknown resistor. If an unknown resistor, R_x, is

placed in series with a known reference resistor, R_R, across a known voltage source, V_S, the ratio of the voltage drop across the unknown resistor, V_X, to the voltage across the reference resistor, V_R, is equal to the ratio of R_X to R_R. This is expressed by the equation

$$\frac{R_X}{R_R} = \frac{V_X}{V_R}$$

Rearranging gives the value of R_X in terms of the known reference resistor and the voltage ratio:

$$R_X = R_R \frac{V_X}{V_R}$$

Extra circuits are designed into the A/D converter so it can be used to measure the voltage ratio V_X/V_R and calculate the unknown resistance, R_X. R_R and V_S are changed for different resistance ranges, but are known values for each measurement calculation.

• Hi-Lo Ranges

The test circuits are carefully designed so that the power dissipated in the device under test is limited to safe values. Some DVMs allow the selection of a HI/LO measurement range. These ranges allow the user to select the voltage drop across the component under test at full scale to be either 2 volts on the HI range or 0.1 volts on the LO range. The LO range allows in-circuit resistor testing without forward biasing diodes or transistor junctions that may be in parallel with the resistor. The HI ranges allow deliberate testing of semiconductor junctions to determine if they are forward or reverse biased and their respective junction resistances.

BASIC CHARACTERISTICS OF DVMS

Besides the characteristics of accuracy and internal resistance (input impedance) that VOMs have, the DVM has specifications for resolution, response time, protection, and burden voltage. The most unique specifications are the ones that define the digital display and the full-scale range.

DIGITS OF THE DVM DISPLAY

A strange term has developed when specifying a DVM. It concerns the digital display. The term "half-digit" is used to describe the display capability of the DVM and the reading beyond full-scale that it can display. This is called overranging.

If a DVM is classified as a 3 ½ digit DVM, it means that the full-scale reading is displayed in 3 digits and that the digit to the left of the 3 digits for full-scale reading is restricted in range. For example, 0.999 would be the full-scale reading when the DVM is measuring one volt on the 1 volt range. The ½ digit specification means that the DVM can display a measurement up to 1.999. The digit to the left of the three full-scale digits is restricted to a one. A 4 ½ digit DVM would have the capability to read a value as high as 3999. Therefore, the ½ or ¾ digit specifies the over-ranging that the DVM can read when set on a particular range.

FULL-SCALE RANGE

Range is specified in one of two ways: (1) a full-scale range with usable over-range capabilities specified as a percentage, typically 100%; or (2) full scale specified as the maximum possible reading encompassing all usable ranges, often 1.999. For example, a DVM may be specified as having 1 volt full scale with 100% over-range, thus indicating useful operations to 2 volts; or the same DVM may be simply specified as having a 2 volt full scale.

Some ranges may not be used to full scale. For example, the higher voltage ranges may be limited because of the voltage breakdown on internal components. A DVM with a 1999 volt full-scale range may not be used to read over 1000 volts because divider resistors cannot withstand over 1000 volts breakdown. The capability may be even lower on AC because of peak voltages.

• Overranging

Overranging was instituted to take full advantage of the upper limits of a range. It also provides better accuracy at the top of a range. In other words, overranging allows a DVM to measure voltage values above the normal range switch transfer points without the necessity of having to change ranges. It allows the meter to keep the same resolution for values near the transfer points.

The extent to which the overrange is possible is expressed in terms of the percentage of the full-scale range. Overranging from 5% to 300% is available, depending upon the make and model of the DVM.

ACCURACY AND RESOLUTION

Simple accuracy specifications are given as "plus/minus percentage of full scale, plus/minus one digit." The "plus/minus one digit" portion of the specification is caused by an error in the digital counting circuit. The "plus/minus percentage of full scale" includes ranging and A/D conversion errors.

The "plus/minus one digit" also relates to the resolution of the DVM. The resolution of an instrument is directly limited by the number of digits in the display. A 3 ½ digit DVM has a resolution of one part in 2,000, or 0.05%, which means that it can resolve a measurement of 1999 millivolts down to 1 millivolt. A 4 ½ digit instrument has a resolution of one part in 20,000, or 0.005%.

A 2 ½ or a 3 digit DVM is considered approximately equivalent to a good VOM multitester as far as accuracy and resolution are concerned. Accuracy generally lies between 0.5% and 1.5%, and resolution to 0.5%. The 3 ½ and 4 ½ digit meters generally have accuracy one order of magnitude higher; that is, between 0.5% and 0.05% with 0.05% resolution. A resolution and accuracy of this amount will generally suffice for most service work today. A 4 ½ digit, 5 ½ digit DVM generally indicate an accuracy of 0.05% and better with resolution of 0.005%. These are indeed considered laboratory instruments. They usually are specified with a "plus/minus percent of reading, plus/minus percent of full scale, plus/minus one digit" specification. They also may have specifications that qualify the accuracy at temperatures other than 25°C.

A DVM has essentially the same accuracy on ac that it does on dc voltage measurements, while an analog meter is most assuredly less-accurate on ac voltage measurements. Accuracy also will depend upon the frequency response or bandwidth of the DVM, and on the ac wave shape when the meter does not measure true RMS voltages.

INPUT IMPEDANCE

DVMs have an input impedance of at least one megohm and more commonly 10 megohms. This holds true on dc measurements and on ac measurements over the frequency range specified for the DVM.

RESPONSE TIME

Response time is the number of seconds required for the instrument to settle to its rated accuracy. The response time consists of two factors: (1) the basic cycle rate of the A/D converter; and (2) the time required to charge capacitances in the input circuit. Instead of response time, some manufacturers simply give a number of conversions per second.

PROTECTION

Meter protection circuits prevent accidental damage to the DVM. The protection circuit allows the instrument to absorb a reasonable amount of abuse without affecting its performance. The specification of input protection indicates the amount of voltage overload which may be applied to any function or range without damage. A separate dc limit may be indicated to cover input coupling capacitor breakdown. Overloads from sources outside the specified frequency range of the instrument may not have as great a protection range. The current measuring circuitry usually is protected by a fast-blowing fuse in series with the input lead.

AMMETER ERRORS DUE TO BURDEN VOLTAGE

When a meter is placed in series with a circuit to measure current, an error caused by the voltage drop across the meter is due to the meter and its current shunts and any protective fuses that are connected in series. This voltage drop is called a burden voltage. The full scale burden voltages for the instrument usually are very low – 0.3 volts for low ranges and from 0.5 to 0.9 volts for the higher current ranges. These voltage drops, of course, can affect the accuracy of a current measurement if the current source is unregulated and the resistance of the current meter represents a significant part (1/1000) of the source resistance. This burden voltage error can be minimized by selecting the highest current range that provides the required resolution. Some manufacturers specify "voltage burden," which is the maximum voltage drop across the meter input terminals caused by full-scale current. Other manufacturers specify series resistance. Either is adequate as long as the value is specified for each current range.

DISPLAYS

We have already mentioned LED and LCD displays. The light-emitting diode (LED) has been one of the most popular displays in use with DVMs because of its brightness, excellent contrast, and low cost. The liquid crystal display (LCD) has become very popular because of its very low power drain and decreasing cost. The newer types do not wash out in bright sunlight. However, a disadvantage is that many of them will freeze at fairly moderate temperatures and become completely useless.

SPECIAL FEATURES

SPEECH OUTPUT

Pressing a button on the probe on some meters causes the meter to call out the meter reading in clear English while also displaying the measured value.

AUTO RANGING

Auto ranging automatically adjusts the meter's measuring circuits to the correct voltage, current, or resistance ranges. One technique is for the DVM to start on the lowest range and automatically move to the next higher range when auto range takes place. A special feature of some auto-range DVMs is a manual control function, which overrides the auto range. This is useful for a series of measurements that are made within a specific range.

On some meters, if the upper limit of the range being held is exceeded, the meter produces a series of beeps if the buzzer switch is ON. A portion of the display will flash indicating an overflow error. Switching to the AUTO position releases the manual control. *Figure 2-11* shows a typical auto-range DVM.

Figure 2-11. Auto-Range DVM

AUTO POLARITY

The automatic polarity feature further reduces measurement error and possible instrument damage because of overload due to a voltage of reverse polarity. A + or − activated on the digital display indicates the polarity and eliminates the need for a POLARITY switch setting.

HOLD THAT READING!

Many digital multimeters have a HOLD feature that is operated remotely by means of a special HOLD button on the meter or included on one of the test leads. It is particularly useful when making measurements in a difficult area because readings can be captured and held and then later read when convenient.

In some DVMs, the hold signal sets an internal latch that captures the data. When the A/D gets to the point in its cycle where data is to be displayed, the state of the internal latch is sampled. New data is not transferred while the latch is in the hold state. In other DVMs, the hold feature stops the instrument clock. The last value displayed on the LCD remains displayed until the ground is removed from the input terminal.

CONDUCTANCE MEASUREMENTS

Some meters display the reciprocal of resistance; that is, a conductance measurement. The controls and connections for conduction measurements are the same as for resistance. The output, however, is displayed in siemens, the reciprocal of resistance (previously called mhos).

SEMICONDUCTOR TESTING

A DIODE CHECK or SEMICONDUCTOR CHECK function appears on some DVMs. Most DVMs have an ohmmeter voltage greater than 1.5 volts. Thus, continuity for most diodes and transistors in the forward bias direction may be checked.

Some DVMs have a special feature when in the DIODE CHECK position that displays a voltage value which is essentially the forward bias voltage of the PN junction.

AUDIBLE CONTINUITY TEST

Often, DVMs have an audible continuity function. With the DVM set to measure resistance and the CONTINUITY switch activated, when the probes are touched together the DVM emits an audible sound. This electronic sound is used to look for short circuits or for tracing for an open circuit. Any time the continuity circuit resistance is less than a minimum amount, usually 200 or 300 ohms, the DVM emits an audible sound when the circuit is complete.

Now that we know the basic concepts of both VOMs and DVMs, let's move on to find out how to make measurements.

About Multitester Measurements

This chapter deals with how to make measurements with a multitester, whether it is with an analog meter as described in Chapter 1, or with a digital meter as described in Chapter 2. However, before discussing the actual measurements, it might be beneficial to review three basic fundamentals of dc circuits. They are: Ohm's Law; series and parallel circuits; and polarity.

OHM'S LAW

In the early 1800's, German physicist Georg Simon Ohm discovered the basic relationship of voltage, current, and resistance in a dc circuit, which he expressed as

$$I = \frac{V}{R}$$

Stated in words, it said that the current, I, in a dc circuit varied directly with the voltage, V, applied to the circuit, and inversely with the resistance, R, in the circuit. With a given resistance, if voltage is increased, current will increase; with a given voltage, if resistance is increased, current will decrease.

SERIES CIRCUITS

In a series circuit, like the one shown in *Figure 3-1*, there is only one current path. As shown, the conventional current direction through the circuit is from the positive terminal of the battery to the negative terminal. Electron current is opposite – the negatively-charged electrons are attracted to the positive terminal of the battery and released from the negative terminal.

Figure 3-1. Simple DC Series Circuit

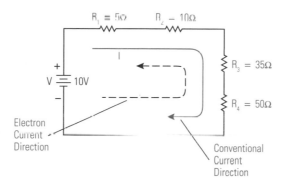

The amount of current in the series circuit can be found by dividing the voltage (10 volts) by the total resistance in the circuit (100 ohms), just like Ohm's Law says:

$$I = \frac{10V}{100\Omega}$$

$$I = 0.1A$$

The current is 0.1 amperes. There is the same current throughout the series circuit and through each series circuit component. The current has one path through all the circuit components in series.

PARALLEL CIRCUITS

Parallel circuits are different. Current in a parallel circuit has more than one path. The different paths are called branches. *Figure 3-2* is a simple parallel circuit. As with the series circuit, it has a 10 volt battery to supply the current, but the current is through two branches – one through R_1 and the other through R_2. The total current, I_T, from the battery divides into the two branch currents, I_1 and I_2. The total current, I_T, is the sum of the two branch currents. Therefore,

$$I_T = I_1 + I_2$$

Each branch current can be calculated by using Ohm's Law. For example:

$$I_1 = \frac{10V}{100\Omega} = 0.1A$$

$$I_2 = \frac{10V}{400\Omega} = 0.025A$$

Figure 3-2. Simple Parallel Circuit

The total current is
$$I_T = 0.1A + 0.025A = 0.125A$$

One-tenth ampere is in the R_1 branch through R_1; 25-thousandths of an ampere is in the R_2 branch through R_2. The total current of 0.125A also can be expressed as 125×10^{-3} amperes. The common abbreviation of "milli" is substituted for 10^{-3}; therefore the current is 125 milliamperes. 100 milliamperes is in the R_1 branch, and 25 milliamperes is in the R_2 branch.

Note that the voltage across each branch is the same. That is a common characteristic of parallel circuits – *the voltage is the same across parallel branches*.

POLARITY

When making dc measurements with your multimeter or multitester, you will be concerned about observing polarity so that your meter will read correctly. Current must be in the proper direction through a dc meter to cause it to read up scale. If polarity is observed properly, then the meter will read up scale. Otherwise, the analog VOM meter will peg against the stop that restricts it from deflecting down scale. Digital meters do not have this problem, but the reference point for the measurement is still very important.

REFERENCE POINT

A reference point is a point in a circuit to which the voltage at other points in the circuit is compared. This is demonstrated best by an example. *Figure 3-3* combines a pictorial and schematic of the common electrical system for starting your car. The negative terminal of the battery is connected to the automobile chassis, which becomes a connecting link of the circuit. It is like a common wire connecting all points marked "chassis ground." This becomes an excellent reference point for all measurements in this automotive circuit. As shown in *Figure 3-3a* and *3-3b*, the common or negative terminal of a VOM is connected to the negative terminal (A) of the battery through chassis ground (A_1). A voltage measurement is made at point B to measure the battery voltage by placing the positive probe of the meter on point B. The meter reads up scale +12 volts. Point B is 12 volts positive with respect to the reference point (chassis ground – the negative terminal of the battery). Here are the other voltages in the circuit with respect to the reference point (keeping the common (-) probe of the meter on chassis ground):

Point	Meter Reading	Comment
A (A1)	0V	Both probes on chassis ground
C	0V	When ignition switch is OFF
C	+12V	When ignition switch is on START
D	0V	Both probes on chassis ground
E	0V	When ignition switch is OFF
E	+12V	When ignition switch is on START

Note that when a voltage measurement is made the meter is across two points. In all cases above, all points are positive voltage with respect to the reference point, or else the have the same potential as the reference point (the voltage is 0 volts).

Other reference points could have been chosen. *Figure 3-3a* also shows the case when the common probe (-) of a DVM is connected to the + terminal of the battery. Now the measured voltages are at the various points (moving the + probe) are:

Point	Meter Reading	Comment
A (A1)	-12V	Reference point now B
B	0V	Both probes at same point
C	-12V	When ignition switch is OFF
C	0V	When ignition switch is on START
D	-12V	Reference point now B
E	-12V	When ignition switch is OFF
E	0V	When ignition switch is on START

Figure 3-3. Automotive Starter Circuit

a. Pictoral

b. Schematic

Note that the negative terminal of the battery, which is connected to chassis ground, has a polarity of -12 volts, and the polarity of point D is -12V instead of 0 volts as when the reference point was the negative terminal of the battery. *So the polarity of a point in the circuit depends on the point chosen for the reference point.*

POLARITY OF VOLTAGE DROPS

One other main point on polarity relates to the polarity of voltage drops across components in a circuit. Refer to *Figure 3-4* where three resistors are in a series circuit with a battery. The voltage drops across the resistors add together to equal the battery voltage. The end of the resistor closest to the positive terminal of the battery will be positive, while the end closest to the negative terminal of the battery will be negative.

If a DVM is connected with its common probe at point D, the intersection of R_2 and R_3, then the voltage read across R_2 will be a positive voltage (point A), and the voltage read across $R_1 + R_2$ (point B) will be a positive voltage. However, the voltage read across R_3 (point C) will be a negative voltage because of the polarity of the voltage drop across R_3 and the fact that point D is the reference point.

Figure 3-4. Polarity of Voltage Drops

If the common probe of the DVM is moved to point A, it becomes the reference point, and the polarity of voltage readings are:

Point	Voltage Drop
B	V_{R1} is positive
D	V_{R2} is negative
C	$V_{R2} + V_{R3}$ is negative

With this review of Ohm's Law, series and parallel circuits, and polarity, let's move on to look at multitester measurements.

METER LOADING

Meter loading can affect voltage measurements and cause inaccurate readings. The concept of meter loading is explained best by looking at an example illustrated in *Figure 3-5*. In *Figure 3-5a*, a VOM is used to measure the voltage across R_2 in a simple dc series circuit to which current is supplied by the voltage V. Notice that to make the voltage measurement you must place the voltmeter across resistor R_2. The common (-) probe of the meter is at point A and the (+) probe of the meter is at point B. In this illustration, the VOM is represented by a resistor in series with a meter movement. The value of the combination is equal to the input impedance (resistance) of the meter.

METER FORMS PARALLEL BRANCH

As shown in the equivalent circuit of *Figure 3-5b*, placing the VOM across R_2 forms a parallel branch of the circuit with R_2. It adds another path for current through R_M besides the path through R_2. It means that I_T increases because now I_T equals $I_1 + I_2$, rather than just I_1 without the meter present. How large will I_2 be? As discussed in Chapter 1, if the voltage drop is large enough across R_2 to cause a full scale VOM reading on the meter range chosen, the current I_2 through R_M will be equal to the current required to deflect the meter movement to full scale.

Figure 3-5. Meter Loading When Making Voltage Measurements

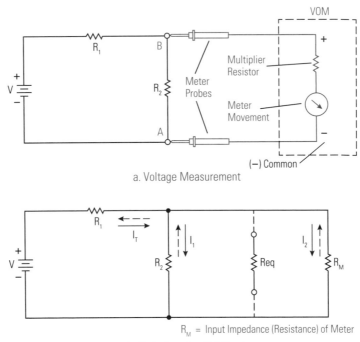

a. Voltage Measurement

R_M = Input Impedance (Resistance) of Meter

b. Equivalent Parallel Circuit

R_M in parallel with R_2 reduces the equivalent circuit resistance represented by the parallel branch, and produces a corresponding error in the voltage across R_2. Let's demonstrate this with actual values.

MEASUREMENT ERROR

The equivalent resistance of the parallel branch is:

$$Req = \frac{R_2 R_M}{R_2 + R_M}$$

Let's assume the normal circuit values are:

$$V = 10V$$

$$R_1 = 1k\Omega$$

$$R_2 = 1k\Omega$$

Without the voltmeter, Ohm's Law can be used to calculate the voltage across R_1 and R_2 using the value of the total current, I_T, and the value of the two resistors, as follows:

$$R_T = 2k\Omega$$

$$I_T = \frac{10V}{2k\Omega} = 5mA$$

$$V_{R1} = 1k\Omega \times 5mA = 5V$$

$$V_{R2} = 1k\Omega \times 5mA = 5V$$

Therefore, if a voltage measurement is made without error, the voltage across R_2 would equal 5 volts.

• Measuring With a 200 Ohms/Volt Meter

Now suppose a voltage measurement is made using a VOM that has an internal impedance of 200 ohms per volt that is set to a full-scale range of 5 volts. As a result:

$$R_M = \frac{5V \times 200 \text{ ohms}}{V} = 100 \text{ ohms}$$

Making the voltage measurement with this VOM makes an equivalent circuit like that shown in *Figure 3-6a*. Req can be calculated from the equation above as:

$$Req = \frac{1k\Omega \times 1k\Omega}{2k\Omega} - 0.5k\Omega$$

As shown in *Figure 3-6*:

$$R_T = 1.5k\Omega$$

$$I_T = 6.67mA$$

$$V_{R1} = 6.67V$$

$$V_{R2} = 3.33V$$

Figure 3-6. Voltage Across R₂ When Measured With a 200 Ohm/Volt Meter

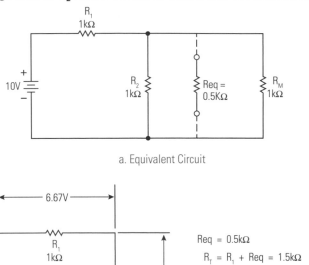

a. Equivalent Circuit

$Req = 0.5k\Omega$

$R_T = R_1 + Req = 1.5k\Omega$

$I_T = \dfrac{10V}{1.5k\Omega} = 6.67mA$

$V_{R1} = 6.67mA \cdot 1k\Omega = 6.67V$

$V_{R2} = 6.67mA \cdot 0.5k\Omega = 3.33V$

b. Voltage Across R₂

The voltage measurement across R_2 (which is really Req because of the parallel R_M) is 3.33V, and the percent error in the measurement is:

$$\% \text{ Error} = \frac{5.00V - 3.33V}{5.00} \times 100$$

$$\% \text{ Error} = \frac{1.67}{5.00} \times 100 = 33\%$$

Making the measurement with a 200 ohms/volt meter has caused the measurement to be in error by 33%.

Measuring with 1000, 2000, and 20,000 ohms/volt VOMs, *Table 3-1* lists the circuit values and errors when the measurement is made on the 5-volt scale. The input impedances are 5,000, 10,000, and 100,000 ohms, respectively.

When R_M equals 5 kilohms, the voltage measurement is still in error by 9%. Not until a VOM is used that has an internal impedance, R_M, of 10 kilohms (10 times the value of R_2, the resistance across which the voltage is measured), does the error (4.8%) come down into the range of measurement error of the VOM itself (usually 2% to 4%). *Therefore, to prevent meter loading on a voltage measurement, make sure the input impedance (resistance) of the voltmeter used for measurement is at least 10 times the impedance (resistance) across which the measurement is made.*

Table 3-1. Percent Error Due to R_M

VOM Ohms/Volt	VOM R_M	R_2	Req	R_1	R_T	I_T	V_{R1}	V_{REQ} (V_{R2})	% Error
k	k	k	k	k	k	mA	V	V	%
0.2	1	1	0.5	1	1.5	6.67	6.67	3.33	33.0
1	5	1	0.883	1	1.833	5.45	5.45	4.55	9.0
2	10	1	0.910	1	1.910	5.24	5.24	4.76	4.8
20	100	1	0.990	1	1.990	5.03	5.03	4.97	0.6

VOM ACCURACY COMPROMISE

The Value of R_M, the VOM input impedance, increases as the voltage full-scale range is increased. A 1000 ohm/volt meter will have an R_M = 10,000 ohms on the 10-volt scale, and an R_M = 50,000 ohms on the 50-volt scale. To have R_M large so that it does not load the circuit, the full-scale range should be large so that the loading error is small. However, to have the greatest reading accuracy, the full-scale range should be as small as possible to make the meter deflection as close to full scale as possible. These are contradictory statements, so the choice of which full-scale range to use is a compromise when the loading of R_M is going to cause significant error.

MEASUREMENT WITH A DVM

As explained in Chapter 2, digital voltmeters use electronic circuitry to make measurements. As a result, the input impedance of the meter is quite high, usually 1 megohm (one million ohms). Therefore, normal voltage measurements across components that have a resistance value as high as 100,000 ohms will have little or no error. This is one of the significant advantages of using a DVM – little circuit loading occurs unless circuit resistances approach megohm values.

BASIC DC MEASUREMENTS

A typical VOM is shown in *Figure 3-7*. It is an instrument that is easy to use and simple to operate; therefore, it is very popular with the handyman or the beginner in electricity and electronics. It functions as a voltmeter, ammeter, or ohmmeter depending on the position of the selector switch.

Figure 3-7. VOM

The meter shown has 18 ranges: 5 to measure DC voltage from 0 up to 1000 volts; 4 to measure AC voltage from 0 to 1000 volts; 2 to measure DC current up to 250 mA; 3 to measure resistance up to 2 MOhms; and 4 to measure decibels from −20 up to +62 db. This meter has an AC sensitivity of 10,000 ohms/volt, and a DC sensitivity of 20,000 ohms/volt. It has an accuracy of ±3% of full scale value when measuring DCV, DCA and resistance; and an accuracy of ±4% of full scale value when measuring ACV.

MAKING A VOM DC VOLTAGE MEASUREMENT

To make a voltage measurement, follow these steps. The voltage to be measured is the voltage across R_3 in *Figure 3-8*.

1. To prevent an error from being introduced, the zero of the meter should be checked before any measurement is made. With a VOM, the instrument should be OFF and the pointer zero position adjusted mechanically with the zero-adjust screw, as described in the instrument owner's manual.

2. Set the range selector switch to the dc voltage range desired. It usually is best to start with a range greater than the final one. If you do not know the approximate value of the voltage, place the selector switch on the highest range.

3. Turn on power. Place the minus (-) meter probe at point A. Now touch the plus (+) probe momentarily to point B. Watch the meter needle and see if it moves up scale. If no movement is detected, rotate the range switch to the next lowest scale and repeat the test until a deflection is noted.

4. If the deflection is up scale, hold the plus probe to point B permanently. (If your test probes have clips on them, clip the leads in place.)

5. If the deflection is down scale (below zero), reverse the leads or, if the meter has a +/- polarity switch, switch the polarity so that the deflection is up scale.

6. Rotate the selector switch to get the greatest on-scale needle deflection without exceeding full scale. In the example of *Figure 3-8*, the voltage is 4 volts; therefore, the selector switch would be set on 10 volts and the meter would read 4 on the 10 volts scale, as shown in *Figure 10-3b*. The 2.5 volt scale of the VOM of *Figure 3-7* would cause the meter to go beyond full scale.

7. The meter of *Figure 3-7* has a switch that reduces the range selected by half. Switching the switch to V/2 reduces the full-scale range to 5 volts and the needle would now read 4 volts, as shown by the dotted line position of *Figure 3-8b*. (The actual reading is taken using the 50 volt scale and, because the range selector is on the 5 volt range, every meter reading is divided by 10.) This provides a deflection closer to full scale and, thus, a more accurate reading.

8. Parallax error is reduced by visually aligning the needle with the image in the mirror above the dc voltage scales.

9. If the battery voltage is to be measured, the plus probe would be momentarily touched to point C of *Figure 3-8a* with the range selector switch on the 50 volt range. Steps 4 through 8 would then be followed to read 12 volts on the 25 volt range.

Figure 3-8. DC Voltage Measurement

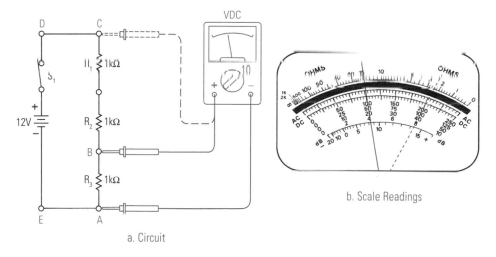

a. Circuit

b. Scale Readings

MAKING A VOM DC CURRENT MEASUREMENT

Current measurements are different. The meter must be inserted into the circuit so that the circuit current is through the ammeter. *Figure 3-9* shows a VOM used as an ammeter inserted into the series circuit of *Figure 3-8* to measure the series circuit current. The steps to be followed for this measurement are as follows:

Figure 3-9. DC Current Measurement

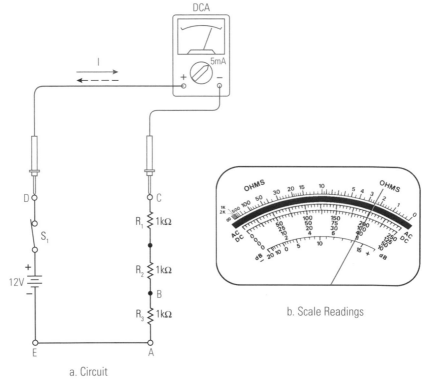

a. Circuit

b. Scale Readings

1. With the meter out of the circuit, check the zero position of the meter and mechanically adjust it with the zero adjust screw, if required.

2. Turn off the circuit power and disconnect the circuit so that the meter may be inserted. In *Figure 3-9*, point C is disconnected from the battery terminal at point D and the ammeter inserted.

3. Set the range selector switch to the highest dc current range. Some VOMs will have a function switch so that volts or amperes or ohms may have to be selected as well as the range. If so, the amperes function would be selected.

4. Place the plus (+) probe of the meter at the most positive voltage point (point D) and the minus (-) probe and the more negative voltage point (point C). The direction of current is as shown.

5. Turn on power to the circuit. Touch the plus probe to terminal C momentarily to see that the meter needle deflects up scale when power is on. If deflection is down scale, reverse the meter leads.

6. After the power is on, adjust the selector switch to give the greatest on-scale deflection. Since the current in *Figure 3-9* is 4 milliamperes, the range selector would be set on 5

milliamperes full scale, and the needle would read 4 milliamperes as shown in *Figure 3-9b* (as with the voltage measurement, the 50 scale is used and all readings divided by 10). There is no need to use the half-scale function switch in this case.

Be aware that the highest current range is 10 amperes. However, on the meter shown in *Figure 3-7*, the plus (+) lead must be plugged into an auxiliary jack to activate the 10A current range.

MAKING A VOM RESISTANCE MEASUREMENT

Complete information on the condition of electrical circuits and their circuit components cannot be obtained by the use of the voltmeter and the ammeter alone. Using an ohmmeter adds significantly to your information about a circuit. Knowing for sure that a circuit is complete (there is continuity) and being able to measure the resistance of the various circuit components are valuable pieces of circuit information obtained by using an ohmmeter.

Recall that a VOM, when used as an ohmmeter, supplies its own current from an internal power source (either 1 or 2 batteries) to operate the meter movement. All circuit power is to be turned off or removed when making continuity and resistance measurements, otherwise there is danger of damaging or completely burning-out the VOM.

• Example Measurement

The meter in *Figure 3-7* uses a series circuit for the ohmmeter. As a result, zero on the resistance scale is full-scale deflection, and an open circuit or "infinity" ohms is the idle position of the needle. We will measure the resistance of the circuit of *Figure 3-8* as shown in *Figure 3-10*. Follow these steps:

Figure 3-10. Resistance Measurement

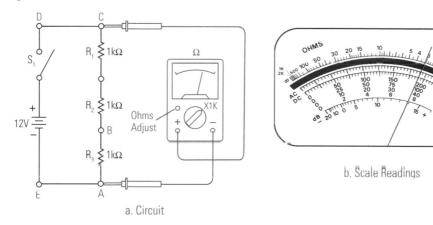

a. Circuit

b. Scale Readings

1. Make sure power is disconnected from the circuit.

2. Make sure the VOM is on the ohmmeter function, either by the position of the range selector or by a function switch that selects the ohmmeter function, or both.

3. Short the meter leads together and with the OHMS (Ω) ADJUST control, adjust the meter reading to 0 ohms. If this adjustment cannot be made, the internal battery in the meter needs to be replaced.

4. Place the meter leads across the resistance to be measured. For example, point A and point C in *Figure 3-10*.

5. Change the range selector switch to cause the meter reading to be between half-scale and full-scale, if possible, or as close to half-scale as possible. If the meter reading is close to the high-resistance end of the scale, select a higher resistance range; if the reading is closer to the low-resistance end, select a lower resistance range. Of course, with very high resistances the meter will always be to the left (high-resistance end) of the scale.

6. Since the resistance in this case is 3 kilohms, the range selector would end up on the R × 1K range and the meter would read 3, as shown in *Figure 3-10b*. The range switch selects different values that multiply the meter reading. On the R × 1 scale, the meter reading is taken directly. On the R × 10K scale, all readings are multiplied by 10,000.

When making in-circuit measurements, remember that circuit paths in parallel with the component being measured may cause reading errors. Check the circuit diagram for the presence of such parallel paths before assuming that the reading obtained is correct.

• VOM Resistance Measurement Accuracy

The accuracy of a VOM in making resistance measurements is slightly different from its accuracy in making voltage and current measurements. The percent of accuracy of an ohmmeter at center scale is specified as a percentage of the complete arc made by the needle when reading resistances from 0 to infinity. A typical accuracy is 2% of arc. To maintain this accuracy, it is important that the idle position of the needle be set on the end of scale mark with the mechanical screw adjustment, and that the full-scale adjustment be set on the end of scale mark with the OHMS ADJUST control.

DVM DC VOLTAGE MEASUREMENTS

A digital multimeter like the one shown in *Figure 3-11* is chosen for our example measurements. Two significant differences are apparent between this DVM and a VOM. First, the output is a digital display where the meter reading is a particular number. Second, since electronic circuits are required to produce the conversion required, power must be supplied to the electronic circuits; therefore, the DVM has a power switch which must be ON for all measurements.

As shown in *Figure 3-11*, beyond these differences, functionally the DVM and VOM are very similar. A slide selector switch selects the function, the range can be selected manually or automatically, the meter leads are plugged into a common (-) jack and a plus (+) jack to make measurements, or the plus lead is plugged into an auxiliary jack for a special current range of 10A.

The steps for making a voltage measurement with a DVM using the circuit of *Figure 3-8* are basically the same as they are when a VOM is used. The exception is that no zero adjustments or polarity precautions are necessary because the meter takes care of these automatically. The actual reading will be a number on the digital display. For example, the 4 volt measurements of *Figure 3-8* would read 4.00 on the 40 volt range, if it is exactly 4 volts; otherwise, it will read some fractional voltage to 2 decimal places.

• Polarity

Test leads need not be switched when measuring with a DVM. The display will indicate whether the voltage reading is a positive or negative voltage with respect to the common lead.

• Overrange and Fused Protection

A special indicator also appears on the display to indicate that the reading is over range

on the range selected. Change the range selector to the next highest range until a digital reading is obtained or the highest range is reached. The voltage being measured exceeds the highest full-scale reading if an overrange indication is obtained on the highest range. Many instruments also are fused against excessive current on any range.

Figure 3-11. DVM Used for Example Measurements

• Low Battery Voltage

Usually, a special indicator on the display warns when the internal batteries supplying power are low and must be replaced.

DVM DC CURRENT MEASUREMENTS

The current measurement made with a DVM functionally is the same as the steps outlined for the VOM current measurement, except, as is the case for the voltage measurements, the test leads need not be exchanged from the wrong polarity, and there is no zero adjustment. The 4 milliamperes would read 4.00 on the 40 milliamperes range if it is exactly 4 milliamperes; otherwise, some fractional value to 2 decimal places will be indicated.

As explained in Chapter 2, what actually is happening in the current measurement is that a small resistance is inserted in the circuit by the meter and the DVM is measuring the small voltage drop across the resistance due to the circuit current.

DVM RESISTANCE MEASUREMENTS

The same precautions must be followed when measuring resistance with a DVM as with a VOM. Remove power from the circuit before making resistance measurements. The measurement is made with the test leads across the component to be measured. Current from the DVM causes a voltage drop across the component resistance and the voltage is read by the DVM and converted to a direct resistance measurement.

When measuring the resistance of *Figure 3-10*, the DVM would read 3.00 on the 40 kilohm range if the resistance is exactly 3000 ohms; otherwise, the reading would be some fractional value to two decimal places.

BASIC AC MEASUREMENTS

Here are some factors that are important when making ac measurements:

1. AC voltage and current measurements depend on frequency. Consult the meter manual to determine the limits of the meter's frequency response.

2. Most VOMs read in RMS values, but ac meters can read either average, RMS, or true RMS values. Only true RMS reading meters do not require the ac signal to be a sine wave without producing error.

3. AC current measurements are accomplished by rectifying a voltage developed across a resistor in the circuit.

4. AC VOM readings are accurate to a percent of full-scale, but the accuracy and sensitivity are usually less than for dc measurements.

5. Non-linear rectifier characteristics make small ac voltage measurements less accurate.

6. VOMs usually have more loading effect on an ac circuit than on a dc circuit.

7. On ac measurements, a DVM usually has the same accuracy, sensitivity, and circuit loading as it does on dc.

8. When an ac voltage is applied to circuits that only have resistance (such as *Figures 3-8* and *3-9*), the measurement steps are the same as those outlined for dc measurements. There will be no polarity observance needed because the ac voltage or current is alternating positive and negative with time.

CLAMP-ON CURRENT METERS

Some VOMs today have a clamp-on accessory that may be used as a clamp-on ammeter for measuring ac currents. This adapter is clamped around a wire carrying a large ac current and the current is then transformed into an ac voltage so that the VOM uses the ac volts function to measure the ac current in the conductor. There may be special scales included on the meter face for the camp-on adapter so the current can be read directly.

AC IMPEDANCE AND REACTANCE

The opposition to current in a dc circuit is termed resistance. If the opposition to current in an ac circuit is due to resistance, the effect is the same; however, if the circuit contains inductors or capacitors, the opposition to ac current is more complex. As discussed previously, inductors are coils of wire wound around iron cores contained in motors, generators, solenoids, relays, chokes, and transformers. Capacitors are the components that store a charge on parallel plates separated by a dielectric so there is no dc path through the capacitor. Inductors store energy in magnetic fields; capacitors store energy in electrostatic fields.

REACTANCE

The opposition offered by an inductor or capacitor is called reactance. The reactance of each of the components is frequency sensitive. Inductive reactance is expressed as

$$X_L = 2\pi f L$$

and capacitive reactance is expressed as

$$X_C = \frac{1}{2\pi f C}$$

Where f is frequency in hertz (cycles per second), L is inductance in henries, C is capacitance in farads, and π is a constant – 3.1416.

The unit for reactance is ohms, just like resistance. If f = 0 (which is dc), X_L will be zero and X_C will be infinity. If f = ∞ (infinity), X_L will be equal to infinity and X_C will be zero.

• Impedance

Impedance is the term given to the total opposition to ac current when both resistance and reactance are present to impede the current. The reactance can be inductive, capacitive, or a combination of both. What makes impedance and ac voltage and current complex is that measured quantities do not add directly. The must be added vectorially.

• Vector Addition

How voltage, current, and impedance add vectorially is best demonstrated by an example. Look at *Figure 3-12*. A 60 cycle 50 volt (RMS voltages are identified by VAC) power source is connected to a resistor and a solenoid. The resistor has 30 ohms resistance, and the solenoid has 40 ohms inductive reactance. To find the total impedance of the circuit the resistance and reactance must be combined at right angles, as shown in *Figure 3-12*. The resistance is plotted horizontally and the reactance is plotted 90° upright from it, joined tip to tail and represented by arrows called vectors with appropriate length and to the same scale. The total impedance, Z, is another vector from the start (tail) of the resistance to the tip of the reactance. This forms the hypotenuse (the long side) of a right triangle.

Figure 3-12. Impedance with R and X_L

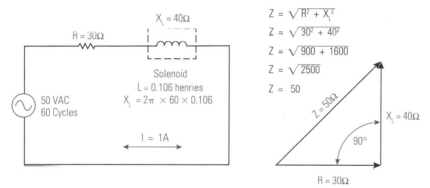

A mathematical theorem (Pythagorean's Theorem) states that the hypotenuse of a right triangle is equal to the square root of the sum of the squares of the sides. Therefore, the total impedance of the circuit of *Figure 3-12* can be calculated as

$$Z = \sqrt{30^2 + 40^2}$$

$$Z = \sqrt{900 + 1600}$$

$$Z = \sqrt{2500}$$

$$Z = 50$$

Since Z is the total opposition, the total current in this series circuit can be found by using a form of Ohm's Law for ac circuits:

$$I = \frac{V}{Z}$$

or

$$I = \frac{50V}{50\Omega}$$

$$I = 1A$$

The total current is one ampere.

Ohm's Law for ac circuits can now be used to find the voltage across the respective components. The voltage across the resistance is

$$V_R = I \times R$$

$$V_R = 1A \times 30\Omega$$

$$V_R = 30 \ V$$

The voltage across the inductance is

$$V_L = I \times X_L$$

$$V_L = 1A \times 40\Omega$$

$$V_L = 40V$$

VOLTAGE MEASUREMENTS

If a VOM set on an ac voltage range of 50 volts is used to measure the voltage across the resistance and inductance, the voltages measured would be 30 volts across the resistance and 40 volts across the solenoid. Now, if the source voltage is measured, it would measure 50 volts. Each of the measurements is shown in *Figure 3-13*. Note that the voltages across each of the components add directly to 70 volts, but the source voltage is only 50 volts. In circuits where the total impedance is made up of resistance and reactance, the measured voltages must be added vectorially. *Figure 3-13* shows how the total voltage of 50 volts is the vectorial sum of the 30 volts across the resistance and the 40 volts across the solenoid.

The steps for making the voltage measurements are basically the same as those used for dc. Summarized, they are:

1. With leads open, adjust the zero reading of the meter with the mechanical zero adjust, if available.
2. Set the function selector switch to the highest ac voltage range.
3. Measure voltage; adjust voltage range downward to get a meter reading as close to full-scale as possible.

Figure 3-13. Voltage Measurements of Figure 3-12 Circuit

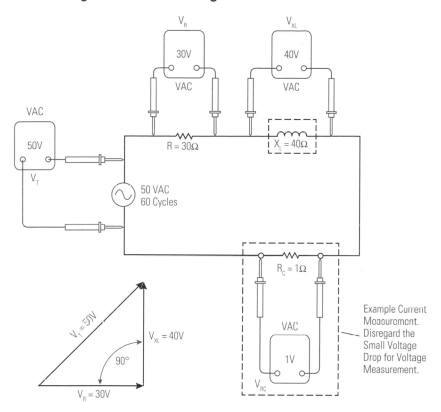

CURRENT MEASUREMENTS

Current measurements are made in ac circuits by using the current function on the selector switch and inserting the meter leads into the circuits, just as with dc current measurements. If your meter does not have an ac current function, current measurements can be made easily by inserting a small know value of resistance into the circuit and measuring the ac voltage across it. An example is shown in the dotted-line insert of *Figure 3-13*. The voltage drop across the one ohm resistor used for the current measurements may be disregarded when the voltage measurements are made.

Caution: When making current measurements in ac circuits that contain parallel branches with inductors and capacitors in parallel, very-high circulating currents can be encountered in the parallel branches at particular frequencies of the applied voltage.

IMPEDANCE MEASUREMENTS

Even though there are special impedance meters where meter scales are calibrated in ohms impedance, VOMs and DVMs normally do not have impedance scales as they have resistance scales. Impedance is obtained by measuring voltage and current and then calculating impedance.

CLAMP-ON CURRENT METERS

Current measurements may be made more easily and without contacting the circuit by using a clamp-on current meter. These instruments also help protect the user from potentially dangerous voltages in high-power circuits. Most VOMs and DMMs can measure current up to only 10 amperes. Larger currents can be measured more safely and conveniently by using a clamp-on meter.

Figure 3-14 shows an example of a true RMS clamp-on ac/dc digital multimeter. This meter can measure dc voltage up to 600V and dc current up to 800A, as well as ac voltage up to 600V true RMS and ac current up to 800A true RMS. In addition, this meter can be used as a standard DMM to measure resistance, capacitance, temperature and frequency using standard test probes.

There are two types of pickups that may be used on clamp-on meters: inductive and Hall-effect. The inductive type measures ac currently only. The Hall-effect type pickup used in the meter shown can measure both ac and dc current.

Figure 3-15 shows the clamp-on meter of *Figure 3-14* measuring the current to a load. There will normally be two or more wires to a load. Separate the wires and place the clamp-on pickup jaws around each wire separately to make a current reading of the current in each wire. *The clamp must only be around one conductor at a time.* The application of self-contained clamp-on meters, both inductive and Hall-effect, is shown in the application chapters that follow.

If the clamp-on meter is an analog meter, there usually is a ruggedized feature to protect the meter movement. A typical feature is to lock the analog meter pointer mechanically with a pointer-lock switch. The pointer-lock switch must be released before the analog meter can read any of the parameters measured. Using test leads, most inductive-pickup analog clamp-on meters will measure ac volts, dc volts, and ohms, in addition to ac current. Some also measure temperature using a special temperature probe.

Figure 3-14. Clamp-On DC/AC Meter

Figure 3-15. Clamp-On AC Ammeter Measuring Current to a Load

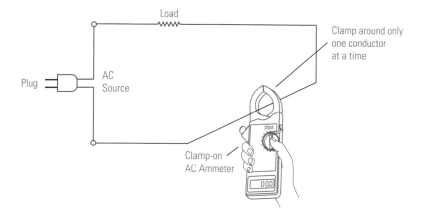

AC CURRENT ADAPTERS AND LINE SPLITTERS

An accessory that is provided with the clamp-on ac ammeter probe is shown in *Figure 3-16a*. It is called an ac current adapter or, in some cases, a line splitter. This accessory is very useful with ac powered products that obtain their power by connecting a molded power cord plug to a 120VAC household outlet. The molded power cord prevents the two wires supplying power from being separated so that a clamp-on ammeter's inductive pickup could be clamped around a single wire. The current adapter, as shown in *Figure 3-16a*, does exactly that – it separates out one of the wires so the clamp-on probe's jaws can measure the current.

Figure 3-16. Measuring Current Using AC Current Adapter

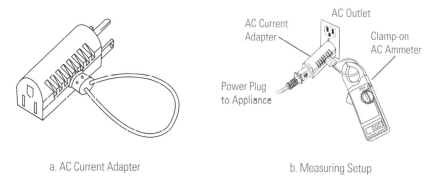

a. AC Current Adapter b. Measuring Setup

As shown in *Figure 3-16b*, the current adapter is made particularly to measure ac currents of appliances that operate using an ac power plug. The standard ac male plug is removed from the standard ac outlet and then the ac current adapter is plugged in. The appliance male plug is then plugged into the end of the ac current adapter. The loop of wire from the current adapter separates out one of the supply wires for measuring the current. Each two amperes of current in the adapter loop produces 1 milliampere of current to the DVM.

There may be limitations on the amount of current that the current adapter or line splitter can handle. If too much current is passed through the line splitter, it will heat up and, therefore, precautions are given in its use and measurements may have to be made within a given amount of time. The ac current adapter of *Figure 2-16a* is limited to 10A.

CLAMP-ON ACCESSORY

Some VOMs today have a clamp-on accessory that may be used to provide a clamp-on ammeter for measuring ac currents. The clamp-on adapter is clamped around a wire carrying a large ac current and the current is then transformed to an ac voltage. The VOM is used as an ac voltmeter to measure the ac current in the conductor. Special scales may be included on the meter for the clamp-on adapter so the current can be read directly.

THE HALL-EFFECT

A Hall-effect device is a semiconductor device that produces an output voltage that is proportional to the magnetic field (changing or steady) in which it is placed. The important difference between the inductive type pickup and the Hall-effect pickup is that the magnetic field must be changing for the inductive type to produce an output, while the Hall-effect pickup produces an output even with a steady magnetic field. The principle of the Hall-effect is shown in *Figure 3-17*. A small current must be maintained through the semiconductor material (either "P" or "N" type may be used). The magnetic field deflects the movement of charge through the crystal and causes a difference of potential across its sides.

Figure 3-17. Principle of the Hall-Effect

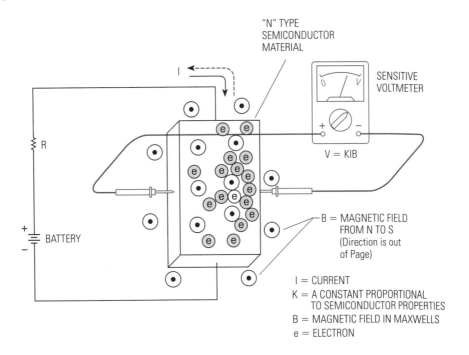

POWER MEASUREMENTS

Indirect measurement of voltage and current will provide the power being delivered or dissipated in a circuit. The power, P, using a measured voltage, V, and current, I, is calculated by:

$$P = I \times V$$

The clamp-on meter described above is an excellent way to obtain the current measurement for the power calculation.

DC CIRCUITS

In dc circuits, the calculation of power is a direct one. Multiply the voltage measured by the current measured. The power is dissipated as heat.

AC CIRCUITS

In ac circuits, reactance again complicates the power calculation. The multiplication of voltage times current may not result in true dissipated power, but may result in an "apparent" power because of the reactance present. Consult a more detailed text on ac circuits for a more complete understanding of this subject.

SUMMARY

With the description of the meters and how they operate, and a basic understanding of measurements, we move on in the next chapter to some actual practical examples of meter measurements.

4

Measurement of Individual Components

An important part of the field of electronics is understanding the various components and electron devices that make up complex electronic circuits. Every electrical circuit has three inherent properties: resistance, capacitance, and inductance. Measuring common components with these properties using a multimeter is the subject of this chapter.

HOW TO MEASURE A RESISTOR

RESISTOR BASICS – FIXED AND VARIABLE

Resistance in a circuit is the opposition to current. All materials used in an electric circuit will offer some resistance. Those offering low resistance are called conductors and are used as paths for current. Those offering extremely high resistance provide no path for current and are called insulators. Insulators arc used to resist or prevent current in certain paths. Components manufactured specifically to be placed in circuits to provide resistance are called resistors. Resistors are used most frequently in electrical circuits to limit current or to create voltage drops.

Resistors come in different values, shapes and sizes. Resistors are classified two ways–by resistance measured in ohms, and by power rating measured in watts. The power rating of resistors for electronic circuits range from 1/8 watt to hundreds of watts. The ohmic values range from hundredths of ohms (0.01) to hundreds of megohms (10×10^6). Manufacturers have adopted a standard color code system for indicating the resistance or ohmic value of low power resistors (normally, those below 2 watts). Higher power resistors usually have the resistance value imprinted on their bodies. An assortment of different types of resistors with different wattage ratings are shown in *Figure 4-1*.

Figure 4-1. Different Type Resistors

CONSTRUCTION

The small wattage rating resistors, which are also physically small, usually are carbon composition or deposited carbon. The carbon composition resistors are made of finely-ground carbon mixed with a binder, molded to a shape, with pigtail leads. The compressed mixture can be made to have a resistance from one ohm to tens of megohms. This type resistor usually has wattage ratings of 2 watts or less, and the resistance value is indicated by color-coded bands encircling the body of the resistor. The deposited carbon resistor consists of carbon vapor deposited on a glass or ceramic form. Spiral paths are etched into the carbon until the desired resistance is obtained. Such resistors are usually higher-precision types with values accurate to 1% or less.

Wirewound resistors of different wattage ratings also are shown in *Figure 4-1*. They are made of resistance wire wound on a ceramic core. Fusible resistors are a special type of wirewound resistor made to burn-out and open the circuit to protect other components if current becomes greater than the fuse resistor is designed to handle.

Figure 4-1 also shows to types of variable resistors. A variable resistor is either carbon or wirewound with a movable wiper arm that will contact the resistance element at any point between the end extremes. When the arm is moved, usually with a shaft, the resistance between the wiper arm and either end varies. These variable resistors are commonly called potentiometers or rheostats. If three terminals are used in the circuit, it is referred to as a potentiometer. If only two terminals are used, it is referred to as a rheostat.

COLOR CODES

Resistor values are measured in ohms with an ohmmeter. As shown in *Figure 4-2*, a common way of indicating resistance values for composition resistors is to use color bands on the body of the resistor. A standard color code for the bands has been adopted by resistor manufacturers, and the numerical values they represent are given in *Table 4-1*. *Figure 4-2* shows how to evaluate the bands. The first band will be nearer one end of the resistor. Read from this band toward the other end. The first band is the first significant number; the

Figure 4-2. Color Bands Indicating Reistance

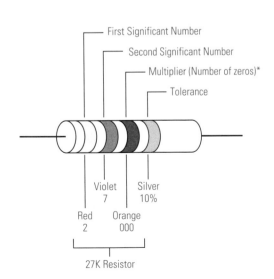

Table 4-1. Resistor Color Code

Color	Value
Black	0
Brown	1
Red	2
Orange	3
Yellow	4
Green	5
Blue	6
Violet	7
Gray	8
White	9

Tolerance	
Gold	5%
Silver	10%
No Band	20%

*If multiplier band is gold, the multiplier is 0.1; if it is silver, the multiplier is 0.01.

second band is the second significant number; and the third band is the multiplier to indicate the resistor's value (the number of zeros that follow the first two numbers). If the third band is gold or silver, this would indicate a multiplier of 0.1 or 0.01, respectively, rather than additional zeros.

As the resistors are manufactured, they all will not be exactly the same value. The fourth band indicates the tolerance of the resistor's value from the indicated (color code) value. A gold fourth band indicates ±5%, a silver band ±10%, and no fourth band indicates a tolerance of ±20%. The resistor's value will be within a tolerance band of ±5%, ±10%, or ±20% of the color-coded value.

The resistor in *Figure 4-2* is a 27,000 ohm, or 27 kilohm, resistor with a ±10% tolerance. The value of the resistor can be anywhere from 24,300 ohms to 29,700 ohms. As shown in *Figure 4-1*, its physical size indicates its power rating.

MEASURING A FIXED RESISTOR

• Out of Circuit

One of the easiest measurements to make with a VOM it to measure the value of a fixed resistor out of a circuit. Use the VOM as an ohmmeter and connect the test leads of the ohmmeter across the resistor, as shown in *Figure 4-3*.

Figure 4-3. Measuring a Resistor Out of Circuit

• In Circuit

Recall from Chapter 1 the two precautions that must be observed when using an ohmmeter to measure a resistance in a circuit:

1. The power source must be turned off. Disconnect the equipment from the power source, if possible.

2. When the resistor is in a circuit, if possible, disconnect one end of the resistor from any circuit or additional component so that only the resistance of the single resistor is measured.

Figure 4-4 shows the correct way to measure the resistance of R_3. Notice the supply V_S has been disconnected. Also, note that one end of R_3 is disconnected from the circuit so the ohmmeter measures the resistance of R_3 alone. If R_3 is not disconnected, then the value of resistance measured would be R_3 in parallel with R_2.

Figure 4-4. Measuring a Resistor In a Circuit

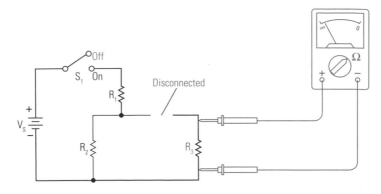

MEASURING A VARIABLE RESISTOR

When a potentiometer is measured with an ohmmeter, the total resistance is first measured from end-to-end, as shown for point A in *Figure 4-5*. The reading typically may be within a tolerance of ±20% of the stated value. Next, the resistance should be tested from the wiper arm to one end as the potentiometer is rotated through its full range, as shown for point B in *Figure 4-5*. The resistance should vary smoothly from near zero to the full scale of the resistance. Since the reading should vary smoothly and continuously, this is one place where a VOM has the edge over the DVM. Any sudden jump to either a higher or lower value, or any erratic reading would indicate a defective spot on the resistance element. If the wiper arm is not making firm contact with the resistance element, simply tapping the case of the potentiometer may produce erratic resistance readings. Any of these erratic indications mean a defective or dirty potentiometer. A spray cleaner may salvage the unit; however, if after cleaning it does not produce a smooth resistance change over its entire range, it should be discarded.

Figure 4-5. Measuring a Variable Resistor

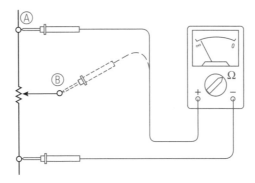

Rheostats may be tested by a similar process with the exception that the only measurement is from the wiper to one end since the rheostat only has two terminals. In general, rheostats will be open if they are defective because they usually are high wattage units and must handle high current.

THERMALLY INTERMITTENT RESISTORS

All electronic components, including fixed and variable resistors, can be thermally intermittent. Measure the resistance while subjecting the suspected component to extreme temperature change to detect this type of defect. Radio Shack stores carry an aerosol spray component cooler to spray on a resistor to cool it. The tip of a soldering iron can be used to heat it – but be careful not to apply such an excessive amount of heat as to damage the resistor. A sudden or erratic change in resistance as temperature is changed indicates the resistor is thermally intermittent and defective.

"SHIFTY" RESISTORS

There is a class of resistors whose resistances change as the operating conditions change. Common ones are thermistors, varistors, and photoconductors. Thermistors and photoconductors can be measured with an ohmmeter. The resistance of a varistor is calculated from voltage and current measurements.

• Thermistors

A thermistor is a resistor whose resistance varies with temperature. It exhibits large negative temperature characteristics; that is, the resistance decreases as the temperature rises and increases as the temperature falls.

• Varistors

A varistor is a resistor whose resistance is voltage dependent. Its resistance decreases as voltage across it is increased.

• Photoconductors

A photo cell's resistance (photoconductor) varies when light shines on it. When the cell is not illuminated, its "dark" resistance may be greater than 100 kilohms. When illuminated, the cell resistance may fall to a few hundred ohms. These values can be measured with an ohmmeter.

HOW TO MEASURE A CAPACITOR

CAPACITOR BASICS

Capacitance is the property whereby two conductors separated by a non-conductor (dielectric material) have the ability to store energy in the form of an electric charge and oppose any change in that charge. The operation of a capacitor depends on the electrostatic field set up between the two oppositely-charged parallel plates.

The unit of capacity is the farad, named in honor of Michael Faraday. It is the amount of capacitance which will cause a capacitor to attain a charge of one coulomb when one volt is applied. Expressed as a mathematical equation:

$$C = \frac{Q}{V}$$

where C will be one farad when Q is one coulomb and V is one volt.

The value of capacitance, the farad, is very large for practical applications; therefore, smaller values are used. A microfarad is 10^{-6} farads; a nanofarad is 10^{-9} farads; and a picofarad is 10^{-12} farads. Microfarads and picofarads are very common in electronic circuits.

The physical factors which determine the amount of capacitance a capacitor offers to a circuit are:

a. the type of dielectric material, (K);

b. the area in square meters of the plates, (A);

c. the number of plates, (n); and

d. the spacing of the plates in meters, which also is the thickness of the dielectric, (t).

The basic capacitor and its symbol are shown in *Figure 4-6* with the relationship between the physical factors indicated so the amount of capacitance can be calculated. N = 6 in *Figure 4-6b,* but the most common capacitors have 2 parallel plates.

Caution: *Before a capacitor is measured with an ohmmeter, remove the capacitor from the circuit and short across its leads or plates to make sure that it has no residual charge. Such a residual charge could damage an ohmmeter.*

Figure 4-6. Basic Parallel Plate Capacitor

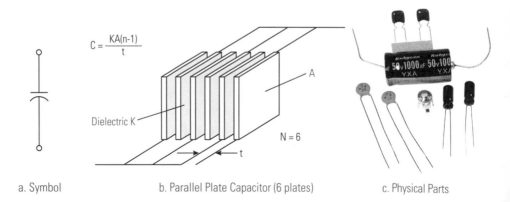

$$C = \frac{KA(n-1)}{t}$$

Dielectric K

A

N = 6

t

a. Symbol b. Parallel Plate Capacitor (6 plates) c. Physical Parts

RELATIVE AMOUNT OF CAPACITANCE

Two capacitors can be compared as to their relative capacitance by using a VOM. The amount of needle deflection of an ohmmeter can be used to indicate a relative amount of capacitance. By connecting the ohmmeter to the capacitor as shown in *Figure 5-7a*, the ohmmeter battery charges the capacitor to its voltage. The meter will deflect initially and then fall back to infinity as the capacitor charges. In *Figure 4-7b*, after the initial charge of the capacitor, the ohmmeter leads are reversed and the capacitor voltage is now in series with the voltage inside the ohmmeter. The charge on the capacitor is aiding the ohmmeter battery. The needle now deflects a larger deflection proportionally to the amount of capacitance, and then decays as the charge is redistributed on the capacitor.

Figure 4-7. Measuring Relative Amount of Capacitance

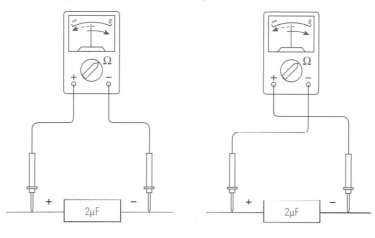

a. Initial Measurement b. Aiding Measurement

LEAKY AND SHORTED CAPACITORS

Paper, mica, and ceramic capacitors fail in two ways. The dielectric breaks down and the capacitor plates short together, or the capacitor becomes "leaky." When "leaky," the dielectric still supports a voltage but the dielectric resistance becomes much lower than normal. Both of these conditions can be detected with a VOM or DVM. There are two checks that can be made. The first is simply a resistance measurement using the VOM or DVM as an ohmmeter across the terminals of the capacitor. If the capacitor is shorted, the ohmmeter will read zero or a very low value of resistance. If the capacitor has become "leaky," then the resistance measurement will be much less than the normal nearly infinite reading for a good capacitor. Leaky capacitors need to be replaced before they turn into shorted capacitors.

In some capacitors, the dielectric does not become "leaky" until a voltage is applied. That is, it breaks down under load. This defect cannot be detected with an ohmmeter, but can be found by using the VOM or DVM as a voltmeter, as shown in *Figure 4-8*. A dc voltage is placed across the series combination of the voltmeter and the paper, mica, or ceramic capacitor (not for electrolytic capacitors, unless proper polarity is maintained). A good capacitor will show only a momentary deflection on the voltmeter, then the reading will decay to zero volts as the capacitor charges to the supply voltage. A defective capacitor will have a low insulation resistance, R_{INS}, (it may be a particular voltage), and will maintain a voltage reading on the meter. The lower the insulation resistance of the capacitor, the higher

the voltmeter will read. When insulation resistance is checked by this method, it is in series with the meter. Because R_{INS} is normally high, it limits the current; therefore, a change in the VOM range does not significantly affect the total resistance of the circuit, and the percentage of meter-scale deflection remains fairly constant with different voltmeter ranges. The power supply voltage, V_S, should be set for the rated working voltage of the capacitor for this test.

If the insulation resistance is such that it produces a scale reading on a VOM or DVM, the R_{INS} may be calculated by using the following equation:

$$R_{INS} = R_{INPUT}\frac{V_S - V_M}{V_M}$$

Where: V_S = supply voltage
V_M = VOM or DVM measured voltage
R_{INPUT} = VOM or DVM input resistance
R_{INS} = capacitor insulation resistance

Figure 4-8. Measuring R_{INS} Using a Voltmeter

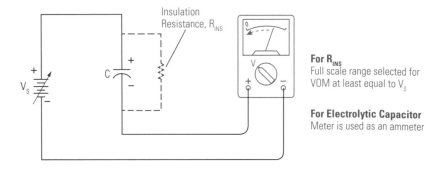

MEASURING AN ELECTROLYTIC CAPACITOR

Special care must be taken when measuring electrolytic capacitors because they are polarized. As a result, when using a VOM as an ohmmeter to test an electrolytic capacitor, the ohmmeter test lead polarity must be correct to give the proper indication. In most cases, this occurs when the positive ohmmeter test lead is connected to the positive electrolytic capacitor terminal. In any case, the test lead arrangement that gives the highest resistance reading is the one to use.

LEAKAGE CURRENT OF ELECTROLYTIC CAPACITORS

Measuring the leakage current of an electrolytic capacitor is the best way to judge whether the capacitor is still useful. The same circuit of *Figure 4-8* is used for measuring leakage current of electrolytic capacitors except now the meter is an ammeter. V_S, the capacitor's rated voltage, is applied across the capacitor, and the leakage current is indicated by the series ammeter. The maximum permissible leakage current of a new electrolytic capacitor is related to the voltage rating (WVDC) and capacitance of the capacitor according to the following equation:

$$I = kC + 0.30$$

where I = leakage current in mA

C = rated value of the capacitor in microfarads

k = a constant as given in *Table 4-2*

Many factors affect the amount of leakage, such as the age of the capacitor, how long it has been uncharged in a circuit, how near its rated voltage it has been working, or how long a new one has been on the shelf. If the capacitor exceeds the permissible leakage values, it should be discarded. Experience will help make this test more conclusive.

Table 4-2. Electrolytic Capacitor Constant k

k	WVDC, volts
0.010	3 – 100
0.020	101 – 250
0.025	251 – 350
0.040	351 – 500

HOW TO MEASURE INDUCTORS

The property of an electric circuit or component that opposes changes in circuit current is called inductance. The ability of the circuit or component to oppose changes in current is due to its ability to store and release energy that it has stored in its magnetic field. Every circuit has some inherent inductance, but devices which purposely introduce inductance to a circuit are called inductors. Let's look at some basics of inductance, and how to test inductors with a VOM or DVM.

INDUCTOR BASICS – INDUCTANCE AND IMPEDANCE

An inductor may take on any number of physical forms and shapes. However, it is basically nothing more than a coil of wire. Inductors are sometimes referred to by such names as choke, impedance coil, reactor, or combinations such as choke coil, or inductive reactor. The amount of inductance of a coil is measured by a unit called the henry. As is the case for capacitors, smaller units are practical – the millihenry is 10^{-3} henries; the microhenry is 10^{-6} henries. These are very common units in electronic circuits.

The amount of inductance in an inductor depends upon the magnetic flux produced and the current in the coil. Mathematically, this may be expressed by the following equation:

$$L = \frac{N\phi}{I}$$

where L is the inductance in henries
I is the current through the coil in amperes
N is the number of turns of wire
ϕ is the magnetic flux linking the turns

Basically, all inductors are made by winding a length of conductor around a core which is made either of magnetic material or of insulated material. When a magnetic core is not used, the inductor is said to have an air core. The physical characteristics, or geometry, of both the core and the windings around the core affect the amount of inductance produced. *Figure 4-9* illustrates these factors. The more turns, the better the magnetic core material, the larger core cross section area, and the shorter the coil length all increase the inductance.

Figure 4-9. Physical Factors That Affect the Value of Inductance

68

In a dc circuit, the only changes in current occur when the circuit is closed to start current, and when it is opened to stop current. However, in an ac circuit, the current is continually changing each time the voltage alternates. Since inductance in a circuit opposes a change in current and ac is continually changing, there is an opposition offered by the inductor to the ac current that is called reactance. The amount of inductive reactance is given by the following equation:

$$X_L = 2\pi fL$$

where X_L is the inductive reactance in ohms

 f is the frequency of ac in hertz

 L is the inductance in henries

The quantity $2\pi f$ represents the rate of change of current in radians per second. It is called angular velocity.

In ac circuits that contain only inductance, the inductive reactance is the only thing that limits the current. The current is determined by Ohm's Law with X_L replacing R, as follows:

$$I = \frac{V}{X_L}$$

If an ac circuit contains both resistance and inductance (reactance), then the total opposition to current flow is termed impedance, and is designated by the letter Z. When a voltage, V, is applied to a circuit that has an impedance, Z, the current, I, is:

$$I = \frac{V}{Z} \left(\text{where } Z = \sqrt{R^2 = X_L^2}\right)$$

CONTINUITY

A series RL circuit may be formed by one or more resistors connected in series with one or more coils. Or, since the wire used in any coil has some resistance, a series RL circuit may consist of just a coil or coils by themselves. The resistance of coils, which effectively is in series with the inductance, supplies the circuit resistance. Using a VOM as an ohmmeter, a simple continuity test will quickly locate an open inductor. The resistance can be measured easily for any inductance that is not open. Simply place the meter used as an ohmmeter across the coil terminals and measure the resistance, just like a resistor was measured in *Figure 4-3*. Normal resistance values depend on the wire size and number of turns (length) of the wire that make up the inductor. Some coils with fine wire and a large number of turns will have hundreds of ohms of resistance; larger coils with large wire and a small number of turns will have tens of ohms of resistance. If infinite or very, very large resistance is measured, then the inductance is open.

OTHER FAILURES

Inductors become defective because insulation breaks down and turns short together, or because the coil shorts to the core. Simple continuity checks with an ohmmeter between one end of the coil and the core detect the coil shorted to the core, but a few shorted turns on an inductor are very difficult to detect. If one-half the coil shorts out, resistance checks should detect it, but for a few turns, very accurate measurements must be made in order to detect that the coils is defective.

TRANSFORMER BASICS

As shown in *Figure 4-10*, a transformer is a device for coupling ac power from a source to a load. A conventional transformer consists of two or more windings on a core that are isolated from each other. Energy is coupled from one winding to another by a changing magnetic field. An ac voltage applied across the primary results in primary current. The changing current sets up an expanding and collapsing magnetic field which cuts the turns of the secondary winding. This changing magnetic field induces an ac voltage in the secondary which produces a current in any load connected across the secondary.

Figure 4-10. Simple Transformer

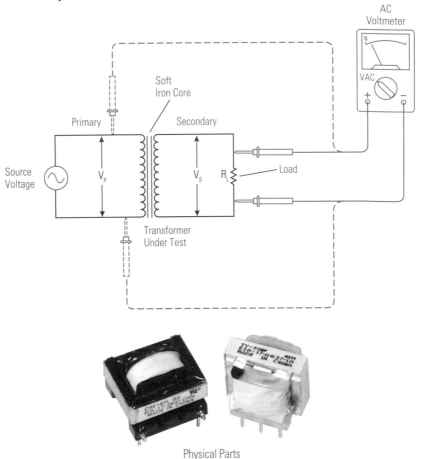

Physical Parts

The core around which the primary and secondary are wound may be iron for low frequencies, as in the case of power and audio transformers. Primary and secondary windings on an air core may be employed for transformers that couple energy in higher-frequency circuits.

IDEAL TRANSFORMER

If the transformer were ideal, there would be no power loss from primary to secondary and 100% of the source power would be delivered to the load. Since voltage times current equals

power, the power relationship is given by:

$$V_P \times I_P = V_S \times I_S$$

where V_P = primary voltage in volts
 I_P = primary current in amperes
 V_S = secondary voltage in volts
 I_S = secondary current in amperes

 In an ideal transformer, the ratio of primary voltage, V_P, to the voltage induced in the secondary, V_S, is the same as the ratio of the number of turns in the primary, N_P, to the number of turns in the secondary, N_S. The following equation expresses the relationship:

$$\frac{V_P}{V_S} = \frac{N_P}{N_S}$$

The turns ratio of a transformer is:

$$\frac{N_S}{N_P}$$

the ratio of the secondary turns to the primary turns.

STEP UP AND STEP DOWN TRANSFORMERS

If the number of turns in the primary and the secondary are equal, then the voltages appearing across the primary and secondary are equal. This type of transformer with a one-to-one turns ratio is called an isolation transformer. If a lower voltage appears across the secondary than across the primary, it is called a step-down transformer. The ratio of turns would be less than 1. However, if a higher voltage appears across the secondary than across the primary, it is called a step-up transformer. The turns ratio would be greater than 1. According to the primary and secondary power relationship given previously, the secondary current will be stepped down if the secondary voltage is stepped up; and if the secondary voltage is stepped down, the secondary current is stepped up.

RESISTANCE TESTING OF TRANSFORMER WINDINGS

• Continuity

A resistance test may be made with an ohmmeter on most small transformers used in electronics to determine the continuity of each winding. Comparison of the measured resistance with the published data from the manufacturer should determine if a suspected transformer is defective. Power transformers and audio output transformers usually have their windings color coded so that the respective winding can be measured with an ohmmeter to determine if there is continuity, and to measure the winding resistance. If the winding measures infinite resistance, the winding is open. The break may occur at the beginning or end of the winding where the connections are made to the terminal leads. This type of break may possibly be repaired by resoldering the leads to the winding. If the discontinuity is deeper in the transformer, then the transformer will have to be replaced.
 If the winding resistance is very high compared to its rated value, there may be a cold solder joint at the terminal connections. If this condition cannot be corrected by resoldering, the transformer will have to be replaced.

• Shorts – Primary and Secondary

A short from the winding to the core or to another winding may be found by measuring the resistance on a high ohms scale from the core to the winding, or from winding to winding. Place the ohmmeter leads on the winding lead and on the core, or across from one winding lead to another winding lead. Any continuity reading at all would indicate leakage to the winding from the core, or between windings, and thus indicate a defective transformer. A few shorted turns are difficult to detect, but if a larger percentage of the transformer is shorted out, resistance measurements will detect it.

The winding-to-core or winding-to-winding resistance of a transformer or an inductor can be tested with a voltmeter and a dc power supply, as shown in *Figure 4-11*. The voltmeter will read zero if there is no breakdown between windings and core. If there is a significant voltage reading on the voltmeter, then there is a significant reduction in the interwinding resistance and the transformer is going bad.

Figure 4-11. Using a Voltage to Test an Inductor for Breakdown Between Winding and Core

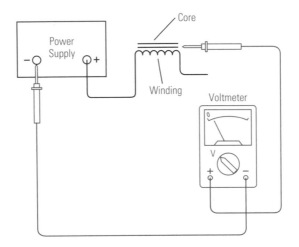

• Turns Ratio

The turns ratio of a transformer can be measured using the circuit of *Figure 4-10*. Apply a small ac voltage to the primary (V_P in *Figure 4-10*). A good source for this is a doorbell transformer. It supplies from 12 to 18 volts ac. Measure V_P with an ac voltmeter as shown in *Figure 4-10*. Now measure the secondary voltage, V_S, with the same voltmeter. The turns ratio,

$$\frac{N_S}{N_P}$$

is equal to

$$\frac{V_S}{V_P}$$

the secondary voltage divided by the primary voltage.

• Step-Up Transformer

Example: If V_p applied is 12 volts and V_s is measured as 60 volts, then the turns ratio is:

$$\frac{N_S}{N_P} = \frac{V_S}{V_P} = \frac{60V}{12V}$$

or

$$\frac{N_S}{N_P} = \frac{5}{1}$$

The turns ratio is 5:1.

• Step-Down Transformer

If the transformer is a known step-down transformer and the primary voltage is known, then 110 VAC line voltage can be applied to the primary and the stepped-down voltage read with the voltmeter.

Example: If V_p is 110 volts and V_s is measured as 10 volts, then

$$\frac{N_S}{N_P} = \frac{V_S}{V_P} = \frac{10V}{110V}$$

or

$$\frac{N_S}{N_P} = \frac{1}{11}$$

The turns ratio is 1:11.

If the primary voltage is unknown, or whether it is a step-up or step-down transformer is unknown, it may be dangerous to place 110 volts across a winding because the secondary voltage could be quite high if it has a step-up turns ratio. Thus, applying a lower voltage for the turns ratio measurement is a much safer procedure. In each case, the secondary is not loaded when measuring the voltage to determine the turns ratio.

MEASURING SEMICONDUCTOR DEVICES

The only definite test for a transistor is operating it in the circuit for which it was designed. However, there are several tests that can indicate the condition of its junctions. There are sophisticated tests that can be made with oscilloscopes, curve tracers, and switching characteristics checkers, but we want to show how it is possible to test a transistor or other semiconductor device fairly completely with only an ohmmeter.

DIODES

The diode is a two-terminal, non-linear device that presents a relatively low resistance to current in one direction and a relatively high resistance to current in the other direction. A "perfect" diode would act like a switch – either ON (conducting) or OFF (not conducting) depending upon the voltage polarities applied to the terminals. The typical construction and circuit symbol of a diode are shown in *Figures 4-12a* and *4-12b*. The cathode of a diode usually is identified by some means of marking. On small-signal glass or plastic diodes, a colored band or dot may be used, as shown in *Figure 4-12c*. For rectifiers, sometimes a + is used to indicate the cathode, as shown in *Figure 4-12d*, or metal-can devices have a large flange on the cathode, as shown in *Figure 4-12e*.

Figure 4-13 shows a diode being tested with an ohmmeter. The test indication that the diode is functioning properly is a low resistance reading when the plus (+) lead is on the anode (P material) (forward biased – *Figure 4-13a*), and a high resistance reading when the ohmmeter plus (+) lead is on the cathode (N material) (reverse biased – *Figure 4-13b*). A low resistance in both directions indicates a shorted diode; a condition where high current has destroyed internal connections. A high resistance in both directions indicates an open diode; a condition where high voltage has broken down the junctions.

Figure 4-12. Diode Construction, Symbol, and Identification

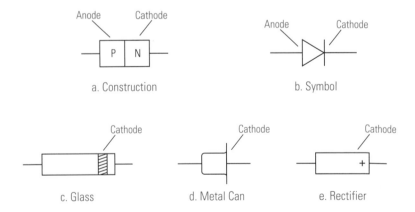

a. Construction

b. Symbol

c. Glass

d. Metal Can

e. Rectifier

TRANSISTORS

The transistor is a three-terminal device that virtually has replaced the vacuum tube. There are two basic types of transistors – the bipolar, and the field-effect transistor.

• Bipolar Junction Transistors (BJT)

A transistor is a device made of two PN junctions, as shown in *Figure 4-14*. The transistor is basically an OFF device that must be turned ON by applying forward bias to the base-emitter junction.

Figure 4-13. Using an Ohmmeter to Measure a Diode

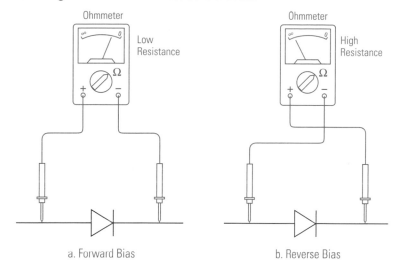

a. Forward Bias b. Reverse Bias

Figure 4-14. Resistance Readings Across Junctions of Transistors

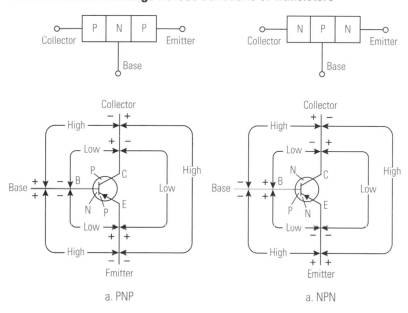

a. PNP a. NPN

Transistors can be considered as two diodes connected back-to-back. Therefore, like a diode, each junction should show low forward resistance and high reverse resistance. These resistances can be measured with an ohmmeter and the results should be as indicated in *Figure 4-14*. The polarities of the voltages applied are shown to indicate forward or reverse bias on the NPN and PNP transistors.

The same ohmmeter range should be use for each pair of measurements to each of the elements (base-to-collector, base-to-emitter, emitter-to-collector). For most transistors, any ohmmeter range is acceptable. However, in some meters the R × 1 range may provide excessive current to a small transistor. Also, the highest resistance range may have excessive

voltage at the terminals of some ohmmeters. Either of these conditions may damage the transistor being tested. As a result, it is best to start testing using the mid-ranges for the resistance measurements.

DEFECTS

If the reverse resistance reading is low but not shorted, the transistor is leaky. If both forward and reverse readings are very high, the transistor is open. If the forward and reverse readings are the same or nearly equal, the transistor is defective. A typical resistance in the forward direction is 100 to 500 ohms. However, a low-power transistor might show only a few ohms resistance in the forward direction, especially at the base-emitter junction. Reverse resistances are typically 20K to several hundred thousand ohms. Typically, a transistor will show a ratio of at least 100 or so between the reverse resistance and forward resistance. Of course, the greater the ratio the better the device is for an application.

• Operational Test of a BJT

The amplification action of a transistor may be checked with the circuit of *Figure 4-15*. It will give some indication if the transistor is operational. Normally, there will be little or no current between the emitter and collector (I_{CEO}) until the base-emitter junction is forward-biased. Therefore, a basic operational test of a transistor can be made using an ohmmeter. The R × 1 range should be used. Closing S_1 will allow a small base bias current to be applied from the ohmmeter internal battery through R_1. If the transistor is operational, the base current will cause collector current to flow, thus reducing the collector-to-emitter resistance. The ohmmeter shows a decreased resistance (an increased emitter-to-collector current) when S_1 is closed to indicate that the transistor is operational and amplifier action is taking place.

Figure 4-15. Operational Test of Transistor with Ohmmeter

When S_1 is closed, resistance decreases.

Note:
Ohmmeter polarity shown is for a PNP. Reverse the polarity for an NPN. Check multitester for voltage polarity at the probes to make sure proper polarity is applied.

FIELD-EFFECT TRANSISTORS (FET)

A field-effect transistor (FET) is a voltage-operated device that requires virtually no input current. This gives them an extremely high input resistance. There are two major categories of field-effect transistors: junction FETs (JFET); and insulated gate FETs, more commonly known as MOS (metal-oxide-semiconductor) field-effect transistors (MOSFET). Like the bipolar junction transistor, the FET is available in two polarities, P-channel and N-channel.

The schematic symbols for field-effect transistors are shown in *Figure 4-16*. Notice the terminals are identical for N-channel and P-channel, but the arrow on the gate terminal is reversed. This also indicates that the current direction from source-to-drain depends on the

Figure 4-16. Field-Effect Transistors

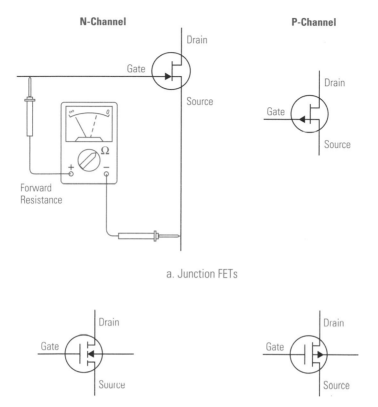

a. Junction FETs

b. MOS (Metal-Oxide-Semiconductor) FETs

polarity type of the FET. Since there is no set designation for the source and drain terminals of the FET, the reference manual or the equipment schematic should be consulted to identify the terminals on the FET being tested.

Testing FETs is somewhat more complicated than testing a BJT transistor. First, determine from all markings if the device is a JFET or MOSFET type. Otherwise, the terminal measurement will have to indicate the type. Do not attempt to remove the transistor from the circuit or handle an FET unless you are certain that it is a JFET or a MOSFET with protected inputs. If one touches the leads of these devices, static electricity can damage an unprotected device very quickly. Make certain all static electricity is grounded out before handling FETs.

• JFET Measurements

To test the forward resistance of the JFET gate-to-source junction, use a low voltage ohmmeter on the R × 100 scale (or nearest to it). For an N-channel JFET, connect the positive lead to the gate (see *Figure 4-16a*) and the negative lead to either the source or drain. Reverse the leads to test a P-channel JFET. The resistance should be less that 1K ohms.

To test the reverse resistance of the N-channel JFET junction, reverse the ohmmeter leads and connect the negative lead of the ohmmeter to the gate and the positive lead to either the source or drain. The device should show almost infinite resistance. Lower readings indicate either leakage or a short. Reverse the leads to test a P-channel JFET.

• Operational Test of a JFET

The following simple, out-of-circuit test will demonstrate if a junction FET is operational, but will not indicate if the device is marginal. Operational means it is not shorted or open, which is by far the most common occurrence when a JFET becomes defective. After the JFET has been removed from the circuit, connect the ohmmeter between the drain and source terminals. Touch the gate lead with a finger and observe the ohmmeter polarity connections to the source and drain terminals and the channel type (P or N). Reverse the leads of the ohmmeter to the terminals and again touch the gate terminal. The ohmmeter should indicate a small change in the resistance opposite to that previous observed if the JFET is operational. The change in resistance will be very slight and some operational (good) JFETs will not appear to change.

MOSFET MEASUREMENTS

To test a MOSFET, the device must be handled with caution and the hands and instruments must be discharged to ground to eliminate any static electricity before measurements are made. If a MOSFET is to be checked for gate leakage or breakdown, a low-voltage ohmmeter on its highest resistance scale should be used. The MOSFET has an extremely-high input resistance and should measure "infinity" from the gate to any other terminal. Lower readings indicate a breakdown in the gate insulation. The measurements from source-to-drain should indicate some finite resistance. This is the distinguishing characteristic of a MOSFET; it has no forward and reverse junction resistance because the metal gate is insulated from the source and drain by silicon oxide. It should be a very-high resistance with both polarities of voltage applied.

SCR TESTING

An SCR (silicon controlled rectifier) is a gated diode that is used for the control of ac power. If a positive voltage is applied to the anode relative to the cathode, the diode will not conduct in the forward direction until triggered by current in the gate. Once triggered on, the diode is turned off by the voltage between anode and cathode going to zero. Testing with an ohmmeter is not recommended for high-current SCRs and should only be used as a relative indication for low-current SCRs. The current supplied by the ohmmeter may not be enough to "fire" or "hold" the SCR and therefore may not always indicate the true junction condition of the device.

Figure 4-17. SCR Testing with an Ohmmeter

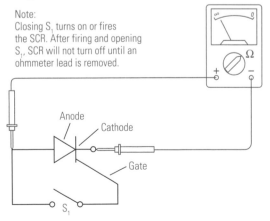

Note:
Closing S_1 turns on or fires the SCR. After firing and opening S_1, SCR will not turn off until an ohmmeter lead is removed.

However, a simple test of low-power SCRs may provide an approximate evaluation of their gate-firing capabilities by connecting a ohmmeter as shown in *Figure 4-17*. The negative lead is connected to the cathode and the positive lead to the anode. Use the R × 1 scale on the ohmmeter. Short the gate to the anode with S_1. This should turn the SCR "ON" and a reading of 10 to 50 ohms is normal. When S_1 is opened and the gate-to-anode short is removed, the low resistance reading should remain until the ohmmeter lead is removed from the anode or cathode. Now, reconnecting the ohmmeter leads to the anode and cathode should show a high resistance until S_1 is closed again to short the gate to the anode.

TESTING A BATTERY

A battery is a single cell or group of cells that generate electricity from an internal chemical reaction. Its purpose is to provide a source of steady dc voltage of fixed polarity. The battery, like every source, has an internal resistance that affects its output voltage. For a good cell, the internal resistance is very low with typical values less than one ohm. As the cell deteriorates, its internal resistance increases preventing the cell from producing its normal terminal voltage when there is load current. A dry cell loses its ability to produce an output voltage even when it is out of use and stored on a shelf. There are several reasons for this, but mainly it is because of self-discharging within the cell and loss of moisture in the electrolyte. Therefore, batteries should be used as soon after manufacture as possible. The shelf life of a battery is shorter for smaller cells and for used cells.

TESTING UNDER LOAD

A very "weak" (high internal resistance) battery can have almost normal terminal voltage with an open circuit or no load current. Thus, a battery should be checked under its normal load condition; i.e., in the equipment that it powers with the power switched on. Out of the equipment, the only meaningful test is with a load resistor across the battery, as shown in *Figure 4-18*. The value of the load resistor depends on the battery being tested. For a standard "D" cell, use R_L = 10 ohms; for a "C" cell use R_L = 20 ohms; for an "AA" cell, use R_L = 100 ohms; and for a 9-volt battery, use R_L = 330 ohms. The terminal voltage should not drop to less than 80% of its rated value under load. The internal resistance may be calculated by the equation:

$$R_I = V_{NL} - \frac{V_L}{I_L}$$

Where V_{NL} = the terminal voltage with no load
$\quad\quad\quad V_L$ = the terminal voltage with a load resistor
$\quad\quad\quad I_L$ = the load current, which is equal to: $\dfrac{V_L}{R_L}$

Measure V_{NL} first without a load, then measure V_L with a load, and calculate the internal resistance.

Figure 4-18. Testing a Battery Under Load

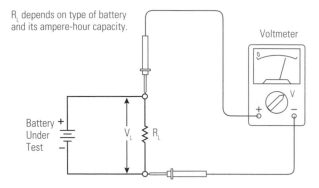

• Current Drain

The current drain of a battery should be measured in its actual operating condition; that is, with its normal load. It can be measured by connecting the current meter in series between the battery and the equipment it is powering. The battery clip may be disconnected from the battery on one side and the current meter connected to complete the circuit. The correct polarity must be observed. To protect the meter from possible damage, start on a high current range in case of an excessively-high current due to a malfunction.

Now that we have learned how to make measurements on individual components, let's look at how to measure components in circuits. That is the subject of the next chapter.

5

Measurement of Circuit Components

The most popular and versatile instrument on any electronics technician's workbench or in his toolbox is the multitester or multimeter. Understanding how to use multitesters to measure individual components is important, but understanding how to use a meter to make measurements in a circuit – the subject of this chapter – enhances their value many times over.

ABOUT IN-CIRCUIT COMPONENT TESTS

GENERAL CONSIDERATIONS

In-circuit measurements with a multitester usually occur with power applied to the circuit. These measurements usually are made because something has happened to cause a circuit, or a device, or a piece of equipment to operate improperly. Measurements are being made to locate the problem. This is called troubleshooting the circuit. Because power is applied, special safety precautions should be observed. Make certain that measurement terminals are not shorted together or to ground by the test leads. This is particularly important when measuring 110 VAC line voltage. Severe shock to the person making the test measurements, or extensive damage to the device being tested, or to the meter, can result if caution is not exercised.

METER SAFETY

Your multitester will remain a valuable servant if reasonable care is taken while operating it. Specification limits should not be exceeded. Start out with high ranges when the value of the measurement is unknown, then move to lower ranges to bring the meter deflection upscale. *Read the owner's manual that came with your meter so you understand the capabilities and limitations of your particular multitester!*

CHECKING A DC POWER SUPPLY

Each electronic system has a power supply, even if it is simply a battery. Let's look at a typical, simple power supply and how its voltage can be measured.

Figure 5-1. A Popular Power Supply Circuit

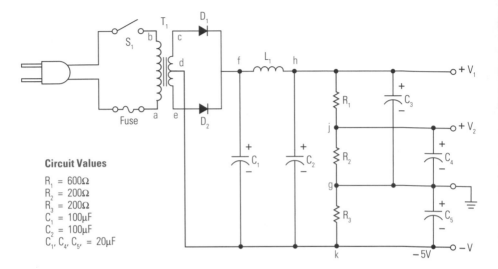

Circuit Values

$R_1 = 600\Omega$
$R_2 = 200\Omega$
$R_3 = 200\Omega$
$C_1 = 100\mu F$
$C_2 = 100\mu F$
$C_3, C_4, C_5, = 20\mu F$

BASIC CIRCUIT UNDERSTANDING

Typically, electronic power supplies consist of rectifiers, diodes, transformers, a filter made of capacitors and inductors or resistors, and a bleeder resistor, which also can be used as a voltage divider. *Figure 5-1* shows a popular power supply circuit.

This circuit uses a full-wave, center-tapped rectifier circuit to convert the ac voltage delivered by the transformer to dc. The pulsating current from the rectifier is smoothed by

Table 5-1. Normal Voltage and Resistance Measurements

	VOLTAGE MEASUREMENTS		RESISTANCE
Type	Voltage Test Points	No-Load Voltage Value (V)	Resistance a thru k to g
ac	a-b	110	∞
ac	c-e	40	*$R_3 \parallel R_1 + R_2 = 160\Omega$
ac	c-d	20	*$R_3 \parallel R_1 + R_2 = 160\Omega$
dc	f-g	+20	$R_1 + R_2 = 800\Omega$
dc	h-g	+20	$R_1 + R_2 = 800\Omega$
dc	j-g	+5	$R_2 = 200V$
dc	k-g	−5	$R_3 = 200V$

* Diodes forward biased.

a filter. The bleeder resistors serve at least two purposes here. First, they provide multiple outputs, including one negative voltage with respect to ground. Second, they also provide a constant minimum load for the power supply to draw a minimum current and stabilize the output voltage.

NORMAL OPERATION REFERENCE VALUES

Normal values of dc voltage, ac voltage, and resistances to ground expected in the circuit are very useful reference values to a technician when troubleshooting a power supply. *Table 5-1* shows some typical values for the circuit of *Figure 5-1* that should prove very useful.

LOCATING DEFECTIVE COMPONENTS

Suppose in the circuit of *Figure 5-1*, that there is no voltage between point h and ground. In order to isolate the problem, a measurement is made to determine if input ac voltage is present. This ac voltage is measured between points c and e. If there is no voltage across c and e, it would indicate trouble due to defects in any of the following:

a. open line cord or defective line outlet plug.

b. open fuse.

c. open switch.

d. open transformer.

Voltage, continuity and resistance measurements are used to find and correct the problem.

If the above is not the problem, and voltage is present at points c and e, then it is likely that the defect would be:

a. the load.

b. the rectifiers.

c. the filter inductor.

d. an open in the wiring between points c ~ e and h.

Disconnect the load from points V_1, V_2 and V_3. If the voltage at h returns, then the problem is in the load. If not, check b, c or d. Voltage and resistance measurements to ground, using *Table 5-1* as a reference, should isolate the problem.

RESISTANCE MEASUREMENTS

NOTE: Before measuring resistance, turn power OFF and discharge all capacitors, especially if they are electrolytic. Specific circuit test points are selected so that resistance measurements can be made from the test points to ground to determine if there are circuit shorts or circuit opens. For example, if one of the filter capacitors is shorted (say C_2), the resistance from point h to ground will be zero. When the trouble is found and the faulty component located and replaced, perform an operational check on the power supply to make sure it is completely repaired.

TROUBLESHOOTING A SIMPLE AC CIRCUIT

A DOORBELL CIRCUIT – HOW IT WORKS

Figure 5-2 shows a typical doorbell circuit. This circuit has the doorbell and switch in series with the transformer secondary winding. The doorbell operates at 10 VAC. This low voltage is not dangerous, and as long as the measurements are made on the secondary side of the transformer, it is not necessary to turn off the circuit breaker to check out the circuit. The voltage measurements for a normally working doorbell circuit of *Figure 5-2* are shown when the button is not pushed. M_1, M_2 and M_3 are different meter readings. If any of the voltages are not correct, the listed readings should help to determine the power supply problem. If not, then resistance measurements will have to be made. *[NOTE: Turn the circuit breaker off (or remove the fuse) before making resistance measurements.]* The resistances for a normally-working doorbell circuit also are shown in *Figure 5-2*.

Figure 5-2. A Typical Doorbell Circuit

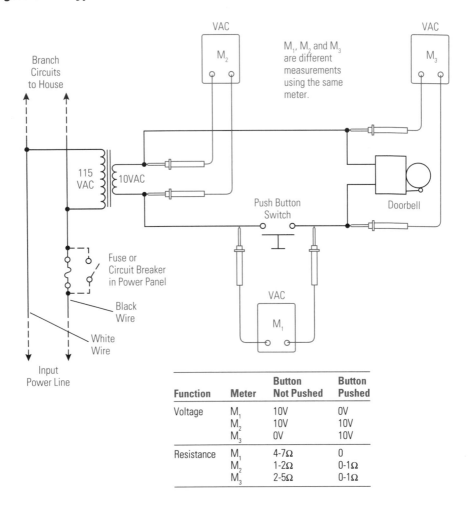

Function	Meter	Button Not Pushed	Button Pushed
Voltage	M_1	10V	0V
	M_2	10V	10V
	M_3	0V	10V
Resistance	M_1	4-7Ω	0
	M_2	1-2Ω	0-1Ω
	M_3	2-5Ω	0-1Ω

WHEN THE BELL DOESN'T RING

Assume that the bell does not operate when the button is pushed. The two most common problems are a bad switch or a bad bell. To track down the trouble, measure the voltage across the push button switch. With the switch open, 10 volts should appear across the open switch. There is no current in the circuit and thus no voltage across the bell (M_3). When the switch is closed, meter M_1 should read zero. If a voltage appears across the switch even when it is closed, this indicates that the circuit is not operating properly. Check the contacts to see if they are corroded or broken. The switch can possibly be repaired by simply burnishing the contacts. However, it may have to be replaced. If 10 volts appears across the bell when the button is pushed and the bell does not ring, then the bell is probably defective. Disconnect it and check its resistance to see if it has an open coil.

TRACING A SHORT CIRCUIT

Now, let's assume that instead of an open we have a short in the circuit. We'll use voltage readings to find the short in the circuit. Assume that M_1 reads the normal zero volts when the switch button is pushed. However, M_1 reads an abnormal value of only 2-3 volts when the switch is open. It should read 10 volts. Now, measure the voltage across the transformer secondary (M_2). It also shows a low reading of 2-3 volts. You note that the transformer is quite warm. You suspect a short, so you disconnect one of the wires to the secondary. The M_2 voltage jumps to 10 volts. This indicates that there is a short circuit somewhere in the leads going to the doorbell. This short circuit drains so much current from the transformer secondary that it is overloaded and the output voltage is reduced to the low value of 2-3 volts.

To locate the trouble, examine the wires for frayed or worn insulation and possible points where they may touch. Sometimes a nail is driven through the wires, scoring the insulation and causing the wires to short out with age. When you find the short, clear it and check for normal voltages as indicated in *Figure 5-2*.

TROUBLESHOOTING YOUR TELEPHONE INSTALLATION

The fact that we can pick up our telephone and talk to almost anyone anywhere in the world is surely a modern miracle. Its dependability is amazing; however, there can be problems. While you are not permitted to perform any repair work on lines or equipment owned by the phone company, you can make simple tests on the line(s) and equipment in your own home or office and repair those problems.

TESTING THE TELEPHONE LINE

A good way to determine if the trouble is on the telephone line or in one of the instruments is by substitution. If you plug a telephone that is known to be good into a line and it does not work well, then you have verified that the line as the problem. If everything works, then you know that the first instrument is the problem. If the trouble is on the line from the central office to the point where it connects to your house, the telephone company is responsible for the repairs. However, if the trouble is in your house, you can repair it yourself.

ON HOOK AND OFF HOOK

The most common place for a telephone line to connect initially as it comes into your house is at the network interface; or, in older installations that have not been updated, at the 42A terminal block. The network interface, shown in *Figure 5-3b*, provides a modular, plug-in connection to the outside telephone line. The 42A terminal block has screw connections for the wires, as depicted in *Figure 5-3a*.

Figure 5-3b shows how 4 phone jacks are wired from the network interface or from the 42A block. The incoming line and the branch lines can be tested with a VOM or DVM. The dc voltage between the red and green wires should be about 48 volts with all of the telephones either "on hook" (hung up) or unplugged from their jacks. The minus (-) lead of the meter is connected to the red (ring) terminal and the plus (+) meter lead is connected to the green (tip) terminal. An open or a short on the line can result in a zero voltage reading at a jack.

The voltage that will be measured across the line in the "off hook" condition (hand piece lifted and ready for use) will depend on several things – mainly the distance from the central office and the wire size used for the phone line. Typically, the voltage will be from 5 to 10 volts dc.

TESTING BRANCH CIRCUITS

Let's now consider how to find a short or open at some point on one of the lines shown in *Figure 5-3b*. First, we will determine that the trouble is inside the building and not phone line from the central office. If you have a network interface, you can simply unplug the inside line connection and plug in a standard telephone set that you know is working properly. If the phone works properly, the outside line is good. If you have a 42A block connection, disconnect the inside line(s) and measure the voltage. There should be about 48 volts dc with the red lead negative (-) and the green lead positive (+). Lets assume that this is as it should be. Again, you can connect a telephone set to the outside line at this point to further confirm that the phone company line is good.

There are two branch circuits from the 42A block in *Figure 5-3b*: Branch A with outlets #1 and #2; and Branch B with outlets #3 and #4. None of the outlets work with a telephone set.

Figure 5-3. A Typical, Modular Telephone Company Network Interface

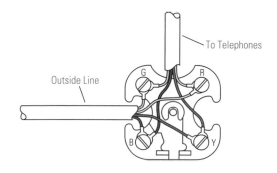

a. 42A Block

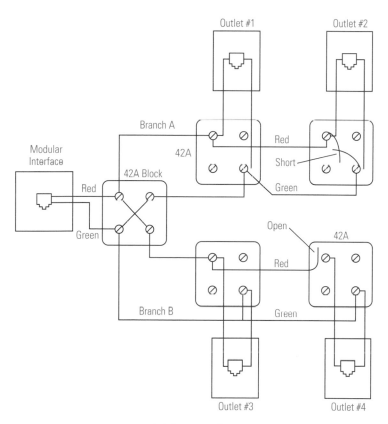

b. Interconnection

When Branch A is reconnected to the 42A, the 48 volts goes to 0. This means there is a short somewhere on Branch A. Going to outlet #1 and visually inspecting the connections indicates no short. If the wires that feet outlet #2 are removed at outlet # 1 (even just one of them), the voltage at outlet #1 now measures 48 volts. A telephone set may be plugged in and it will work fine. Reconnecting the feed line to outlet #2 again kills outlet #1. Examination of the wiring at outlet #2 shows that the two wires are shorted together. After the short is cleared, both outlets #1 and #2 work properly.

Branch B is now reconnected to the 42A block and outlet #3 checks out okay, but outlet #4 does not. It has no voltage. Examination of the wiring of outlet #4 turns up a broken red wire and, thus, an open circuit. Reconnecting the red wire to the outlet terminal screw restores the voltage and operation to outlets #3 and #4. Plugging in a good telephone in all outlets shows that they entire system is operating properly.

TESTING THE TELEPHONE SET

Three problems are very common if you determine that a telephone set is not operating properly: 1) a switch contact is bad; 2) the talk-and-listen circuits are faulty; or 3) the ringing circuit does not operate. Three quick tests can be made to isolate these problems.

Figure 5-4. Measuring the Handset With an Ohmmeter

• Measuring Resistance

In order to determine if the switchhook contacts are operating properly, the resistance of the telephone set can be checked with an ohmmeter. Measure between the red and green wires leading to the telephone set with the set disconnected from its outlets, or from the telephone jack. This measurement is shown in *Figure 5-4*. With the handset on hook, the resistance should be infinity; with the handset off hook, the resistance should be 2,000 to 10,000 ohms. Any reading below 1,000 ohms indicates some problem with the telephone set. Further detailed troubleshooting would be necessary to locate the problem.

By measuring with an ohmmeter as shown in *Figure 5-4*, a clicking will be heard from the receiver of the handset to indicate that the talk and listen circuits are working properly. If the transmitter is an electrodynamic microphone, the clicks also will be heard from the mouthpiece.

• Testing the Ringer Circuit

The easiest way to test the telephone set for ringer problems is to measure if the ringing voltage is available. With the telephone set connected to the line, the handset on hook, and a voltmeter connected across the line, as shown in *Figure 5-5* at the jack (or at the initial entry point of the phone line into the building), have a friend call your number. The phone company central office applies between 90 and 105 volts to the line when the telephone is to ring. The amount of voltage at the telephone set depends on the distance to the central office. If the voltage appears but the phone doesn't ring, more detailed troubleshooting is required to locate the specific problem with the telephone set. If the voltage doesn't appear and you know that your friend has dialed your number, then the problem is in the phone company line.

Be careful when conducting this test not to touch the phone wires. The ac voltage is nearly equal to that of a wall outlet and you can receive a serious electrical shock.

Figure 5-5. Measuring Ringing Voltage

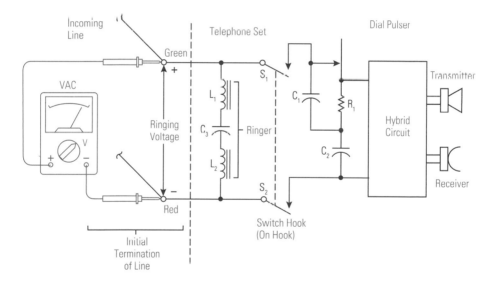

OPERATION OF A BJT CIRCUIT

NORMAL OPERATION

Figure 5-6 shows a typical circuit that uses a BJT (bipolar junction transistor) as the active device in an amplifier circuit. In this case, the BJT is an NPN transistor. Certain conditions must be met in order to make the transistor circuit operate properly. The base and emitter junction must be forward biased in order for the transistor to be turned on and conduct current. If the base and emitter junction is reverse biased (lack of forward bias) the transistor will be turned off and will not conduct current.

Figure 5-6. Transistor Amplifier for Normal Operation

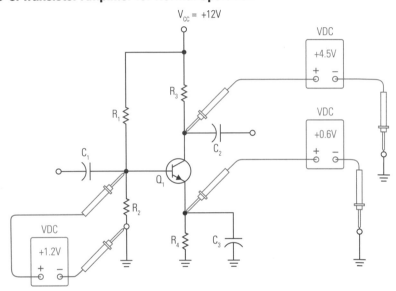

The letters NPN and PNP that identify the type of transistor used tell us much of what we need to know about the voltages in the circuit for normal operation. For example, the center letter (P in NPN) means that the base must be positive with respect to the emitter in order to forward-bias it. P must be positive and N negative to forward bias a PN junction. This letter also tells the polarity of the power supply applied to the collector in a BJT amplifier circuit, since the collector-to-base junction must be reverse biased. If the transistor is an NPN, a positive voltage is applied to the collector compared to the base and vice versa for a PNP. As the base voltage of an NPN transistor is increased with respect to the emitter, the base current increases, which increases the collector current. As the base-to-emitter voltage is decreased, the less the transistor conducts, until it stops completely. A conducting transistor normally has a high resistance between collector and emitter until it is driven into the saturation region (the region where the collector is only a few tenths of a volt away from the base). In a saturated transistor, the resistance is low, and an increase in base bias (forward) results in no further increase in collector current. A saturated transistor may be considered near a dead short. Conversely, a cutoff transistor (one that has no collector current except leakage current) is a very high resistance, near an open circuit.

MEASURING VOLTAGES

An easy way to evaluate whether a transistor is operating properly in a circuit such as the one shown in *Figure 5-6* is to measure the voltages at the collector, base and emitter while

the transistor is in the circuit. *Figure 5-6* gives typical voltage values when measuring the voltage from ground to the respective transistor element of an NPN BJT.

The voltages could have been measured between the transistor electrodes – that is, from element to element – but the most common way, and the way most voltage values are given in service manuals and on schematics, is to have ground as a common reference, as shown in *Figure 5-6*. Ground usually is the chassis into which the circuit is mounted, and very normally one terminal of the power supply.

• Junction Voltages

Silicon transistors normally have a difference of 0.6 to 0.8 volts between the emitter and base with the polarities depending on the type of transistor (NPN or PNP). As mentioned previously, the voltage between emitter and base will be in the direction to forward bias the junction; that is, positive on P material and negative on N material. The collector-base junction is reverse biased, positive on the N and negative on the P. If the transistor amplifier happened to be made with a germanium transistor, the emitter-to-base voltage would be 0.2 to 0.3 volts. The types and polarities are the same as silicon.

• Steady-State No Signal Voltages

Voltages given in *Figure 5-6* are the steady-state, no-signal bias voltages. The transistor amplifier usually will be operated Class A, which means that the signal will increase or decrease the current in the transistor from that due to the no-signal bias voltages. Little change will occur in the emitter-to-base voltages, but large changes can occur in the collector-to-base (or collector-to-ground) voltage due to the voltage drop in the load resistor, R_3, caused by the signal current change. The amount of shift is an indication of the amplifier's gain.

PARALLEL RESISTANCE CHECK

One of the simplest tests to determine that the transistor is operating properly in the circuit is to place a resistor, R_X, equal in value to R_1 across R_1 (in parallel) in the circuit. As shown

Figure 5-7. Increasing Transistor Current by Paralleling R_1

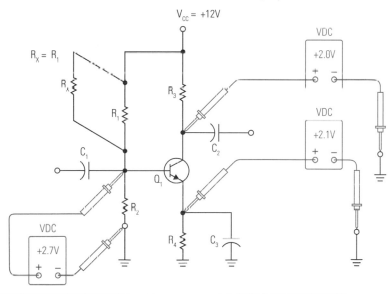

in *Figure 5-7*, if the voltages are measured at the base, emitter, and collector with respect to ground, we see that the voltages at the base and emitter are increased over what they were in *Figure 5-6*, indicating an increased base current. The collector voltage is decreased due to the increased voltage drop across R_3 due to the increased collector current resulting from the increased base current. The emitter current and voltage has increased due to the increased base current and increased collector current.

MEASURING CURRENT GAIN

Transistors basically are current amplifying devices. The small-signal current gain is the gain that is active in producing the amplification in Class A small-signal amplifiers like that shown in *Figure 5-6*. Even though the small-signal current gain and the dc current gain are not directly correlated, the dc current gain can be used as an indicator of the relative small-signal current gain available from a transistor. To measure the dc current gain, the base current and collector current can be measured as shown in *Figure 5-8*, and the dc current gain, h_{FE}, commonly called "Beta," can be calculated.

The common problem with *Figure 5-8* is that circuit leads must be broken to insert the current meters. To avoid breaking the circuit, voltage measurements can be made across resistors as shown in *Figure 5-9* and, by using Ohm's Law, the current through the resistors can be calculated. For example:

$$I_1 = \frac{V_1}{R_1} \qquad I_2 = \frac{V_2}{R_2} \qquad I_3 = \frac{V_3}{R_3} \qquad I_4 = \frac{V_4}{R_4}$$

The collector current is I_3, the emitter current is I_4, and the base current, I_B, is

$$I_B = I_1 - I_2$$

Therefore, h_{FE} or Beta can be calculated using

$$h_{FE} = \frac{I_C}{I_B} = \frac{I_3}{I_1 - I_2}$$

Figure 5-8. Measuring Collector Current and Base Current to Calculate Current Gain

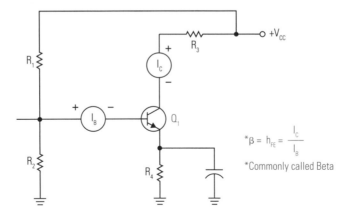

$$*\beta = h_{FE} = \frac{I_C}{I_B}$$

*Commonly called Beta

Figure 5-9. Using Voltage Measurements to Calculate Currents

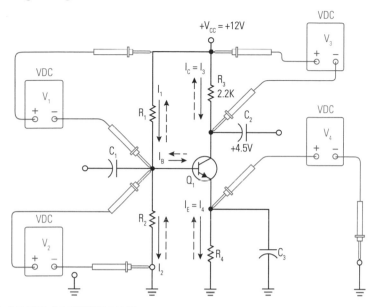

DEFECTIVE TRANSISTORS

OPEN JUNCTIONS

If the transistor becomes defective, the most common faults are for a transistor junction to either breakdown because of over-voltage and short out, or to burn out because of excessive current and open. If a junction opens, the transistor will no longer draw current. The most obvious measurement to detect this condition is a measurement of the collector voltage. If

Figure 5-10. Shorting Base-to-Emitter to Turn the Transistor Off

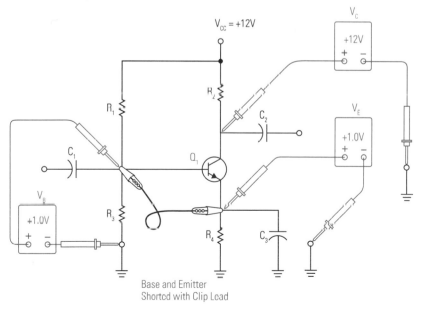

the collector does not draw current, the collector voltage will be very near to the supply voltage. This voltage will be considerably higher than the normal no-signal steady-state operating voltage shown in *Figure 5-6*. There may not be a great deal of difference in the base voltage if the base-emitter junction opens because its voltage is commonly set by the bias resistor network of R_1 and R_2, and will not change much if the small current into the base is stopped.

SHORTED JUNCTIONS

If a junction is shorted, more than normal current is likely to flow and operating voltages will be affected accordingly. Suppose the collector-to-base junction is shorted. Now the collector voltage is likely to be much lower than normal because the current is controlled by the short circuit and not by the transistor. In addition, the base voltage is likely to be much different because of the loss of isolation of the collector junction.

If the emitter-to-base junction is shorted, the transistor action will stop. As a result, the collector voltage should be very close to the supply voltage, emitter voltage will be the same as base voltage, and the transistor is disabled. This case is shown in *Figure 5-10*, where a physical short has been placed across base and emitter with a clip lead. The voltage measurements are shown.

DEFECTIVE RESISTORS

OPEN R_1

Even though it is quite rare, let's demonstrate how BJT circuits can be analyzed considering the effect of certain resistor failures – that is, particular resistors opening or shorting. What would happen if R_1 of *Figure 5-6* were to open? The voltages that result are shown in *Figure 5-11*. The no-signal steady-state condition of the transistor is not forward-biased and the collector is at the supply voltage. If a resistor doesn't have current through it, there will not be a voltage drop across it. The output signal, if any, would be grossly distorted. It would only be negatively going. Any negatively-going portion of the input signal would be clipped off because any signal present would be capacitively coupled to the base.

Figure 5-11. Voltages Resulting from an Open R_1

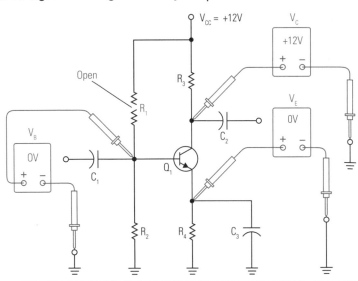

SHORTED R₁

What would happen if R_1 were shorted? A short across R_1 puts a very-high forward-bias voltage on the base. The resistance of R_3 and R_4 in series is the only limit to collector current. The base-emitter current is limited only by R_4. It is likely that the transistor will be destroyed. The initial voltages are shown in *Figure 5-12*. Note that the collector and emitter voltages are the same. The transistor is said to be in saturation.

Figure 5-12. Voltages Resulting from a Short Across R₁; Q₁ is in Saturation

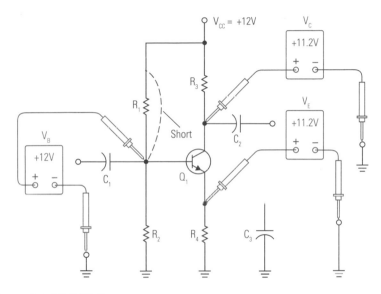

OPEN AND SHORTED R₂

An open R_2 produces an increase in current similar to that discussed above for R_1 shorted. Since the current through R_2 is now zero, there is less current through R_1. The voltage drop across R_1 is much less and the base voltage is much greater. In fact, the base current rises to a value that completely turns on, or saturates, the transistor. Its collector voltage will be only about 0.1 volts above the emitter voltage and it cannot amplify signals. A short across R_2 is very similar to the condition shown in *Figure 5-10*, except the base and emitter voltages are zero.

OPEN R₃

Now consider R_3. If this load resistor is open as shown in *Figure 5-13*, the collector current is zero. Any emitter current must now be supplied by the base. The base-emitter junction acts like a forward-biased diode, which places R_4 in parallel with R_2. Since R_4 is a small value of resistance, the emitter voltage falls to a very low value. As can be expected, the base voltage will be its normal 0.6 to 0.8 volts above the emitter voltage.

It might be assumed that the collector voltage would read zero since the load resistor is open. However, when a voltmeter is connected, it presents a high resistance path from the collector to ground. The collector-base junction acts like a forward-biased diode allowing a small current through the meter. Note the voltage from base-to-collector is $0.75 - 0.1 = 0.65$ volts in the forward-bias direction.

Figure 5-13. Voltage Resulting from Open Load Resistor R₃

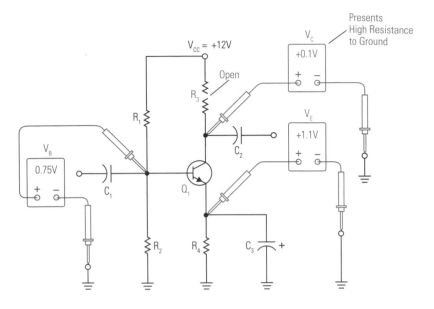

OPEN R₄

Figure 5-14 shows the voltage values that result when R₄ opens. Since all transistor current is through the emitter lead, with an open circuit between the emitter and ground, there is no current through the transistor. The collector voltage rises to V꜀꜀ because of no voltage drop across R₃. The voltage at the base is a result of the voltage divider R₁ and R₂, and, because the base current is relatively insignificant, it remains almost unchanged. The voltage at the emitter depends on the resistance of the voltmeter used to measure it. When it is connected, a small emitter current exists because the meter's resistance replaces R₄. Therefore, the voltage at the emitter is slightly higher than normal. If the voltmeter measuring emitter voltage is left in place, and the collector voltage measured, the collector voltage will be lower than +12 volts because some small collector current will flow due to the completed emitter circuit.

SHORTED R₄

A shorted R₄ is equivalent to a shorted C₃ since they are in parallel. Because capacitor shorts are common (resistor shorts are rare), this condition is more likely to occur than any we have discussed. The emitter voltage reads zero. The transistor, heavily forward-biased, saturates and passes a current limited by V꜀꜀ divided by R₃. This normally prevents the transistor from being damaged. The base voltage will be clamped 0.7 volts above the emitter and the collector will measure 0.1 volts above the emitter. This is the approximate saturation voltage of a silicon transistor.

The function of C₃ is to provide an ac signal bypass across or around the bias stabilization resistor R₄. If C₃ is open, an ac signal voltage will appear across R₄ introducing negative feedback into the amplifier circuit. The gain of the stage will be reduced by a value close to the ratio of R₃/R₄. The dc voltages will remain unchanged. A quick check is to shunt (parallel) the bypass capacitor C₃ with a known good capacitor of the same value. *CAUTION:* Shut off the power before connecting the shunt capacitor to prevent a large surge current from damaging Q₁. Then reapply power.

Figure 5-14. Voltages Resulting from an Open Emitter Resistor R_4

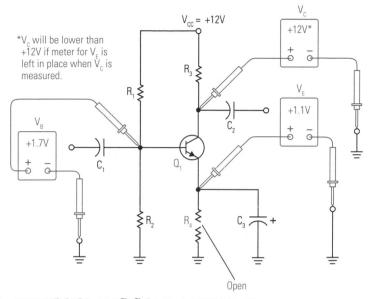

*V_C will be lower than +12V if meter for V_E is left in place when V_C is measured.

A FIELD-EFFECT TRANSISTOR AMPLIFIER

An operating FET amplifier is shown in *Figure 5-15*. The normal operating no-signal steady-state voltages are shown. Although the functions of the capacitors in the FET amplifier circuit are similar to those in the BJT amplifier circuit, the results of failure are not necessarily the same. The values of capacitance are much smaller due to the higher impedances in the FET circuit. In the case where C_1 shorts in the FET circuit of *Figure 5-15*, the voltage from the preceding stage will be coupled to the gate and will increase current

Figure 5-15. A Typical FET Amplifier Circuit

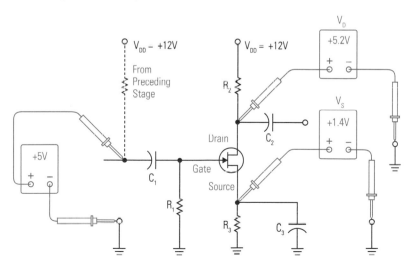

through the FET. In some cases C_1 will only be leaky and not be shorted. Any voltmeter reading above zero at the gate indicates a leaky C_1. With a leaky C_1, only a small portion of the voltage coupled from the previous stage will appear on the gate, but the effect is the same. A leaky C_1 reduces the reverse bias on the gate causing the drain current to increase, which will cause the drain voltage to be lower than the steady-state value and restrict the signal swing.

TYPICAL AMPLIFIER IN A RADIO OR TV

Figure 5-16 shows a transistor amplifier circuit that might be designed into a television or radio receiver. Note that although the power supply voltages within the system are quite a bit higher than those in the previous circuits, resistor divider circuits are used to step down the supply voltage for the circuit to the normal static voltages used in the previous circuits. R_8 may or may not be present.

Figure 5-16. A Typical Amplifier in a TV or Radio Receiver

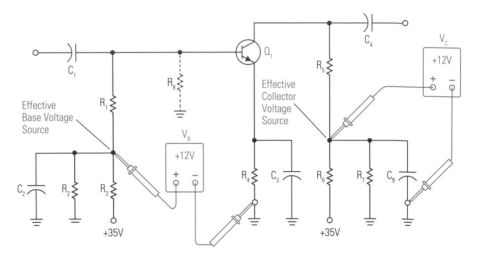

GROUND REFERENCE AND CIRCUIT CONFIGURATION

Sometimes circuits are drawn or wired so that they look different from *Figure 5-6*. However, as far as the transistor is concerned, the operating conditions are the same.

Look at *Figure 5-17* and compare it to *Figure 5-6*. Because the positive power supply terminal is at ground, the top base-bias resistor and collector load resistors are returned to ground also. The emitter resistor, R_4, and the bottom base bias resistor, R_2, are connected to the negative supply terminal. It is important to realize that the transistor bias voltages between its elements are identical in the two figures and that is what matters. If the positive supply terminal is used as a reference, the voltages will be negative. If the negative supply terminal is used as a reference, the voltages will be positive.

It is a matter of personal preference of some technicians to measure the voltage between elements of transistors directly. This is the fastest and least confusing method of establishing whether the bias on a transistor is correct. The method of specifying transistor voltages on schematics and in service manuals is from each element to a common or ground. The technician must then take the voltage measurement at each element to ground and subtract to find the bias voltage (the difference in voltage between the elements). For example, the

Figure 5-17. Transistor Amplifier State with Positive Ground Power Supply

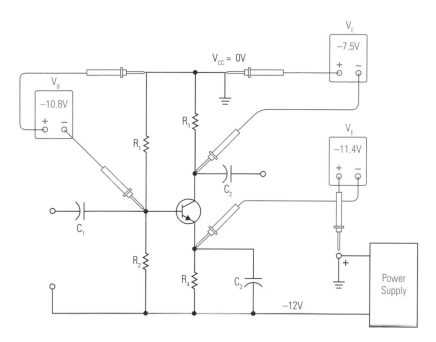

voltage on the base of the transistor in *Figure 5-17* is -10.8 volts from ground. The voltage on the emitter is -11.4 volts. The base-emitter voltage is +0.6 volts, the difference between -10.8 volts and -11.4 volts. The base voltage is more positive than the emitter voltage.

With this chapter, we have completed the individual component measurements and the measurement of components in circuits. In the next chapter, we will look at common types of measurements that normally are made around the home.

6

Home Appliance Measurements

OBJECTIVE

Home appliances used to be very simple. The circuit usually was made up of a plug for the household wall outlet, the electrical cord, a switch, and a load. Most likely, the load was a motor, a lamp, or a heating element. Today, however, the circuit for even small, inexpensive appliances may be more than simple. Often the home appliance, such as a coffee maker or vacuum cleaner, will have a microcomputer in it. The microcomputer, or microprocessor, has assumed an important role in the appliance industry. They are being used as an integral part of many electronic controls for timing, sequencing, and controlling events. As a result, testing is likely to be more complex. Yet, there are many things that can be tested, so that troubleshooting and repair of most appliances is still possible in the components individually and in circuits.

We now will illustrate various uses of a multitester by discussing common measurements that you can make on several home appliances to verify proper electrical circuit operation, identify a circuit problem if there is one, and correct or repair any improper operation. We will go through several multitester applications in detail to indicate the procedure. Other applications will not include as much detail, but with schematics and our explanation of the circuit performance you should be able to use similar procedures to check the circuit performance.

At first glance, a schematic diagram of an appliance circuit seems complicated and confusing. It presents many paths for current and many more components than the simple circuit schematics that we have used up to now. The circuit may be a series circuit or a parallel circuit, but in many cases it will be combinations of both series and parallel circuits. The schematic is a "roadmap" of the circuit and shows the wires, fuses, switches, and current-using devices and their interconnection to form the various paths for current. The schematic actually consists of a number of simple circuits, each with a specific function, combined into the total circuit. To begin to understand such circuits and how to measure them, let's use a common heating and air conditioning system.

HEATING & AIR CONDITIONING

A heating and/or air conditioning system is found in every home. In many older homes, the furnace system to provide heat is separate from a system to provide cooling. However, most newer homes are built with systems that contains both heating and air conditioning. We will use such a central, forced-air system as our example. Heating is provided by burning natural gas or electric heating elements and blowing air through a heat exchanger. Air conditioning is provided by an electrically-powered refrigeration system with the compressor and condenser outside the house and the evaporator inside the house on the output side of the furnace plenum. The furnace fan/blower is used to distribute both the hot or cold air throughout the house.

ELECTRICAL CIRCUIT

Figure 6-1 shows a schematic wiring diagram of a typical central heating and air conditioning system. The thermostat has two switches. SW1 controls the system function – COOL-OFF-HEAT – and SW2 controls the fan/blower function – AUTO-ON. In the ON position, SW2 causes the fan/blower to run continuously regardless of the setting of SW1. In the AUTO position, SW2 allows the system to control when the fan/blower is on.

When the system switch or the fan/blower switch is in the set position indicated by the legend shown in *Figure 6-1*, the contacts are shorted together. FR is a relay that controls the fan/blower motor through contacts FR_1 and FR_2. When these contacts are closed, 115VAC is applied to the fan/blower to cause it to run. CR is a relay that controls the operation of the compressor through contacts CR_1 and CR_2. When these contacts are closed, 220 VAC is applied to the compressor motor and the compressor fan motor to cause them to run.

Notice that the control system uses the relatively low and much safer 24VAC that is supplied by the step-down transformer, TR_1, from the 110-120VAC line. The 24VAC from TR_1 supplies power to the fan/blower relay, the compressor control relay, and the gas control valve. The latter allows gas to flow into the combustion chamber when heat is required. A gas pilot light – or an electric coil – ignites the gas in the combustion chamber. (In *Figure 6-1*, a heater relay, HR_1, also is shown which controls 220VAC electric heater elements. A real system would have either the gas control valve or the electric heaters. It is not likely to have both.)

GENERAL PROBLEMS

Normally, when there is an electrical problem with an appliance, only one component is not functioning as it should. For example, common problems with the heating and air condition system might be: the fan/blower fails to come on; or the fan/blower runs but the unit is not producing heat or cool air. Assuming the problem is electrical, our job is to find out which of the electrical devices – fan/blower motor, relay, heating element, compressor motor – is not functioning. By looking at the schematic and observing system operation as available controls are changed, you should try to determine which component is not working properly, and the circuit that must be complete to operate the non-functioning device. With the help of the schematic, you should be able to quickly determine which wires and components could be causing the problem. Then you can physically locate the component and trace the circuit that must be completed to supply current to the component. Finally, using your multitester as a voltmeter, ammeter, or ohmmeter, as required, you can determine the cause of the problem.

For example, if the compressor doesn't run or the electric heating element doesn't heat, a simple continuity check will indicate if the compressor or heating element is open. *However, before using your multitester as an ohmmeter, all power must be removed from the circuit.* Turn all main power switches for the heater and air conditioner on your home distribution panel to OFF before making any ohmmeter measurements. Extreme caution should be taken because the power source is 220VAC. Some furnaces also have a power cord plugged into an outlet in the furnace compartment, which also must be unplugged. Before making a continuity check, check with a voltmeter to make sure no voltage is present across the contacts to be measured. Find the CR or HR and make the measurement at the contacts as shown in *Figure 6-1*. No continuity indicates that the windings of the compressor or heater element, respectively, are open.

ISOLATING THE PROBLEM

Most of the problems with the heating or air conditioning system will be in the low-voltage control circuits. Rarely do they relays go out, unless their contacts are burned due to a short

Figure 6-1. Schematic Wiring Diagram of a Typical Central Heating and Air Conditioning System

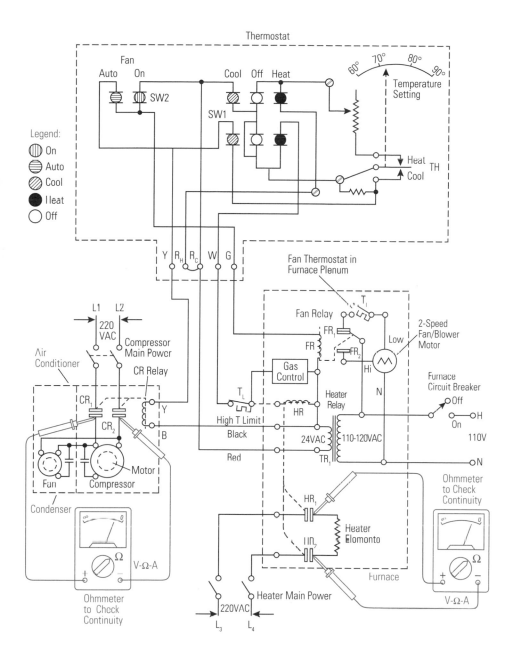

in the motor, compressor, or heating element. The best way to find a problem if the heater or air conditioner does not work is to isolate the system operation into the respective heating and air conditioning functions.

HEAT CYCLE

Figure 6-2 shows the schematic of *Figure 6-1* when in the heating mode. Only the circuitry associated with the heating function is shown. The system function switch is in the HEAT position and the fan/blower switch is in the AUTO position. If the system is operating properly, the thermostat contacts TH_H would be closed because the thermostat was turned up to a temperature higher than the temperature of the space to be heated, thus demanding heat. Closing TH_H energizes the gas control (or the heater relay) turning on the gas flow, which burns and generates heat. When the inside of the furnace plenum reaches the temperature set by the fan/blower thermostat T_F, T_F closes and energizes the fan/blower motor, which delivers heated air to the space to be heated. If the temperature inside the furnace ever exceeds the temperature set by the temperature limit switch, T_L, T_L will open and disconnect the power from the gas control to shut off the gas.

Figure 6-2. Heat Cycle

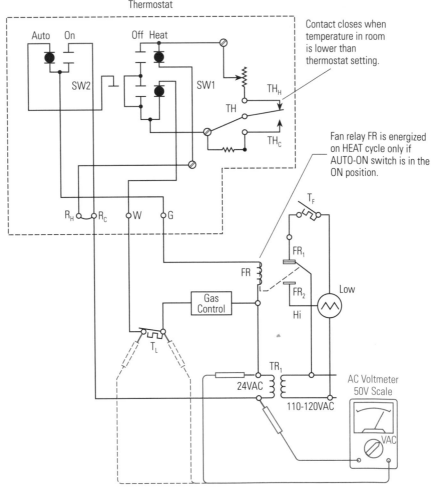

Of course, for a gas furnace the pilot light (if it has one) must be lit to heat the thermocouple, and the thermocouple must be delivering its control voltage (in the millivolt range) before the gas control valve will turn on and allow gas to flow. So, if the furnace is not heating, be sure that the pilot light is lit. If all other control functions seem to be working properly, then the thermocouple may be defective and must be replaced.

If the pilot light is on and the furnace does not come on when the thermostat is turned up, follow these steps:

1. Remove the panel from the furnace and the cover from the thermostat.
2. Measure the voltage across the secondary of TR_1, the 24VAC low-voltage control transformer, as shown in *Figure 6-2*. If there is no voltage at the secondary, measure the 110-120VAC at the primary. If there is no primary voltage, check the furnace circuit breaker at the power panel. If there is primary voltage and no secondary voltage, turn off the power and measure the continuity of the secondary to make sure it is not burned out.
3. If 24VAC is present, manually operate TH so that TH_H closes and determine if gas flows and the furnace flame comes on. If gas does not come on, switch SW_1 from OFF to HEAT several times to determine if the switch contacts may be corroded and not completing the circuit correctly. Turn off all power and burnish the contacts with a contact burnishing tool.
4. Another common problem is that the temperature limit thermostat, T_L, is defective. AC voltage measurements around the loop as shown in *Figure 6-2* should isolate the problem.

The same procedure can be used to isolate a problem in the fan/blower circuit. However, a first easy check of the fan/blower circuit is to set the fan/blower switch to ON, which will make the fan/blower relay, FR, operate and make the fan/blower run continuously. If the fan/blower does not run, operate the switch several times. If this does not correct the problem, make ac voltage measurements around the circuit to isolate the problem. 24VAC is much safer to work around, but you should still observe caution; be especially careful that your test leads or tools do not short across the 24VAC source and cause physical damage to the wiring.

The FR relay will make a noise when it operates. If it operates when the fan/blower switch is set to ON but the fan/blower doesn't come on, then there may be problems with the contacts FR_1 and FR_2 on *Figure 6-1*, or the fan/blower motor may be defective.

COOL CYCLE

Figure 6-3 shows the schematic when the system function switch is set to COOL and the fan/blower switch is set to AUTO. The temperature in the space to be cooled is higher than the thermostat setting, thus TH_C is closed to demand cooling. When TH_C closes, it completes the circuit to supply 24VAC to the compressor control relay, CR. The compressor runs and supplies coolant to the evaporator mounted in the air flow path in the furnace.

At the same time the TH_C completes the circuit for CR, it also completes the circuit to supply power to the fan/blower relay, FR, through the fan/blower switch, SW_2, which is set to the AUTO position. This turns on the fan/blower motor and the room air is forced through the evaporator coils to supply cool air to the space to be cooled.

ISOLATING A PROBLEM

Obviously, if the air conditioning system is not cooling, may problems could be present besides the electrical circuit; therefore, a qualified air conditioning repair technician must be called to isolate the problem. However, several simple checks will determine that the electrical circuit is operating properly.

Figure 6-3. Cool Cycle

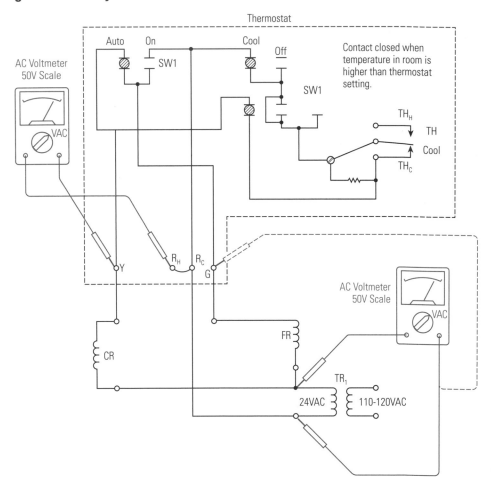

FAN/BLOWER MOTOR CIRCUIT

First of all, the fan/blower circuit can be checked easily by placing the fan/blower switch in the ON position. This should make the furnace fan/blower run continuously. As shown in *Figure 6-3*, moving the fan/blower switch to ON completes the circuit to supply 24VAC directly from the secondary of TR_1 to the fan/blower relay, FR. If the fan/blower does not come on, move the fan/blower switch from AUTO to ON several times; the contacts may be corroded and the movement may burnish them to make contact.

If the fan/blower still does not come on, remove the furnace panel and isolate FR and TR_1. First, measure the secondary ac voltage of TR_1 to assure that the transformer is operating properly and supplying 24 volts. Second, measure ac voltages around the circuit as shown in *Figure 6-3* to isolate the problem. The FR relay will make a noise when it operates. If it operates when the fan/blower switch is turned ON but the fan/blower doesn't come on, then there may be problems with the contacts FR_1 and FR_2 of *Figure 6-1*, or the fan/blower motor may be defective. *With all furnace and air conditioner power turned off (circuit breakers off at the power panel),* use your multitester as an ohmmeter for continuity checks to isolate the problem.

COMPRESSOR CIRCUIT

From *Figure 6-3*, we see that the compressor control relay, CR, receives its 24VAC supply through a circuit that is completed through the contacts of SW_1 when the switch is in the COOL position. CR is located in the housing for the compressor and air conditioning condenser that is mounted outside the house or building to be cooled. If the temperature in the room is higher than the thermostat setting, TH_C should be closed and CR should operate when SW_1 is placed in the COOL position. A person located near the condenser can hear CR operate when SW_1 is placed in the COOL position. The compressor should turn on when CR operates. If CR is operating and the compressor turns on, and the fan/blower motor turns on, but the unit still does not cool, an air conditioning specialist should be called.

If CR does not operate, then check to determine that TR_1 is supplying 24VAC properly. An easy check of this is to remove the thermostat cover and measure the voltage at Y and R_C, R_H of *Figure 6-3*. When TH_C is open (no cooling – thermostat set higher than temperature in the room) then the voltage across Y and R_C, R_H should be 24VAC. When TH_C is closed, the voltage should be zero volts. Just with these simple checks you can determine if the electrical circuits are operating properly.

If CR operates but the compressor does not come on, the contacts CR_1 and CR_2 may be bad or the compressor may be defective. Call and air conditioning specialist if the problem is isolated to this point. CAUTION: *If CR is operating properly and the compressor comes on, do not cycle the compressor off and on rapidly. Doing so may burn out the compressor.*

USING A TEMPERATURE PROBE

Some multimeters can be used to measure temperature directly with a temperature probe connected in place of the test leads. Some multitesters read temperature in degrees Fahrenheit (°F); others in degrees Centigrade (°C). Some have both °F and °C. A multitester reading temperature is really functioning as an ohmmeter. Therefore, if an analog multitester is used, with the FUNCTION/RANGE selector switch set to the TEMP function and test leads plugged in the -COM and +(V-Ω-A) jacks, the test leads are shorted together and the meter zeroed with the OHMS ADJUST control before the temperature probe is plugged in. For the DMM shown in *Figure 6-4*, this is not necessary. Just set the DMM function on TEMP and plug in the temperature probe. Place the temperature probe directly in contact with the surface to be measured for temperature or let it be exposed to the

atmosphere being measured. The temperature can be read directly from the digital display or the analog temperature scale.

Figure 6-4. Measuring Temperature Directly with Temperature Probe

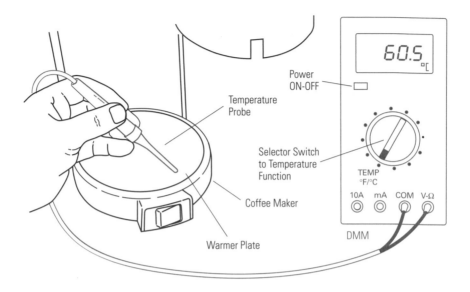

WASHER & DRYER CIRCUITS

We will not go into detail with respect to locating and isolating problems with clothes washer and dryer electrical circuits. We will just present the circuit and a short description of the circuit operation and expect that, after the above examples and the material in the preceding chapters, you will be able to follow measurement procedures for continuity, voltage, current and resistance to isolate any problems. To that end, the following are some overall guidelines.

TROUBLESHOOTING THE ELECTRICAL SYSTEM

In almost all cases, troubleshooting the electrical section of a system is straightforward and usually simple. Always apply basic rules of electrical theory when testing any circuit. *Remember, if theory and practice do not agree, it means either incorrect theory or incorrect practice!*

The first step in troubleshooting any circuit is to have a clear understanding of the circuit and its function before starting. If you do not understand how a circuit functions when there is no problem, it is almost impossible to troubleshoot the circuit when there is a problem because you may not know what you are looking for. This does not mean you must have a total understanding of the circuit, but it does mean that you must have a general overall knowledge of the circuit's function.

The next step is to eliminate the obvious, no matter how simple it may seem. This includes first checking the fuses, circuit breakers, and overload resets. If careful observation does not yield recognition of an out-of-the-ordinary condition, then the problem must be isolated to the control circuit, power circuit, load, or incoming power. Each of these areas, although connected and related, can be isolate from all the others to make troubleshooting easier.

The following is a step-by-step procedure:

1. Eliminate the incoming power supply as the source of problems by measuring the 220VAC or 115VAC that is the main supply. One of the most common troubles found in all electrical circuits is a blown fuse or tripped circuit breaker. *Be very careful not to touch any metal parts of the test leads when testing line loads – you cold receive a serious shock.*

2 . Usually, the control circuit of most systems is at a low voltage – 24VAC is common. Isolate it and measure it to make sure it is operating properly. By measuring voltages around a circuit loop, the presence of the 24VAC can be used to indicate continuity through a particular branch of the control circuit. A complete circuit will have current through the circuit components and the measured voltage will decrease as measurements are made from the source around the circuit. An open circuit will have the same voltage reading at each component.

3. Electric drive motors, fan/blower motors, and heaters are common electrical loads. Electric motors are essentially reliable machines and require little maintenance in comparison to the rest of the circuit. Check the voltage at the motor to see if it is the correct level; that is, if it matches the nameplate voltage within ±10%. If the voltage is correct at the motor, but it does not run, there may be an internal thermal switch in the motor that has become defective or is open because the motor is hot. One common problem for motors is worn-out brushes. Check the brushes and make sure they are okay.

4. The current that the motor draws from the supply is a good indication of its condition, and here is a good place to make use of the clamp-on ammeters described in Chapter 3. Remember that the clamp must be around **only one** of the motor leads to measure the current. Connecting around two leads causes the magnetic field of one lead to cancel the magnetic field of the other. *Figure 6-5* shows the proper use of a clamp-on ammeter probe to measure the current of a simple motor using just one wire at a time.

5. The electrical loads are controlled through relays that are controlled by the low-voltage circuit. Even though low voltage is present and the relay is operating, it does not mean that the contacts themselves are not defective. A closed contact should have almost zero volts across it. A defective "closed" contact will actually be open and have line voltage across it.

Figure 6-5. Measuring Motor AC Current with Clamp-on AC Ammeter

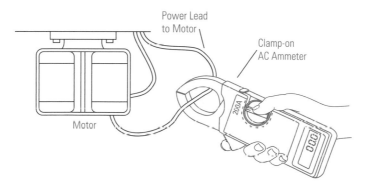

Figure 6-6. Typical Automatic Washer Wiring Diagram

(Courtesy of Sears, Roebuck and Co.)

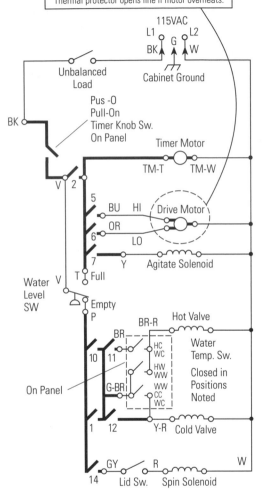

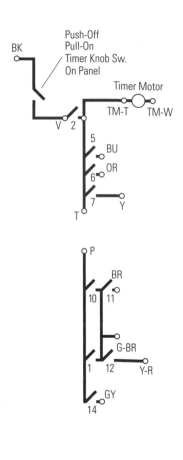

TYPICAL DRIVE MOTOR

Has start winding with start capacitors.
Centrifugal switch disconnects start winding
when motor is up to speed.
Thermal protector opens line if motor overheats.

WATER TEMP. SW.

Symbol	Wash	Rinse
HC	Hot	Cold
WC	Warm	Cold
CC	Cold	Cold
HW	Hot	Warm
WW	Warm	Warm

Symbol beside switch means switch is closed
for the wash/rinse condition designated.

a. Typical Complete Wiring Diagram

Small circles indicate terminals.
Bold lines indicate circuitry is on timer.
Numbers near switches designate
switches number
The number does not appear on timer
or other switches.
GY G-BK BR and etc. indicate
insulation color of wire connected to
terminal.

b. Typical Timer Wiring Diagram

WASHING MACHINE ELECTRICAL SYSTEM

THE ELECTRICAL CIRCUIT

One of the biggest stumbling blocks encountered when servicing an appliance is the variety of wiring diagrams one can encounter or – even worse – the lack of a diagram at all. Each manufacturer has its own idea of a wiring diagram. Once you have interpreted the diagram and/or the sequence chart, the appliance will be much easier to troubleshoot. *Figure 6-6* shows a typical wiring diagram for a washer. *Figure 6-6a* indicates the typical complete diagram as it would appear on the back of a washer. *Figure 6-6b* indicates the circuitry contained on the timer. We have added notes to *Figure 6-6* to help in the understanding of the diagrams. Many of these notes would not appear on a typical diagram on the back of a washer. You have to know what is to happen and when it is to happen before you can tell if there is anything wrong. The sequence of events is controlled by a timer.

TIMERS

The timer in an appliance may be thought of as the "brain" of the machine because it controls the sequence of operation. As shown in *Figure 6-7*, it generally consists of three basic components assembled into one unit:

1. the timer motor,
2. the escapement, and
3. the cam switchbox.

The motor is similar to that used in an electric clock. It is geared down to a small pinion gear that drives the escapement, which drives cams in the cam switchbox to close numbered switches in a timed sequence. Obviously, if the timer motor is defective, only the motor should be replaced, not the entire timer. The purpose of the escapement is to rotate the cam shaft in a series of timed pulses. It is not generally serviceable and a problem here normally requires replacement. The cams in a timer open and close the electrical switch contacts, thereby controlling the sequence of operations. If contacts are suspected, disconnect power and measure across the contacts with a multitester used as an ohmmeter. Burnish the contacts with a contact burnishing tool if they are corroded.

A cycle-sequence chart, shown in *Figure 6-8*, tells when a circuit is active, and also at what time in a cycle a particular function is in progress. Be aware that there are delay times between the steps.

Figure 6-7. Typical Appliance Impulse Timer
(Courtesy of Sears, Roebuck and Co.)

Figure 6-8. Automatic Washer Timer Sequence Chart
(Courtesy of Sears, Roebuck and Co.)

TIMER SWITCH NUMBERS correspond to the numbered switch symbols on the schematic.

FUNCTION or circuit controlled by each switch is shown in the column beneath the switch number.

TIMER TERMINAL designation and the color of the wire attached to that terminal is shown for each switch.

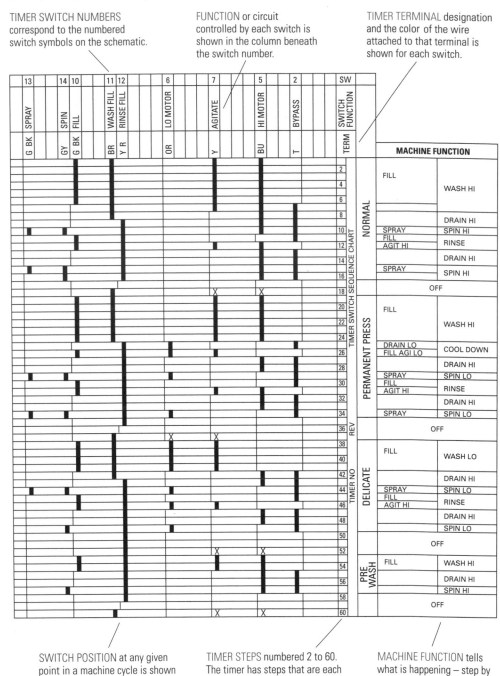

SWITCH POSITION at any given point in a machine cycle is shown in a column beneath the awitch number. black bar indicates that

TIMER STEPS numbered 2 to 60. The timer has steps that are each 120 seconds long – the timer will remain stationary for two minutes

MACHINE FUNCTION tells what is happening – step by step – as the timer advances through the selected cycle.

SAFETY SWITCHES

There are switches designed to provide safer operation of the machine but, if they become defective, they may prevent proper operation. An example is the switch that stops the spin action when the door is opened, such as the one designated as Lid Sw in *Figure 6-6*. Many machines have a switch that opens the line when an unbalanced load is detected. Thermal switches are put in motors to protect them if they overheat. Many machines have variable water level switches, which are common suspects for open circuits. The water temperature switches on the front panel are not as likely to become defective.

TROUBLESHOOTING

With the aid of *Figures 6-6* and *6-8*, you can tell if voltage is to be applied to the timer and drive motors, agitate or spin solenoids, or the hot or cold water valves. If a component is suspected, unplug the machine's power cord and use an ohmmeter to trace the circuit for continuity and to locate accessible terminals where voltages can be measured. Then, if further troubleshooting is needed, plug in the power cord and make appropriate measurements of the 115VAC to verify proper operation. There is no low voltage control voltage this circuit, so be very careful not to short out the 115VAC.

Here is an example: The washer is on the NORMAL cycle and there appears to be a problem with spinning. Looking a the chart in *Figure 6-8* shows that the normal spin cycle occurs at timer step 10. Moving across the chart at step 10 shows that switches 2, 5, 12, 13, and 14 should all be closed. You note that the drive motor is running properly, and that the rinse fill valve is working, but the tub is not spinning. You trace the connections to the terminal on switch 14 of the timer and measure 115VAC with your multitester. You locate the spin solenoid and find zero volts at the spin solenoid. You look for the lid switch and, in the process, discover that the lid switch has been broken out of its snap holders and is not being held closed by the lid. You snap the switch back in place, close the lid, and the spin problem is solved.

DRYERS

The electrical circuit of a clothes dryer is very similar to a washer in that it contains a timer motor, escapement, and a cam switchbox. However, the circuit is much simpler because basically there are only two functions being performed – rotating the drum and blowing hot air through the clothes for preset amounts of time to dry them. In an electric dryer, the heating element is a resistance wire which glows red hot when a voltage is applied. The voltage to the heating element is 220-240VAC. The drive motor to turn the drum that tumbles the clothes operates from 115VAC. This motor also drives a blower that moves air through the dryer and vents it outside the dryer. The circuit diagram is shown in *Figure 6-9*. This diagram would be the same form on the back of a dryer as the one shown in *Figure 6-6* for the washer. We have simplified and rearranged it into a schematic to make it easier to explain. To understand the operation, let's first look at the safety switches.

SAFETY FEATURES

If the drive motor is not turning the drum, there will be no power to the heating elements. The 220VAC circuit is held open by the centrifugal switch, C_{F2}, that is on the drum drive and blower motors. Both C_{F2} and C_{F1} close when the motor is at the correct speed. C_{T1} disconnects the start winding of the motor after it reaches the correct speed. It also closes the circuit to the buzzer at the cool-down thermostat.

The cool-down thermostat closes when the temperature inside the dryer rises to its operating temperature. It does not open again until the temperature cools below this temperature. An exhaust temperature thermostat is located in the exhaust port of the

Figure 6-9. Typical Automatic Dryer Schematic Diagram
(Courtesy of Whirlpool Corporation)

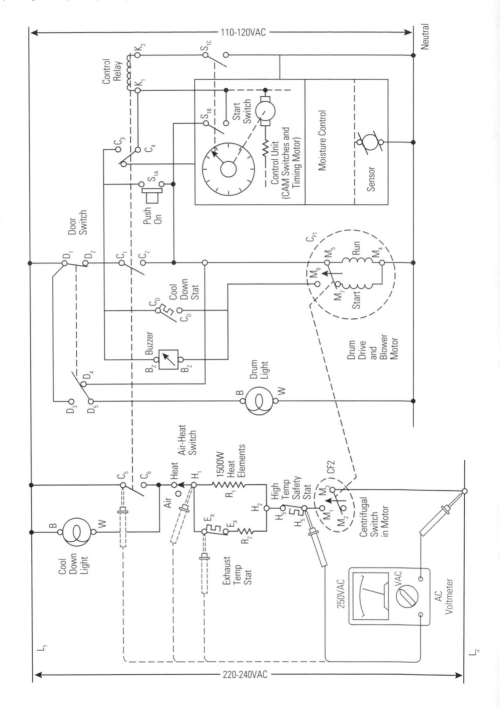

dryer. It is normally closed and will not open unless the exhaust temperature exceeds a given temperature that is pre-set by the manufacturer. As a double precaution against the dryer rising above a maximum temperature, there is a second safety switch in the heating element power circuit. It is a high-temperature safety thermostat that opens the circuit if the temperature rises above a maximum set by the thermostat. No power will be applied to the drive motor or the control relay circuits unless the door of the dryer is closed. The door switch closes contacts D_1 and D_2 to complete the power circuits. No power could be applied to the heating elements because the control relay would have no power and contacts C_5 and C_6 would be open. All of these switch positions and controls would be presented on a timing sequence diagram similar to *Figure 6-8* for the washer.

DRYER OPERATION

The start switches, S_{1B} and S_{1C}, are closed by setting the timing control on the control unit to the desired drying time or cycle. The power circuit to the control relay is completed by pressing the momentary push button S_{1A}, which energizes the control relay and closes contacts C_1 and C_2, C_3 and C_4, and C_5 and C_6. C_1 and C_2 complete the power circuit to the drive motor for the drum and blower, and C_3 and C_4 complete a holding circuit for the control relay so it will remain energized after S_{1A} is released. C_5 and C_6 complete the power circuit to the heating elements if the air-heat switch is in the HEAT position. No power will be applied to the heating elements if the air-heat switch is in the AIR position when only room-temperature air will circulate through the clothes.

When the timer times out, S_{1B} and S_{1C} are opened and the control relay is de-energized, which opens contacts C_1 and C_2, C_3 and C_4, and C_5 and C_6. Even though contacts C_1 and C_2 are open, the drive motor does not stop. The cool-down thermostat continues to complete the circuit until the temperature cools below the limit. The power circuit in this case is through the cool-down thermostat contacts C_1, and through the M_6 and M_5 contacts of the centrifugal switch in the motor.

Once the cool-down thermostat opens, power is disconnected from the motor. However, until the motor slows down, the M_6 and M_5 contacts remain closed to supply power momentarily to the buzzer that signals that drying is completed. Cool down is indicated by a light bulb that receives its power when C_5 and C_6 contacts of the control relay open. It remains on until the M_1 and M_3 centrifugal switch contacts in the heating circuit open when the drive motor stops.

The circuitry is straightforward with door safety switches, temperature sensitive switches that turn off the heating element if the temperature of the air over the clothes is too hot, and a centrifugal switch in series with the heating element that keeps the power circuit to the heating element open if the motor is not turning the drum. In other words, the motor that tumbles the clothes must be running before power is applied to the heater.

TROUBLESHOOTING A DRYER

A common problem with electric dryers is that the heating element burns out. With power off (disconnect the power cord from the wall outlet), check the continuity of the heating element with an ohmmeter. This can be done easily be removing the back panel. Check the schematic carefully to determine the proper interconnections.

If safety switches or thermostatic switches appear to be defective, voltage measurements across them should isolate any defective components. Usually if the switch is operating properly, 115VAC will be across its terminals if the switch is open, and zero volts if the switch is closed.

Analyze the timing sequence chart carefully when you find the dryer is not working properly. Identify the switches, relays, and motors that should be operating, and troubleshoot the problem in the same manner as demonstrated for the washer.

ELECTRICAL HEATING APPLIANCES

Coffee makers are common appliances found in most homes. A coffee maker has two functions – first, to heat water to brewing temperature, deliver the hot water over the ground coffee, and collect the brewed coffee in the carafe or glass pot; and second, to keep the coffee warm after it has been brewed.

A common circuit to accomplish these functions is shown in *Figure 6-10*. The operation is as follows: When S_1 is in the BREW position, 115VAC is applied to the heater through the thermal links, TL_1 and TL_2 and the thermostat, TH_1. The thermostat and thermal links sense the temperature of the water. TH_1 cycles to heat the water to brewing temperature. If all the water is boiled out and the BREW switch is left on, TL_1 and TL_2 become high resistances and restrict the current through the heater to protect the coffee maker from damage.

Once the coffee is brewed, S_1 is switched to the WARM position and 115VAC is applied to the warming coil to keep the brewed coffee warm. At the same time, power is removed from the heater circuit. In the OFF position of S_1, no power is used by the heater or the warmer. Indicator lights show the position of S_1.

Common problems that occur are open heater and warmer elements, burned out WARM and BREW indicator lights, and open TL_1 and TL_2 thermal links. All of these problems are easy to troubleshoot by using a multitester as an ohmmeter and checking for continuity.

Remove the plug from the 115VAC outlet. Place S_1 in the OFF position. Remove the back cover from the coffee maker to access the connections. Check continuity from pin 4 to pin 3 to establish that the WARM indicator is okay. Check continuity from pin 3 to pin 5 to establish that the warmer element is okay.

Figure 6-10. Common Coffee Maker Schematic Diagram

Place S_1 in the WARM position. Remove the connections for the heater element and then check across pins 1 and 2 to establish continuity of the BREW indicator. Check across the removed leads of the heater to establish continuity of the heater circuit. There is no need to check voltages in this case, but you can verify them if you wish before or after you locate the problem.

SUMMARY

In this chapter, we have looked at finding problems in home appliances. The examples given should provide measurement principles that can be applied to troubleshooting other types of appliances. In the next chapter, we will look at lighting and security systems.

7

Lighting & Related Systems Measurements

Thomas Edison invented the incandescent lamp – commonly called a light bulb – in 1879. By the early 1900s, electricity rapidly replaced natural gas as the preferred method of artificial illumination, at least in major metropolitan areas. It wasn't until the 1930s, with the advent of the Tennessee Valley Authority and other Depression-era public works efforts, that rural electrification became widespread. Today, it's hard to imagine our world without electricity, not only for lighting, but for the abundance of appliances and other devices that plug into the common electric outlet in our homes and offices.

You don't have to be an electrician, engineer, or have a license to install and/or test simple electrical power circuits. There are many simple measurements and repairs that you can make on your home electrical wiring system. In this chapter, we will look at the more common types of measurements used on home wiring, security systems, and more.

GENERAL PRECAUTIONS

By following the instructions in this chapter, you will be able to do a great deal of basic electrical work yourself and save expensive installation and repair bills. First, however, a word of caution concerning two things:

1. All wiring must be installed in accordance with the National Electrical Code and all local electrical codes.

2. *The voltage and power in household wiring circuits can KILL!*

To learn about the electrical code in your area, visit your local city electrician or building department. To reduce the risk of personal injury from electric shock, fully observe the following simple safety rules.

SAFETY FIRST

Always observe extreme caution when testing electrical circuits and devices around the home. The high voltages and currents that are present in your home wiring system are dangerous. If you are not careful, they can cause severe damage, injury, or death. Follow these precautions to assure your safety:

- Always be certain that the power has been turned off at the circuit breaker or fuse panel in any situation where you must come into contact with the circuit. Never work on a live circuit unless you are absolutely sure of what you are doing, then proceed with extreme caution. When the power is off, make sure that it cannot be inadvertently turned on by anyone else.

- Do not stand on damp ground or floors, never stand in water, and always wear dry shoes with rubber soles and heavy socks when working on electrical circuits.

- Even when the power is off, always try to handle wires by the insulation or with insulated pliers – avoid touching bare wires whenever possible.

- Use only well-designed and well-maintained tools and measuring instruments to test and repair electrical systems and equipment. Always hold the test probes of your multitester by their insulation. Never touch the metal probe tip while testing outlets or circuits.

HOME ELECTRICAL CIRCUITS

Unless your home was built before World War II and never updated, the electrical power feed to your home has three wires that come from the power company's line transformer. One of the wires is the common or neutral. The other two are "hot" and each has 110-120VAC with respect to the common line. The voltage across the two "hot" wires is 220-240VAC. The three wires come through the electric company's meter and connect to the main power panel in your home.

MAIN POWER PANEL

The main power panel usually is a large metal box containing a main power switch and circuit breakers (or, in older installations, fuses), as shown in *Figure 7-1*. Inside the main power panel, the main line from the electric meter is divided into a few 230VAC branch circuits, and many 115VAC branch circuits. Only one 230VAC and two 115VAC branch circuits are shown in *Figure 7-1* as examples. Each branch circuit is protected from overload by either a circuit breaker or a fuse that opens the circuit when there is too much current. Although a circuit breaker or a fuse does the same thing, a circuit breaker is better because it can be reset after being tripped. A "blown" fuse cannot be used again and must be replaced. The main line's common wire is connected to the ground bus in the main power panel. The white wire for each branch circuit is connected to this ground bus. The black wire for each branch circuit is connected to the protected output side of the circuit breaker or fuse.

Division of the electrical load in the home has two main purposes: first, it keeps the current in each branch low (usually 15A or 20A) so the branch wires are smaller, less expensive, and easier to install; and second, an overload on one branch is isolated so that it does not affect the other branches.

115VAC LIGHTING CIRCUIT

Circuit #1 in *Figure 7-1* is a lighting circuit that has two 100W light bulbs wired across (in parallel with) Leg 1 of the 115VAC main power. A 15A circuit breaker is in series with the black wire of this branch. The wires (pigtale leads) from the light bulb sockets are connected to the lighting circuit by stripping insulation from the ends of the wires and twisting the stripped ends together. Quick connectors, called wire nuts, screw onto the twisted wire ends. The wire nuts hold the twisted wires in place and insulate the bare wire ends. These wires are tucked under the lighting socket and into the junction box in the ceiling or wall, then the light socket is fastened to the junction box.

To measure the voltage at either of the light sockets, open the circuit breaker for the branch, remove the socket from the junction box, pull out the wires, and remove the wire nuts. Close the circuit breaker and measure the voltage at the twisted wire connections with an ac voltmeter on the 150VAC range or greater. Additionally, or alternatively, the voltage also can be measured at the light switch terminal as shown, if it is accessible.

WARNING:
Be sure that the main power switch is turned OFF before making the following test connection. Be sure that there is not voltage at Point A of Figure 7-1 before inserting an ammeter.

If the current is to be measured and you do not have a clamp-on ammeter, the circuit can be opened at the circuit breaker by removing the black lead from the circuit breaker and inserting an ac ammeter in series, as shown in *Figure 7-1*. With two 100W light bulbs in the circuit, the ammeter should read approximately 2A.

Figure 7-1. Home Power Distribution System

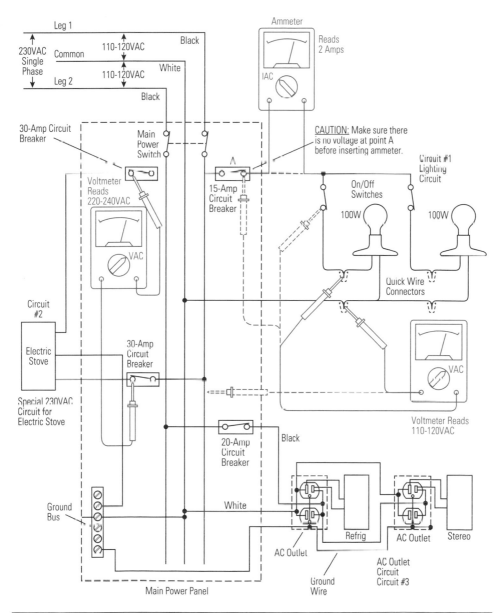

230VAC CIRCUIT

Circuit #2 is a 230VAC circuit for an electric stove. It is connected across both incoming power legs. As shown in *Figure 7-1*, the voltage can be measured easily by placing an ac voltmeter (set to scale 250VAC) across the two circuit breakers (one in each leg) in the power panel. As a result, the measurement is much safer because no wire connectors need to be removed and no wires need to be disconnected.

As mentioned earlier, the center wire (between leg 1 and leg 2) is called "common." It also is sometimes called "ground." Technically, there is a difference between the two terms; however, there should be no voltage difference between the common and ground wires. We will have more to say about ground as we discuss the outlet circuit.

115VAC OUTLET CIRCUIT

Circuit #3 in *Figure 7-1* is a 115VAC circuit with two wall outlets; one with a refrigerator plugged into it, and the second with a stereo plugged in. If it is suspected that an ac outlet is not functioning properly, the ac voltage at the receptacle can be measured as described in Chapters 1 and 2. If it has been determined that an outlet does not have voltage, further measurements can be made as shown in *Figure 7-2* by following these steps:

Figure 7-2. Measuring 115VAC at a Wall Outlet

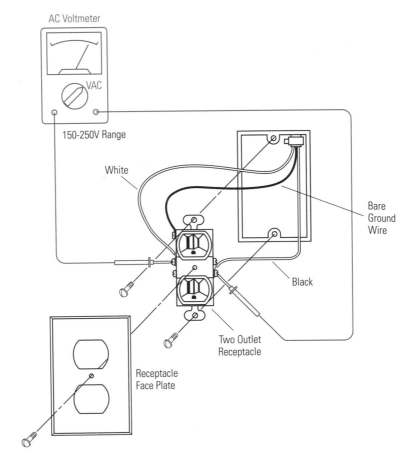

1. If possible, identify another outlet receptacle on the same circuit. Plug in a lamp and turn it on.

2. Remove the center screw and face plate of the suspected outlet receptacle.

3. At the main power panel, throw the circuit breaker for the outlet circuit to OFF. This should turn off the lamp to indicate that the power to the circuit is off.

4. Remove the screws that hold the suspected outlet receptacle in the box.

5. Pull the receptacle out of the box, as shown in *Figure 7-2*.

6. At the main power panel, throw the circuit breaker ON.

7. Measure the voltage at the receptacle's screw terminals as shown in *Figure 7-2*.

8. If there is no voltage, look for broken wires, loose screws, a damaged outlet, and loose connections on "daisy-chained" outlets on the same circuit. If the outlet receives its power by wires inserted into spring contacts in the receptacle rather than the wire being wrapped around a screw, carefully check to make sure that the wire is firmly gripped by the spring contacts.

9. If the outlet is okay, continue to isolate the problem by tracing the circuit back toward the power panel. Loose connections at the previously "daisy-chained" outlet or in a junction box in the circuit may be the cause of the trouble. Proceed carefully by turning the power ON and OFF at the circuit breaker as necessary.

IMPORTANCE OF GROUNDING

Outlets in many older homes and buildings are not properly grounded. Here is an example of why a grounded outlet is important:

Suppose an appliance develops an internal short from the 115VAC or 230VAC line to its ungrounded metal case. This causes a very dangerous condition. If you touch the appliance case with one hand, and touch something else which is grounded – such as a water faucet – with your other hand, you will complete a circuit through your body and receive a shock – *it could be a fatal shock*. However, if the appliance is grounded via a properly-grounded outlet, the excessive current from the shorted "hot" wire to the common through the grounded outlet will trip the circuit breaker. Thus, power will be removed from the outlet until the defective appliance is unplugged and the circuit breaker is reset.

Figure 7-3. Installing a Ground Adapter Plug

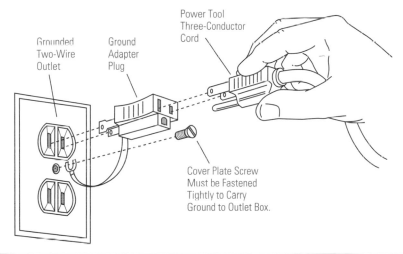

Power Tool
Three-Conductor
Cord

Grounded
Two-Wire
Outlet

Ground
Adapter
Plug

Cover Plate Screw
Must be Fastened
Tightly to Carry
Ground to Outlet Box.

If you have two-wire ungrounded outlets, you may want to have them replaced with three-wire grounded outlets by a licensed electrician. If you have two-wire grounded outlets, then you may want to replace them yourself, or temporarily install a ground adapter plug, as shown in *Figure 7-3*.

SHORTS AND GROUND FAULTS

A short circuit occurs when current takes an accidental path short of its intended circuit. It is caused by the creation of a path of significantly lower resistance than that of the normal circuit. A short circuit can be damaging to an electrical system because of excessive currents that occur under a short circuit condition. Short circuits usually are caused by a breakdown in the insulation between parts, or by wires shorting together because of vibration.

A ground fault is an accidental connection of a non-grounded conductor to the equipment frame or case. It is a form of short circuit that results in current leaving the circuit conductors and going through a path of other conducting materials provided by the frame. A ground fault usually is caused by a fault in insulation.

Both short circuits and ground faults can be located with an ohmmeter. Check the circuit schematics of the equipment under test to determine the normal resistance of the circuit. **CAUTION:** *Be sure that the power is off before measuring ohms!*

INCANDESCENT LIGHT BULB

The incandescent light bulb basically is a simple device whereby the electrical current passing through the filament wire heats it so hot that glows and gives off light. The amount of heat produced by the filament is determined by the wattage of the bulb. The wattage, in turn, is determined by the voltage, current, and resistance according to Ohm's Law. The quickest and easiest measurement to make on a light bulb just to determine if it has continuity is to measure the filament resistance with an ohmmeter. However, for determining wattage, the filament's cold resistance is greater than its hot resistance, so that a simple measurement with an ohmmeter will not be correct for finding the wattage. The hot resistance can be found by measuring the voltage across the bulb and the current through it, and dividing the voltage by the current to obtain the resistance. Power, or watts, equals the voltage times the current.

DUAL-FILAMENT INCANDESCENT LIGHT BULBS

A popular type of table or floor lamp uses a three-way incandescent light bulb that allows the lamp to be set to any one of three brightness levels: dim, medium, or bright. The light bulb has two filaments and the lamp fixture has a special switch that connect the filaments singly or in parallel. The continuity of a three-way bulb can be checked with an ohmmeter just like the single-filament bulb, except there will be a separate ring in the base of the bulb for the second filament. If the lamp fixture is suspected to be defective, you can measure the voltage from line to switch with an ac voltmeter.

FLUORESCENT LAMP

The fluorescent lamp, which was introduced in 1939, is much more efficient than the incandescent light bulb. As shown in *Figure 7-4*, fluorescent lamps or fixtures require a starter circuit to heat the filaments until they emit sufficient electrons to ionize the mercury vapor gas inside the fluorescent lamp. After the gas is ionized, the starter circuit removes heating power from the filaments. The internal resistance of the lamp drops very low when the gas is ionized and current flows through the tube. In fact, the resistance is so low that if it were connected directly to the power line, it would draw so much current that it would burn out very quickly. A current-limiting device, called a ballast, is connected between the lamp and the power source to limit the current.

Figure 7-4. Fluorescent Lamp Circuit

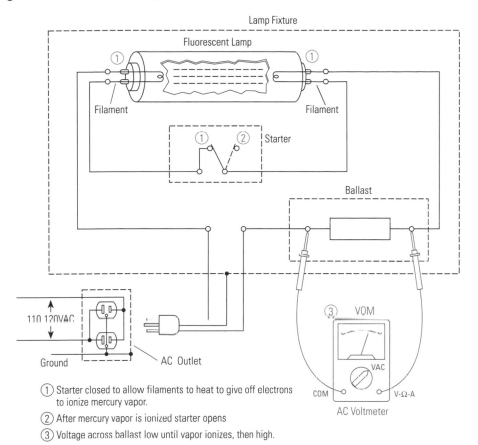

① Starter closed to allow filaments to heat to give off electrons to ionize mercury vapor.

② After mercury vapor is ionized starter opens

③ Voltage across ballast low until vapor ionizes, then high.

In the fluorescent lamp circuit shown in *Figure 7-4*, the starter must close to start the lamp, but on the other hand, if the starter does not open it will not allow the fluorescent lamp to light. The ballast and starter usually are contained within the fluorescent lamp fixture. Some early fixtures had removable starters, but today the starter is wired into the fixture. Measuring the voltage drop across the ballast with a voltmeter as shown in *Figure 7-4* gives and indication of the circuit operation. The lamp, the starter, and the ballast are the most likely components to fail, in that order.

LOW-VOLTAGE LIGHTING

A decorative, low-voltage outdoor lighting system can provide an electrically safe way to illuminate dark steps and sidewalks. Low-voltage outdoor lighting also is far more economical to operate than ordinary household lighting fixtures. As an example, the six-light system shown in *Figure 7-5* uses less electricity that a single 75-watt light bulb.

Figure 7-5. Low-Voltage Lighting System

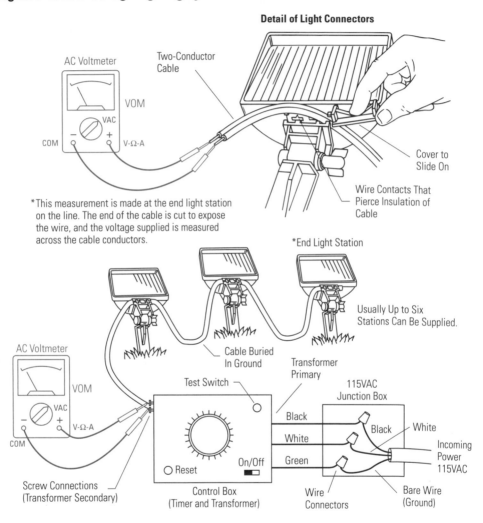

The control box contains a programmable timer, a transformer, a circuit breaker, and a test switch to bypass the timer to test the lights. The transformer is what makes this system electrically safe. It converts the primary 115VAC line voltage to a secondary voltage of between 8VAC and 24VAC. The transformer's low-voltage output is fed to two screw terminals on the control box. Incoming power is supplied either through a standard three-prong plug from a ordinary 115VAC outlet, or, as shown in *Figure 7-5*, it must be connected with wire connectors to a 115VAC power line in a junction box. The ground wire (usually green or bare) connects the control box housing to ground.

WARNING:

The 115VAC in the primary circuit is very dangerous and the wires must be handled with extreme care, as discussed earlier in this chapter under the heading "Safety Rules."

A heavy-gauge (usually #12 or #16 stranded), waterproof, two-conductor cable is used to bring electricity from the control box to the lights. Some lights have screw terminals, while others have pin contacts to pierce the cables, as shown in detail in *Figure 7-5*. The cable can be buried in the earth as it runs between lights. The secondary has no ground connection and, since it is ac, there is no need to be concerned with polarity. The control unit is a clock timer that operates a switch at the programmed times to turn the lights on and off.

The usual symptoms of a problem in a low-voltage lighting system are either: 1) dim lights; 2) all lights out; or 3) one or two lights out.

Dim lights mean there is an extra voltage drop caused by an overloaded line or by bad connections. Using an ac voltmeter as shown in *Figure 7-5*, measure the voltage at the control box and at the end light station. If the voltage difference is greater than two volts, the connecting cable wires are too small. A larger cable must be used. If the voltage drop is small, examine all connections and make sure they are clean and that they pierce the cable properly.

All the lights out means that no power is getting to the cable. Be sure the ON/OFF switch is on and that the circuit breaker is on. Use an ac voltmeter to measure the voltage at the output of the control box. It should be about 10 volts for a 12V system. Check the 115VAC if there is no voltage at the output of the control box. If there is 115VAC supplied but no output voltage, press the test switch and measure the output voltage again. If there is output voltage, the control box clock timer is not working properly. Contact a qualified maintenance center to help you.

If only one or two lights are out and the others are operating normally, the control box is okay, but there probably are burned out bulbs, bad connections, or faulty wiring. Use your multitester as an ohmmeter or voltmeter to check the bulbs and the cable voltage and this should located the problem. A good bulb will have a cold resistance of about one ohm.

OPTICAL SENSORS

Optoelectronics is the technology that combines optics and electronics to change light into electricity. Of the many optoelectronic devices, the two simplest are most likely to be found around the home. They are the photoconductive and photovoltaic cells.

Figure 7-6. Photoconductive Cell

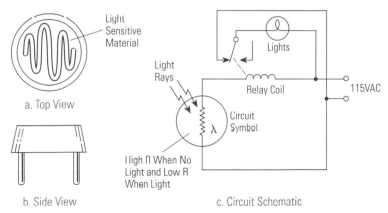

a. Top View

b. Side View

c. Circuit Schematic

Photoconductive cells – or light sensors – are basically light-sensitive resistors. This means that their conductivity depends upon the incident light on the cell, as shown in *Figure 7-6*. Many materials are photoconductive to some degree; however, the commercially important ones are cadmium sulfide, germanium, and silicon. The spectral response of the cadmium sulfide cell closely matches the human eye, so it is often used in applications where human vision is a factor. Controlling lights, like the low-voltage system, and automatic iris controls for cameras are two typical applications.

Figure 7-6c shows how the photoconductive cell is used to turn on a light at dark and off at dawn. The photoconductive cell must be removed from the circuit to test it and measured with an ohmmeter. When you cover it from light, its resistance will be very high – greater than 100,000 ohms. When illuminated, the cell's resistance may be less than a few hundred ohms.

Whereas photoconductive cells can only control current, photovoltaic cells are devices that produce a voltage when they are exposed to light. A popular photovoltaic cell is a solar cell which converts the radiant energy of the sun into an electrical power source. In many applications, such as calculators, there is no other external power source but the photovoltaic cells. The photovoltaic cell's output may be measured with a dc voltmeter, as shown in *Figure 7-7*. When illuminated with bright sunlight, a single cell's output voltage may be as much as 0.55V. They can be connected in series for high voltage capability, and in parallel for higher current capability.

Figure 7-7. Photovoltaic Cell

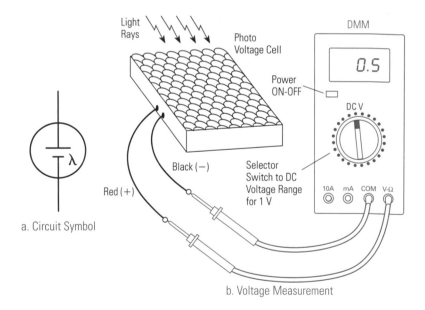

a. Circuit Symbol

b. Voltage Measurement

GARAGE DOOR OPENER

The radio-linked electronic control of a garage door opener is very sophisticated, with security systems involving digital codes (or channel selection) and output signals to activate lights both inside and outside the garage. The circuitry outside of the transmitter, however, is simple enough to allow you to perform troubleshooting with your multitester. The basic circuit is shown in *Figure 7-8* with the most likely test points indicated. The relay that operates the motor can be activated either by the radio transmitter or the hard-wired push-button switch that usually is mounted on the wall inside the garage.

Figure 7-8. Garage Door Opener

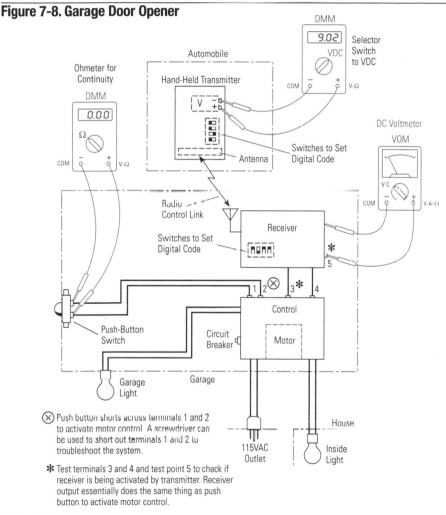

⊗ Push button shorts across terminals 1 and 2 to activate motor control. A screwdriver can be used to short out terminals 1 and 2 to troubleshoot the system.

* Test terminals 3 and 4 and test point 5 to check if receiver is being activated by transmitter. Receiver output essentially does the same thing as push button to activate motor control.

LOCATING A PROBLEM

If the push-button switch activates the motor control relay but the transmitter does not, the first thing to check is the battery in the transmitter by measuring it with a voltmeter. If the battery is good, or if you replace it, and the remote transmitter still does not activate the motor relay, check the digital code or channel selector switch to make sure the receiver and transmitter are on the same code or channel. Check the owner's manual to determine if there is a test point at the receiver (as shown in *Figure 7-8*). If so, you can use a dc voltmeter to

measure for an output voltage that indicates if the transmitted signal is being received. In many cases, the receiver, when it receives a transmitted signal, shorts out the same terminals (1 and 2) as the push-button switch; however, in *Figure 7-8*, the receiver has its own inputs (3 and 4). If the indication is that the transmitter or receiver is at fault, call a qualified technician to service the unit.

If the push-button switch does not activate the motor relay, you can bypass the push-button switch circuit by shorting across the screw terminals 1 and 2 with a screwdriver, as indicated in *Figure 7-8*. If this shorting activates the motor, unplug the control from the 115VAC outlet and use your multitester as an ohmmeter to check for broken wires to the push-button switch and for continuity problems in the push-button switch itself.

If the motor is not activated, use an ac voltmeter to measure to be sure that there is 115VAC power to the unit. Many units have a circuit breaker in them, so check to be sure that it has not been tripped. If it has, reset it. The shorting of terminals 1 and 2 usually causes a stepping relay in the control box to activate. If the stepping relay activates, but the motor doesn't run, check the contacts of the stepping relay. They may be burned or shorted together. If they are shorted, the circuit breaker has probably been tripped. If none of these checks reveals the problem, you may have to call a service technician.

INSTALLING A CEILING FAN

Physically, there are two ways a ceiling fan can be installed: 1) the traditional installation using the down pipe, as seen in *Figure 7-9a*; or 2) the close-to-the-ceiling, low-profile method as seen in *Figure 7-9b*. Regardless of the physical type of installation, the electrical wiring is the same, except for running the wires through the down pipe. Typical fan kits are shown in *Figure 7-9*.

To reduce the risk of electrical shock, turn off the power at the circuit breaker or fuse box before beginning installation. An assortment of lighting kits usually are available to attach to the ceiling fan. The connections using wire-nut connectors of the blue-to-black and white-to-white wires between the fan and light are shown in *Figure 7-9*. The fan and the light each have a pull chain to operate their individual internal switch to control the fan speed and light, respectively. Usually, there also is an external switch to reverse the fan motor. If this provides all of the control that you want, then wire the fan as shown in *Figure 7-9a*. The black wire from the fan, the blue wire from the light, and the black wire from the 115VAC branch circuit are all twisted together and connected with a wire nut. The common white wire from the fan and the light, and the white wire from the 115VAC branch circuit, are twisted together and connected with a wire nut. The bare ground wire from the branch circuit should be connected to the outlet box. Connect the green ground wire from the fan to the outlet box as well.

Some people like to have additional control, such as a wall switch for the fan and/or light, or a solid-state dimmer for the lights. The circuit shown in *Figure 7-9b* adds a wall switch or dimmer for the light, and a fan switch. The white wire and ground connections are the same as for *Figure 7-9a*. The black wire from the fan and the blue wire from the fan light are connected through their respective switches (or dimmer) to the black 115VAC supply wire. *Do not connect a solid state light dimmer to the fan motor. It will cause the fan to overheat and possibly burn out.* If a fan switch is not required, then the black wire for the fan is connected directly to the black 115VAC supply wire, as indicated in *Figure 9-9b*.

The wires that you add from the ceiling fan to the light switch and fan switch should be standard, two-conductor electrical cable with #12 or #14 gauge wire that has a black and a white wire. Connect them as shown in *Figure 7-9b*. You will end up with an unused white wire. When the wiring is complete, re-inspect the connections, then turn on the circuit breaker. Everything should work properly.

Figure 7-9. Ceiling Fan Wiring

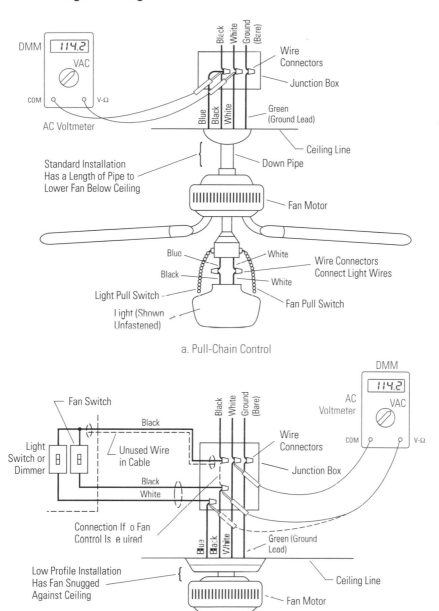

a. Pull-Chain Control

b. Wall-Switch or Dimmer Control for Light and Fan Switch

If there is a problem, pull the chain switches so the fan is off and the light is on. *Remember, the circuit is still live, so proceed carefully.* Test for 115VAC with your multitester as an ac voltmeter at the circuit points indicated in *Figure 7-9*. First, measure to make sure there is 115VAC at the black and white supply wires of the branch circuit. Then test for 115VAC at the light wire connector connections, and at the wire connector connections in the outlet box for the blue and black leads for the fan and light, respectively. If any voltage is not present, throw the circuit breaker and recheck all of the electrical connections. Using your multitester and the schematic of *Figure 7-9b*, you will solve your problem.

SUMMARY

Common electrical circuits around the home provide excellent cases where you can use your multitester for troubleshooting a problem. In this chapter, we have reviewed a number of examples. In the next chapter, we discuss automotive measurements.

8

Automotive Measurements

INTRODUCTION

The electrical system in older automobiles consisted of a lead-acid storage battery, alternator, starter motor, ignition switch, and various lighting circuits. Today's automotive electrical systems include a variety of electrical and electronic devices used not only in the basic electrical system, but also in almost every sub-system of the vehicle. Gone are the days when the car mechanic could troubleshoot anything on the vehicle with a test lamp. To successfully diagnose modern automotive systems, the technician must know how and what measurements to make, and be able to make them accurately and precisely. This skill requires a solid understanding of how to correctly use multitesters.

The purpose of this chapter is to present some basic automotive troubleshooting techniques using multitesters. With these techniques and a basic understanding of electrical principles such as voltage, current, and resistance, you will be able to recognize the operation of several automotive systems and successfully troubleshoot them.

WARNING:
When working in the engine compartment, keep the test leads and your hands away from moving parts, such as the fan and belts.

BATTERY, ALTERNATOR, AND REGULATOR

The battery can be considered the heart of an automobile electrical system. Every electrical and electronic device on a vehicle draws its power from the battery. However, the battery cannot perform as a continuous reservoir of electrical power unless the charging system keeps it operating at full capacity.

The alternator is the principal part of the charging system, as shown in *Figure 8-1*. When the vehicle engine is running, the alternator generates a voltage and delivers it both to the battery and to the rest of the electrical system. The charging system contains a regulator, which can be either internal or external, that acts as an automatic control in the system. Without a regulator, an alternator would output its highest possible voltage continuously. Such a high voltage would exceed the limits of many components in the electrical system, including the battery and the alternator itself, and would result in extensive damage to the entire electrical system. So let's begin by looking at some charging system measurements that can be made using a multitester.

Figure 8-1. Automobile Charging System

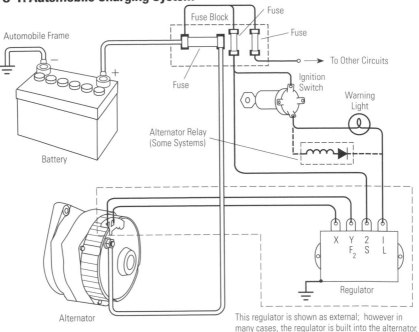

Fuse Block
Fuse
Fuse
Automobile Frame
To Other Circuits
Ignition Switch
Fuse
Warning Light
Alternator Relay (Some Systems)
Battery
X Y 2 I
F₂ S L
Regulator
Alternator
This regulator is shown as external; however in many cases, the regulator is built into the alternator.

BATTERY MEASUREMENTS

All too frequently, the automobile battery is ignored until it fails to crank the engine. And, as though this inconvenience is not enough, lack of proper maintenance will considerably shorten the useful life of a battery. Most car batteries today are the "maintenance free" type. With an older-type battery, the status of the battery's charge was checked by testing the electrolyte with a hydrometer. With a maintenance-free battery, you test the charge by measuring the no-load voltage across the battery terminals. *Figure 8-2c* shows the measurement using a DMM.

First, remove any current drain from the battery by disconnecting the cable from the positive (+) battery terminal. (If the terminal and cable are corroded, clean them according to the section on Battery Terminal Corrosion that follows before proceeding with the measurement.) Measure the voltage as shown in *Figure 8-2c*, and compare the voltmeter reading to the no-load test voltage in the batter charge state table (*Figure 8-2b*). This voltage test only tells the battery's charge state, not its overall condition. The overall condition is best determined under load.

A load test that can be done at home without a special setup also is shown in *Figure 8-2c*. The battery terminal voltage is measured with a multitester while the current drawn by the starter is measured with a Hall-effect clamp-on ammeter – a clamp-on multitester that measures dc current.

Make sure the cable to the positive (+) battery terminal is properly connected. Place the voltmeter test leads across the battery connectors, and the clamp-on ammeter around the large cable running from the positive terminal of the battery to the starter. Read the voltmeter and the ammeter while the ignition switch is held closed to crank the engine for starting. The current reading will drop sharply once the car starts and the starting switch is released. Note that the current range for the ammeter must be from 600A to 1000A. The voltage range is 20VDC. Five typical readings are shown in *Figure 8-2a*. If the voltage reading falls below 7.2V, the battery should be charged or replaced.

Figure 8-2. A No-Load and Simple Load Test for a Car Battery

LOAD TEST As Engine Is Cranked (Cold)		
Type of Car	Load Current	Battery Voltage
Ford 8 Cyl.	758A	10.6V
Ford 8 Cyl.	498A	10.8V
*Chrysler 8 Cyl.	490A	9.2V
Toyota 8 Cyl.	489A	11.2V
Toyota 8 Cyl.	468A	11.4V

*Old Battery, Slow Starting

NO-LOAD TEST	
Voltage	% Change
12.6V	100%
12.45V	75%
12.3V	50%
12.15V	25%

a. Current and Voltage While Starting

b. Battery Charge State

c. Actual Measurement

BATTERY TERMINAL CORROSION

One of the most common problems with automotive electrical systems is battery terminal corrosion. If there is a high-resistance corrosion built up between the cable connector and the terminal, there will be a significant voltage drop at the cable connectors. Therefore, when measuring battery voltage under load, as in *Figure 8-2*, be sure that the multitester test lead probes are on the battery cable connectors and not on the battery terminals so that the voltage reading will reveal if there is a drop. If the terminals are corroded, apply a thick paste of baking soda and water on the connectors and terminals and let it set for a while. Rinse thoroughly with water to remove all of the solution and corrosion by-products. Then thoroughly clean the cable connectors and terminals with a wire brush. Scrape the inside of the connectors and the outside of the terminals with a knife or file until they are bright and shiny. When everything is clean, apply a thick coat of anti-oxidant compound to the terminals and connectors, tighten the connectors properly (be careful not to over-tighten), and then recheck the battery voltage under load to make sure the voltage drop has been eliminated.

LOCATING CURRENT DRAINS

By selectively activating individual accessories, you can locate and measure the current drain from the battery by all the accessories. Under hood lights, glove-box lights, trunk lights, and dome lights are candidates for drawing excess current if they are stuck ON. Check them carefully if excess current drain is indicated.

ALTERNATOR MEASUREMENTS

The exploded view of an alternator shown in *Figure 8-3* shows that it consists of a rotor inside a stator enclosed within a housing. The alternator changes mechanical energy into electrical energy. The mechanical energy to spin the rotor inside the alternator is supplied by the engine through a drive belt. The rotor spinning inside the stator produces a rotating magnetic field. The stator is a stationary set of windings attached to the housing. The rotating magnetic field of the rotor generates an electromotive force in the stator winding, which provide an ac output voltage from the alternator.

Figure 8-3. Exploded View of Alternator

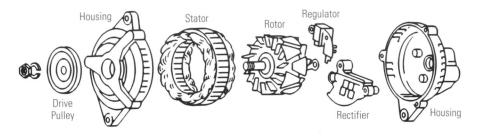

The alternating output voltage produces an alternating current in any circuits connected to the alternator output. An automobile electrical system is designed to use direct current, so the ac voltage must be rectified (changed) into dc before it can be used by the automobile's electrical system. This is accomplished with diodes connected in an arrangement that is called a rectifier circuit. A rectifier and regulator, packaged inside the alternator, are shown in *Figure 8-3*. The alternator of *Figure 8-4* also contains these components.

ALTERNATOR DIODES

If alternator diodes are defective, they either can be open or shorted. Diodes that have had excessive voltage applied to them usually short when they fail. Diodes that have had excessive current through them usually open. About the only way to find an open diode is to disassemble the alternator and individually test each diode in the rectifier assembly. On the other hand, shorted diodes can be found without having to remove the alternator from the vehicle by using the Diode Test function of a DMM, as shown in *Figure 8-4*.

• Using the Diode Test Function

With the DMM FUNCTION/RANGE selector switch set to the diode-test position (⊣⊢), insert the test leads in the V-Ω and COM jacks. *With the vehicle engine **not** running*, remove the connecting wires from the alternator then, as shown in *Figure 8-4a*, touch one test probe to the alternator output terminal and the other test probe to the alternator housing and note the reading. Now, reverse the test probes and note this reading. On one direction of the test, the DMM should display for overrange – an "OL", a flashing "1", or just a "1" – which

Figure 8-4. Measurement on Diodes with Alternator Still Mounted in Vehicle

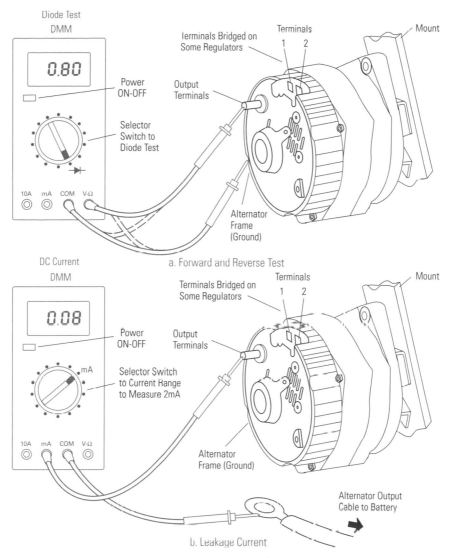

a. Forward and Reverse Test

b. Leakage Current

indicates an open (reverse-biased) diode. In the other direction, the DMM should display 0.8V, which indicates the forward voltage of two diodes in series. If the display is about 0.4V, then one diode probably is shorted. A reading of 0.1V or less indicates two shorted diodes.

• Leakage Test

If the rectifier diodes test okay, you can get an idea of how good they are by making a leakage current measurement. This time, set the DMM FUNCTION/RANGE selector switch so the meter is a milliammeter, as shown in *Figure 8-4b*. Place the test leads in the mA and COM jacks. *Make sure the engine is **not** running.* Connect the milliammeter in series with the alternator output cable as shown in *Figure 8-4b*. The leakage current should be less than 1mA, and will probably be less than 0.1mA. If the leakage current approaches 20mA, the rectifier should be replace.

VOLTAGE REGULATOR

A typical alternator circuit with an electronic regulator is shown in *Figure 8-5*. The description of the regulator action admittedly is simplified, but it should serve our purpose. The alternator output cable to the battery is connected to terminal 3. Current in this cable charges the battery and supplies current to the vehicle electrical system. The battery voltage must be sensed by the 2. If the voltage sensed is too low, the regulator causes a greater current through the rotor field coil, which increases the alternator output voltage. If the voltage sensed is too high, the regulator causes a lesser current through the rotor field coil, which reduces the alternator output voltage.

Figure 8-5. Alternator Electrical Circuit with Internal Regulator

Transistor Q_1 in *Figure 8-5* is the component that controls the current through the field coil. Delco™ alternators used on GM vehicles have a convenient "D" hole (see *Figure 8-5*) to determine if Q_1 has failed or is about to fail. For the regulator to work properly, the voltage from the collector to the emitter must be low. As shown in *Figure 8-5*, a voltmeter – either analog or digital – can be used to measure the voltage from the collector of Q_1 to ground by inserting the positive test lead probe into the "D" hole and connecting the common test lead to ground with an alligator clip supplied with the meter.

Start the engine and run it at fast idle. Fully load the alternator by turning on the headlights, radio, heater or air conditioner, and the windshield wipers. Read the voltage. If the voltage, called V_{CEsat}, is greater than 1.75V, Delco recommends that the regulator be replaced.

CHECKING ALTERNATOR WHEN INTERNAL REGULATOR IS DEFECTIVE

If the voltage at the "D" hole is close to the battery voltage, it means that the regulator is not working and needs to be replaced. The alternator warning light is on, but the question remains: Is the alternator okay? We can answer that with a measurement that also is shown in *Figure 8-5*. It assumes that Q_1 is not shorted.

Start the engine and run it at fast idle. With the internal regulator defective, the alternator is not charging and the battery voltage probably is below 12V. As shown in *Figure 8-5*, with a voltmeter on the 20VDC scale, measure the alternator output at terminal 3. At the same time, insert a piece of wire in the "D" hole and short it to the alternator case (a spare multitester lead is a good thing to use for this). If the alternator is good, the output voltage should immediately increase when the "D" hole connection is shorted to ground.

CHECKING ALTERNATOR WHEN EXTERNAL REGULATOR IS DEFECTIVE

A similar measurement can be made when an external regulator is not operating properly. There actually are two measurements shown in *Figures 8-6a and 8-6b* because there are two types of regulators. The type A regulator in *Figure 8-6a* connects the field coil to ground through the regulator. Shorting from terminal F_2 to ground shorts out the regulator and, if the alternator is good, should produce the same increased alternator output voltage as the measurement in *Figure 8-5*.

Figure 8-6. Testing for Good Alternator When External Regulator Is Not Working

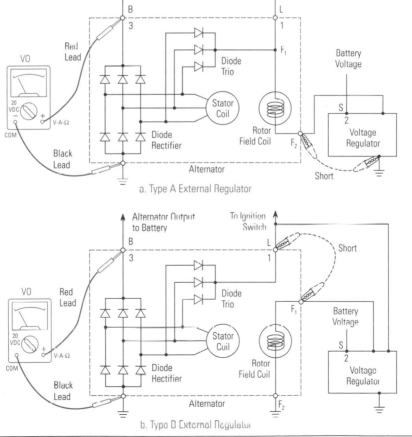

a. Type A External Regulator

b. Type D External Regulator

The type B regulator in *Figure 8-6b* connects between terminals 1 and F₁. Terminal 1 is the battery voltage from the ignition switch and terminal F₁ is the ungrounded end of the field coil. If the alternator is good, a short between terminals 1 and F₁ should produce the same results as the measurement in *Figure 8-5*.

MEASURING THE OVERALL ALTERNATOR

One way to measure the overall performance of an alternator is to measure the output current, output voltage, and field current all at the same time. *Figure 8-7* shows such a measurement using a DMM for the output voltage, and Hall-effect ac/dc current clamp-on multitesters for the field current and the output current. Hall-effect clamp-on ammeters are used because dc current must be measured. The 200A ranges are used on the clamp-on meters, so care must be taken not to measure starting currents because the output current can run as high as 800A. *Do not put clamp-on meters on wires until the engine is running.* The nominal operating currents and voltages should be on the name plate on the alternator that gives the model number and operating conditions. If not, an automobile dealer's parts department or a parts house should have the data.

Figure 8-7. Testing Overall Alternator Performance

TESTING A DISASSEMBLED ALTERNATOR

If you find that the alternator is bad, it must be disassembled to test it further. If you decide to do this, carefully note the arrangement of parts as you disassemble it so that you do not leave out one of the insulating washers or sleeves when you reassemble it. Use *Figure 8-3* as a guide.

The respective cathodes and anodes of the diodes are electrically connected to the stator windings as shown in *Figure 8-5*. They are mounted and connected in the alternator case or in a separate mechanical assembly (heat sink) that will dissipate the heat that the diodes generate.

Figure 8-8. Measuring Disassembled Alternator Diodes

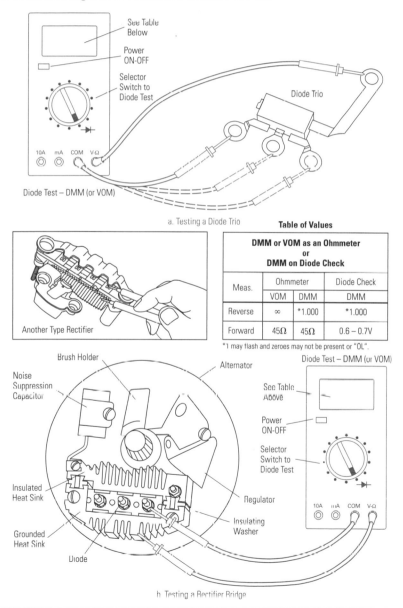

a. Testing a Diode Trio

Table of Values

Meas.	DMM or VOM as an Ohmmeter or DMM on Diode Check		
	Ohmmeter		Diode Check
	VOM	DMM	DMM
Reverse	∞	*1.000	*1.000
Forward	45Ω	45Ω	0.6 – 0.7V

*1 may flash and zeroes may not be present or "OL".

b. Testing a Rectifier Bridge

In the alternator of some newer model cars, as shown in the schematic of *Figure 8-5*, the diodes are in the form of a diode trio for the field current and a rectifier bridge for the stator windings output. Representative disassembled parts are shown in *Figure 8-8*. Note that some of the diode heat-sink assembly is insulated. The diode trio is measured as shown in *Figure 8-8a*, and the rectifier bridge is measured as shown in *Figure 8-8b*. The readings for an ohmmeter and diode-check are shown in the table. The rotor and stator can be measured for opens or shorts to the case by using a VOM or DMM as an ohmmeter.

ENGINE IGNITION

ONE CYLINDER SYSTEMS

An ignition system for a one cylinder engine is shown in *Figure 8-9a*. Its electrical circuit consists of the battery, ignition switch, ignition coil, distributor, and a spark plug in the combustion chamber. Early systems used a set of contacts, called "points," in the primary circuit of the ignition coil. The points close and open again quickly only at one point in the rotation of the distributor, which is mechanically coupled to the crankshaft. The momentary closing of the points causes a pulse of current in the primary which, through magnetic coupling, causes a very-high-voltage pulse in the secondary. The secondary has a very large number of turns compared to the primary. The high-voltage pulse causes the spark plug to arc and ignite the air-fuel mixture compressed inside the combustion chamber. The burning of the air-fuel mixture in the combustion chamber expands the gas in the chamber. The expanding gas pushes the piston down and rotates the crankshaft. Some external cranking is required to get the engine and ignition system started.

Because the mechanical points burned due to the arcing across them, they have been replaced with an electronic component – in *Figure 8-9a* it is a transistor. A magnet on the distributor shaft sweeps by a sensing coil at a particular point in the distributor shaft rotation. The pulse produced in the sensing coil triggers the electronic control circuit and turns the transistor ON. Because the transistor acts as a switch, it does the same job as closing the points – it causes the spark plug to arc igniting the air-fuel mixture.

MULTIPLE-CYLINDER ENGINES

Multiple-cylinder engines have the same basic circuit, as shown in *Figure 8-9b*, except that the distributor is different. Another part has been added to the distribute the high-voltage pulse to the correct cylinder, and more magnets have been added corresponding to the total number of cylinders in the engine. The magnets are spaced around the distributor to provide the proper high-voltage to each spark plug at the correct time. The action is the same as for one cylinder, except it occurs for each cylinder in a timed sequence.

Figure 8-9. Engine Ignition

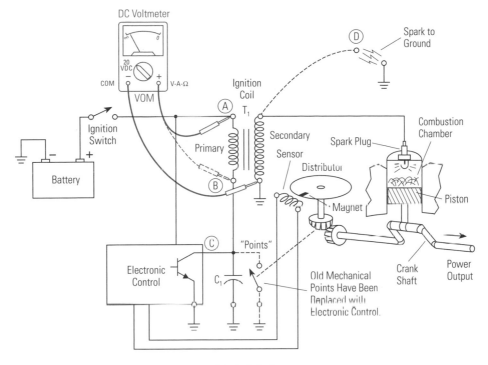

a. Single Cylinder

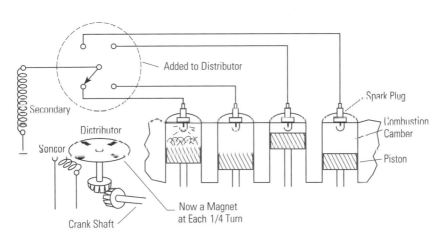

b. Multiple Cylinders

LAWN MOWER SYSTEMS

A lawn mower engine's ignition system (single cylinder) follows the same basic principles, and may be either the magneto type or the solid-state type shown in *Figure 8-10*. Both types have a powerful magnet mounted on a flywheel attached directly to the engine crankshaft. Both have a coil assembly mounted close enough to the flywheel so the magnetic field from the magnet is coupled to the coil assembly. The magneto system has a set of points that operate basically the same as the one-cylinder system. The opening of the points generates the high-voltage spark for the plug through a secondary on the coil assembly. Twisted or bent engine shafts that throw off the mechanical timing of the points is a major problem in the magneto system.

Figure 8-10. Lawn Mower Solid-State Ignition
(Courtesy of Sears, Roebuck and Co.)

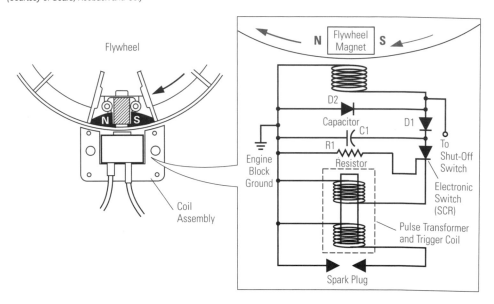

The solid-state system coil assembly is a bit different. It contains a charge coil, a trigger coil, and the high-voltage secondary pulse transformer. The electronic switch is an SCR (silicon-controlled rectifier). The basic operation is as follows: the magnet on the flywheel, sweeping by the coil assembly, charges the capacitor, C_1. A pulse from the magnet in the trigger coil turns on the SCR, which discharges C_1 through the coil assembly and produces 25,000 volts in the secondary pulse transformer to cause the spark in the plug.

IGNITION SYSTEM MEASUREMENTS

CAUTION:
Do not attempt to use an ordinary multitester to measure the high voltage at the ignition coil secondary or at the spark plug. The multitester could be severely damaged or destroyed.

If you suspect than an engine's ignition system is not operating properly, the first thing to do is measure with a voltmeter from point A to ground, as shown in *Figure 8-9*. *With the ignition switch on, but the engine not yet started,* you should read battery voltage at A (across

the primary). If A does not have battery voltage, check the connections to the primary of the ignition coil and check for corrosion at the battery terminals. If A has battery voltage, check point B as you crank the engine. You should see a pulsing or flicking of the needle or jumping of a DMM meter reading if the electronic control is working properly. If B does not pulse as the engine is cranked, remove the electronic control module and test from the output, C, to ground with an ohmmeter or with a diode checker. If there is a short, the electronic control module must be replaced. If there is an open circuit, see if you can isolate the output transistor to measure its junctions and determine if one or both of the junctions are open.

If there is proper operation at point A and B, turn off the ignition switch and remove the spark plug wire from the spark plug. Arrange the wire at point D to lay on the engine, as shown in *Figure 8-9*. *Do not hold onto the spark plug wire!* Now crank the engine. If a spark jumps from the end of the spark plug wire to the engine block at point D, the system is operating properly, and the problem probably is a bad spark plug. If the system is a multiple cylinder system, check each plug wire this way. If there are problems, check the distributor rotor or the contacts inside the distributor cap that connect to the spark plug wire terminals. They may be burned or corroded. Burnish the contacts or buy a new distributor rotor and cap.

If there is no spark to ground at D, turn off the engine, remove the ignition coil and measure the coil primary and secondary for opens or shorts to the case. Sometimes the measurements must be made when the coil is hot to detect a defective condition. Spark plug wires also could be open. This is a common problem. Check each one with an ohmmeter, but be aware that they are a high-resistance wire, usually about 10,000 ohms per foot. They should not be any more than 50,000 ohms. Gently twist the wires as you make the measurements to detect intermittents. Replace any wires that are defective.

CAPACITORS

Automotive capacitors (condensers) can be checked with a multitester in the same manner as discussed in Chapter 4. This is one test where the analog meter does a better job than a DMM. Before any measurement is taken, make sure that you short across the capacitor terminals to discharge the capacitor.

DISTRIBUTORS

Today's automotive vehicles have many different types of distributors, as well as solid-state electronic ignitions. There are only a minimal number of checks that can be made with a VOM or DMM on these systems. All put out pulses to trigger the control module to produce a high voltage to the spark plugs. If you suspect the distributor or ignition module is the problem, go to a qualified service center and have it checked by a qualified technician.

SUMMARY

In this chapter, we have shown some common measurements that can be made to troubleshoot problems in an automotive electrical system. VOMs and DMMs have been used as voltmeters, ammeters, and ohmmeters in a variety of applications. In the next chapter, we will describe measurements on the circuits contained in power tools found around the home and in the workshop.

9

Tool Control Circuit Measurements

INTRODUCTION

In this chapter, we will examine the circuit operation of several power tools and the control circuits that are used for them. We also will look at several measurements that you can make on these circuits with your VOM and DMM, *as long as the power tool is **not** of the double-insulated type.*

WARNING

The assembly or reassembly of double-insulated type tools requires checking with special high-voltage test equipment by trained, qualified technicians. These tools should not be disassembled by the user for testing or parts replacement. A severe electrical shock hazard may occur if the replacement parts are not installed properly and then correctly tested. Service should only be performed at a qualified repair center.

GROUND TEST

If your electric drill motor is not of the double-insulated type, but instead has a metal case and a three-prong power plug, you should be sure that the case is grounded and, in addition, be sure that there are no bare wires shorted to the case. Either condition is potentially dangerous.

The measurements to be made with an ohmmeter are shown in *Figure 9-1*. If everything is normal, the wires that carry the ac power to the drill from the outlet should each measure infinity ohms to the drill case, and the ground wire should measure zero ohms (continuity) to indicate that it is tied to the drill case.

Figure 9-1b is a schematic showing how the ground pin to case measurement is made. This is a typical schematic of most electrical hand tools. If the variable speed control is not in the circuit, terminals A and B would be shorted together. If the reversing switch is not in the circuit, the armature may be connected on either end of the field or between the two field coils, and the ON/OFF single-pole single-throw switch is just in series with the black power line.

VARIABLE SPEED CONTROLS

There are several methods used to control the speed of electric motors in variable-speed appliances and power tools. All of the methods used have the effect that the electric motor runs slower when the operating voltage is reduced. Let's look at several.

VARIABLE R AND L CONTROLS

Many early control systems used a variable resistor connected in series with the motor. Adjusting the resistor changed the amount of voltage applied to the motor and, thus, changed the operating speed. This method wastes a great deal of power at slow speed because most of the line voltage was dropped across the resistor. Another type reduced the motor voltage

147

Figure 9-1. Measurements on Electric Hand Drill

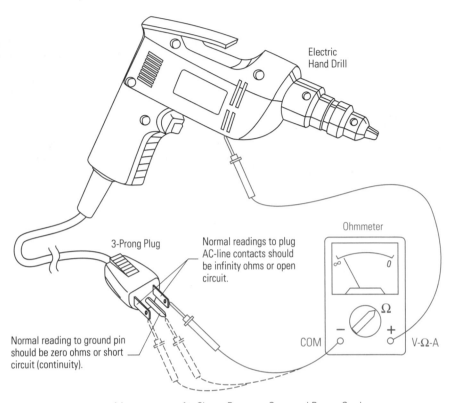

Electric
Hand Drill

3-Prong Plug

Normal readings to plug
AC-line contacts should
be infinity ohms or open
circuit.

Ohmmeter

Normal reading to ground pin
should be zero ohms or short
circuit (continuity).

COM V-Ω-A

a. Measurements for Shorts Between Case and Power Cord

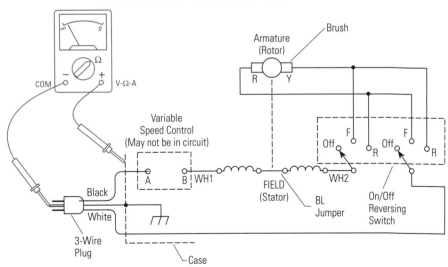

Brush

Armature
(Rotor)

COM V-Ω-A

Variable
Speed Control
(May not be in circuit)

Off Off

Black

WH1 WH2

White

FIELD
(Stator) BL
Jumper

On/Off
Reversing
Switch

3-Wire
Plug

Case

b. Schematic (Typical of Most Electrical Hand Tools)

by connecting an inductor – instead of a resistor – in series with the motor. This circuit was more efficient than the resistive power control, but more difficult to make variable.

SOLID-STATE CONTROLS

A much more efficient speed control used in today's appliances and tools uses a solid-state device. The term *solid-state* means that an electrical circuit has diodes, transistors, thyristors, and/or integrated circuits built into it. The control circuit, which may also include resistors, capacitors and inductors, provides a variable operating voltage to the motor. It works on the principle that the greater the average operating voltage, the faster the motor speed.

• Diode Speed Control

The simplest solid-state speed control is shown in *Figure 9-2*. It is a two-speed control. It either switches a diode rectifier in series with the motor for the low speed, or bypasses the diode for high speed. *Figure 9-2* also shows the waveforms associated with each speed. The diode simply blocks current during one of the power line voltage alternations, effectively cutting the average operating voltage in half. This reduces the motor operating speed by about one-half without wasting any power. Switch S_1 is shown as a trigger switch on a power tool, such as an electric drill. When the trigger is not pulled, S_1 is in the OFF position. By pulling the trigger half way, S_1 connects the diode in the circuit and the drill runs at low speed. When the trigger is pulled all the way, S_1 bypasses the diode and the motor runs at full speed. Notice that the motor must be capable of running on both ac and dc voltage if this type of control is used. Such a motor is called a universal motor.

Figure 9-2. Simplest Solid-State Speed Control

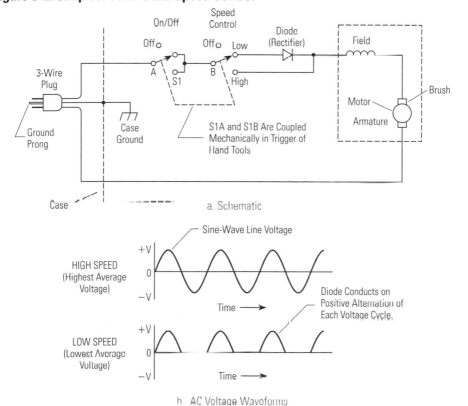

a. Schematic

b. AC Voltage Waveforms

• Testing the Two-Speed Diode Control

As previously stated, if the electric drill motor is *not* of the double-insulated type, then you can troubleshoot it with your multitester. The ways to make several common measurements on the two-speed circuit of *Figure 9-2* are shown in *Figure 9-3*. The two-speed circuit has very few parts, so testing it is relatively simple. Here are four common symptoms that could possible happen when a two-speed hand tool does not work:

1. The motor does not run at any speed setting.

2. The motor runs only when the trigger switch is in the high-speed position.

3. The motor runs at high speed in either the low- or high-speed trigger switch position.

4. The motor runs only when the trigger switch is in the low-speed position.

Let's look at these symptoms one at a time.

First, if the motor does not run at any speed, an open circuit is indicated, either in the wiring to the trigger switch, in the switch itself, in the power cord, or in the motor circuit. A continuity check with an ohmmeter on OHMS or the audible tone continuity position of the FUNCTION/RANGE switch should indicate the cause of the open circuit. Specific measurements with a meter at different circuit locations are shown in *Figure 9-3*. When the trigger switch is pulled to the high-speed position, measurement M2 indicates a low resistance if the circuit is operating properly. Since there is an open circuit, M2 will read infinity ohms. Measurements M1 and M3 will indicate if the trouble is in the power cord or lines bringing power into the tool. The cord, which is the most common problem, can then be measured as shown in *Figure 9-3b*. Another common problem, worn or broken brushes, can be located with the M1 measurements. M1 also locates opens in the motor field windings. Measurements M3 and M4 locate problems in the trigger switch.

If the control switch indicates an open, you can use a jumper wire to short out the switch as shown in *Figure 9-3a*. **CAUTION**: *Be sure the power cord is unplugged from the outlet before attaching the jumper wire.* Now, when the drill is plugged in, the motor should run at high speed *if the power cord has been verified as good.* The shorting jumper bypasses the switch and diode rectifier so that the only thing left in the circuit is the motor and connecting wires. If the motor still fails to run, verify that you have power at the outlet. If there is power at the outlet, check the power cord again and all circuit screw or wire connector connections for broken leads or bad connections.

For the cord measurement of *Figure 9-3b*, a multitester with an audible tone continuity tester can be used effectively to find an intermittent break in the power cord. Set the multitester FUNCTION/RANGE switch to the audible continuity ()))) position. Connect the test leads to the plug prongs and twist the cord, especially near the plug and drill motor. If the cord has intermittent breaks, they will be indicated by tone bursts from the continuity tester as the break in the wire momentarily touches.

Second, if the motor only runs with the switch in its high-speed position, an open diode or open S_1 in its low-speed position is indicated. The diode may be checked with a VOM on the ohmmeter function or a DMM with a Diode Test function, as shown for the M5 measurement. If a VOM is used, be sure to measure the diode in both directions, as discussed in Chapter 4. If the VOM reads high resistance (over 1000Ω) in both directions, the diode is open. Measurements M3 and M4 are used to test S_1.

Third, if the motor runs at high speed on either the low- or high-speed position of the trigger switch, then either the diode is shorted or the trigger switch has a short between the two speed selection positions. If the diode is shorted, it can be tested as described above. Remember that a shorted diode will measure low resistance in both directions on a VOM. Again, measurements M3 and M4 will locate the trouble in S_1.

Now the fourth symptom – where the motor runs only when the trigger switch is in the low-speed position. This indicates that the diode is in the circuit and that the low-speed position is okay; however, there is an open when the trigger switch is in the high-speed position. Measurements M3 and M4 should locate the problem.

Figure 9-3. Diode and Continuity Measurements

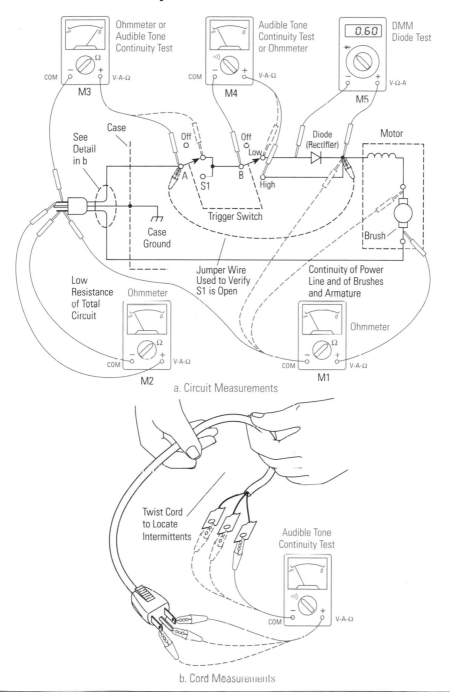

a. Circuit Measurements

b. Cord Measurements

SOLID-STATE MODULE SPEED CONTROL

Figure 9-4 shows a hand tool circuit where a solid-state speed control module controls the average operating voltage to the motor. The external speed adjustment, which is simply a variable resistor built into the trigger switch, controls the solid-state module, which controls the motor speed. The circuitry of the solid-state module usually is encapsulated so that repair is not possible. If it is defective, the entire module must be replaced. Problems in the module, ON/OFF switch, line cord, and trigger switch with its variable resistor can be tested with your VOM or DMM as described for *Figure 9-3*. We will look at how this is done, but first let's briefly describe how a solid-state module speed control works.

Figure 9-4. Solid-State Variable Speed Module for Hand Tool

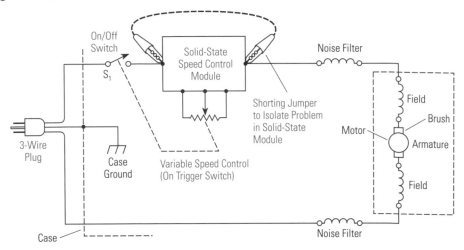

At the heart of the solid-state speed control module is a semiconductor device called a *thyristor*. It provides continuous control through a gate terminal. Thyristors are a family of solid-state power switching devices that include silicon controlled rectifiers (SCRs) and bi-directional triode thyristors (TRIACs). The current to the gate determines when the device triggers from a high resistance across its power terminals to a low resistance. The device will not trigger at a particular gate current until the amount of voltage across the device reaches a certain value.

A TRIAC power control circuit is shown in *Figure 9-5*. During the positive half cycle of the input sine-wave supply voltage, diode D_1 is forward biased, diode D_2 is reverse biased, and the gate terminal is positive with respect to A_1. During the negative half-cycle, D_1 is reverse biased and D_2 is forward biased so that the gate becomes positive with respect to A_2. Adjustment of R_1 controls the point at which conduction begins.

The variable resistor controls the gate signal and, therefore, it determines when the TRIAC turns on during each power half-cycle. When the applied voltage is a sine wave, the point at which the gate current and the voltage across the device causes the device to conduct provides an electronic time delay. The amount of the delay interval is determined by the setting of R_1, the variable resistor. The time delay occurs within each half-cycle. The later the TRIAC is turned on, the lower the average voltage applied to the motor and the slower the speed.

Figure 9-5. Solid-State TRIAC Control Circuit

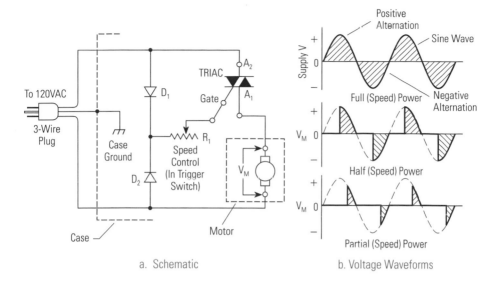

a. Schematic b. Voltage Waveforms

• Troubleshooting the Solid-State Variable Speed Control

The power cord, the switch, and the motor brushes are the most likely sources of electrical trouble on power tools, including those with universal motors. Of course, the field and rotor coil winding or the commutator also may cause problems. Visual inspection of the parts is, as usually, the first troubleshooting step. The measurements and techniques described in *Figure 9-3* will pinpoint the exact circuit trouble.

The electronic components included in the solid-state control circuit, if they are not encapsulated, are almost always mounted on a printed circuit board. The same shorting jumper technique as used for the trigger switch of *Figure 9-3* can be used to short out the solid-state module and eliminate it from the circuit so that the other circuit components can be checked. This techniques is shown in *Figure 9-4*. When it is determined that the module is bad, try resoldering its connections. If this does not fix the problem, the entire module will probably have to be replaced.

SUMARY

This chapter concludes our discussions of the application of multimeters to all types of electrical measurements. Our objective was to introduce you to multitesters and show you how to use them to make a wide variety of measurements. By now, you should be comfortable with a multitester and have found it as useful as your pliers and hammer.

Appendix

Metric Conversions

INTERNATIONAL SYSTEM OF UNITS (SI) – METRIC UNITS

Prefix	Symbol		Multiplication Factor
exa	E	10^{18} =	1,000,000,000,000,000,000
peta	P	10^{15} =	1,000,000,000,000,000
tera	T	10^{12} =	1,000,000,000,000
giga	G	10^{9} =	1,000,000,000
mega	M	10^{6} =	1,000,000
kilo	k	10^{3} =	1,000
hecto	h	10^{2} =	100
deca	da	10^{1} =	10
(unit)		10^{0} =	1
deci	d	10^{-1} =	0.1
centi	c	10^{-2} =	0.01
milli	m	10^{-3} =	0.001
micro	u	10^{-6} =	0.000001
nano	n	10^{-9} =	0.000000001
pico	p	10^{-12} =	0.000000000001
femto	f	10^{-15} =	0.000000000000001
atto	a	10^{-18} =	0.000000000000000001

1 meter (m) =
100 centimeters (cm) =
1000 millimeters (mm)

25.4	mm	= 1 inch
2.54	cm	= 1 inch
30.48	cm	= 1 foot
0.3048	m	= 1 foot
0.9144	m	= 1 yard
1.609	km	= 1 mile
1.852	km	= 1 nautical mile

FRACTIONAL DIMENSIONS

	Inches			Inches			Inches	
Fraction	Decimal	Millimeters	Fraction	Decimal	Millimeters	Fraction	Decimal	Millimeters
1/64	0.016	0.397	23/64	0.359	9.128	11/16	0.688	17.463
1/32	0.031	0.794	3/8	0.375	9.525	45/64	0.703	17.859
3/64	0.047	1.191	25/64	0.391	9.922	23/32	0.719	18.256
1/16	0.063	1.588	13/32	0.406	10.319	47/64	0.734	18.653
5/64	0.078	1.984	27/64	0.422	10.716	3/4	0.750	19.050
3/32	0.094	2.381	7/16	0.438	11.113	49/64	0.766	19.447
7/64	0.109	2.778	29/64	0.453	11.509	25/32	0.781	19.844
1/8	0.125	3.175	15/32	0.469	11.906	51/64	0.797	20.241
9/64	0.141	3.572	31/64	0.484	12.303	13/16	0.813	20.638
5/32	0.156	3.969	1/2	0.500	12.700	53/64	0.828	21.034
3/16	0.188	4.762	33/64	0.516	13.097	27/32	0.844	21.431
13/64	0.203	5.159	17/32	0.531	13.494	55/64	0.859	21.828
7/32	0.219	5.556	35/64	0.547	13.891	7/8	0.875	22.225
15/64	0.234	5.953	9/16	0.563	14.288	57/64	0.891	22.622
1/4	0.250	6.350	37/64	0.578	14.684	29/32	0.906	23.019
17/64	0.266	6.747	19/32	0.594	15.081	59/64	0.922	23.416
9/32	0.281	7.144	39/64	0.609	15.478	15/16	0.938	23.813
19/64	0.297	7.541	5/8	0.625	15.875	61/64	0.953	24.209
5/16	0.313	7.938	41/64	0.641	16.272	31/32	0.969	24.606
21/64	0.328	8.334	21/32	0.656	16.669	1.0	1.000	25.400
11/32	0.344	8.731	43/64	0.672	17.066			

Logarithms and Decibels

A. LOGARITHMS

EXPONENTS

A logarithm (log) is the exponent (or power) to which a given number, called the base, must be raised to equal the quantity. For example:

Since $10^2 = 100$, then the log of 100 to the base 10 is equal to 2, or $\text{Log}_{10} 100 = 2$

Since $10^3 = 1000$, then the log of 1000 to the base 10 is equal to 3, or $\text{Log}_{10} 1000 = 3$

BASES

There are three popular bases in use: 10, 2 and ϵ. Logarithms to the base 10 are called common logarithms (log). Logarithms in base ϵ are called natural logarithms (ln).

Logarithms to the base 2 are used extensively in digital electronics.

Logarithms to the base ϵ (approximately 2.71828...) are quite frequently used in mathematics, science and technology. Here are examples:

Base 10

$\log_{10} 2 = 0.301$ is $100^{0.301} = 2$

$\log_{10} 200 = 2.301$ is $10^{2.301} = 200$

Base 10

$\log_2 8 = 3$ is $2^3 = 8$

$\log_2 256 = 8$ is $2^8 = 256$

Base ϵ

$\ln_\epsilon 2.71828 = 1$ is $\epsilon^1 = 2.71828$

$\ln_\epsilon 7.38905 = 2$ is $\epsilon^2 = 7.38905$

RULES OF EXPONENTS

Since a logarithm is an exponent, the rules of exponents apply to logarithms:

$\log (M \times N) = (\log M) + (\log N)$

$\log (M/N) = (\log M) - (\log N)$

$\log M^N = N \log M$

B. DECIBELS

The bel is a logarithmic unit used to indicate a ratio of two power levels (sound, noise or signal voltage, microwaves). It is named in honor of Alexander Graham Bell (1847-1922) whose research accomplishments in sound were monumental. A 1 bel change in strength represents a change of ten times the power ratio. In normal practice, the bel is a rather large unit, so the decibel (dB), which is 1/10 of a bel, is commonly used.

Number of dB = 10 log P2/P1

A 1 dB increase is an increase of 1.258 times the power ratio, or 1 db = 10 log 1.258.

A 10 dB increase is an increase of 10 times the power ratio, or 10 db = 10 log 10.

Other examples are:

3 dB	= 2 times the power ratio
20 dB	= 100 times the power ratio
-30 dB	= 0.001 times the power ratio

It is essential to remember that the decibel is *not* an absolute quantity. It merely represents a change in power level relative to the level at some different time or place. It is meaningless to say that a given amplifier has an output of so many dB unless that output is referred to a specific power level. If we know the value of the input power, then the *ratio* of the output power to the specific input power (called power gain) may be expressed in dB.

If a standard reference level is used, then *absolute power* may be expressed in dB *relative* to that standard reference. The commonly used reference level is one milliwatt. Power referenced to this level is expressed in dBm. Here are power ratios and dBm ratios:

dB	Power Ratio	dBm	Power (mw)
1	1.258	1	1.258
3	2	3	2
10	10	10	10
20	100	20	100
-30	0.001	-30	0.001

Schematic Symbols

RESISTORS

Fixed

Variable

Tapped

CAPACITORS

Fixed Capacitor

Variable Capacitor

DIODES

Diode Zener Diode

Photo Diode Light Emitting Diode (LED) Solar Cell

TRANSISTORS

Bipolar PNP Transistor

Bipolar NPN Transistor

PNP Phototransistor

NPN Phototransistor

N Channel JFET

P Channel JFET

N Channel MOSFET

P Channel MOSFET

TUBES

Diode Tube Triode Tube

Tetrode Tube Pentode Tube

TRANSFORMERS

Fixed Transformer Adjustable Transformer

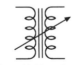

INDUCTORS

Tapped Inductor

Variable Inductor

Iron Core Inductor

Air Core Inductor

Rectifier

V_{IN} V_{OUT}
Voltage Regulator

Operational Amplifier (OpAmp)

Terminal Block

Solenoid

Schematic Symbols

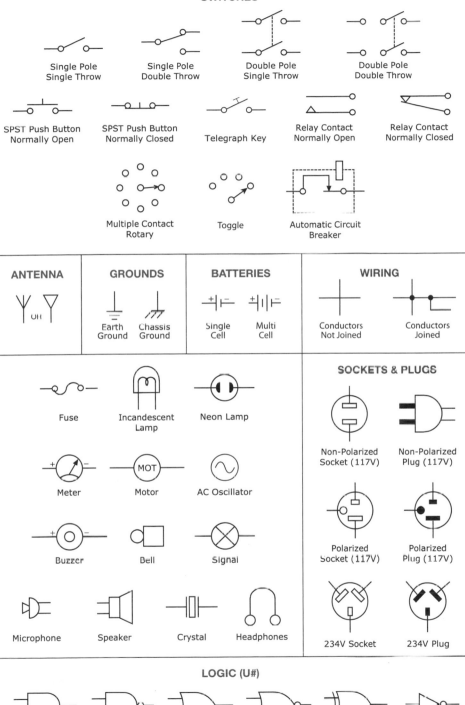

SWITCHES

Single Pole
Single Throw

Single Pole
Double Throw

Double Pole
Single Throw

Double Pole
Double Throw

SPST Push Button
Normally Open

SPST Push Button
Normally Closed

Telegraph Key

Relay Contact
Normally Open

Relay Contact
Normally Closed

Multiple Contact
Rotary

Toggle

Automatic Circuit
Breaker

ANTENNA

GROUNDS

Earth
Ground

Chassis
Ground

BATTERIES

Single
Cell

Multi
Cell

WIRING

Conductors
Not Joined

Conductors
Joined

Fuse

Incandescent
Lamp

Neon Lamp

Meter

Motor

AC Oscillator

Buzzer

Bell

Signal

Microphone

Speaker

Crystal

Headphones

SOCKETS & PLUGS

Non-Polarized
Socket (117V)

Non-Polarized
Plug (117V)

Polarized
Socket (117V)

Polarized
Plug (117V)

234V Socket

234V Plug

LOGIC (U#)

AND

NAND

OR

NOR

XOR

Invert

Glossary

Alternating current (AC, ac): An electrical current that periodically changes in magnitude and in direction of the current.

Alternation: Either half of a cycle of alternating current. It is the time period during which the current increases from zero to its maximum value (in either direction) and decreases back to zero.

Alternator (or ac generator): An electromechanical device which transforms mechanical energy into electrical energy — an alternating current. Very early users called this a dynamo.

Ammeter: An instrument for measuring ac or dc electrical current in a circuit. Unless magnetically coupled, it must be placed in the current path so the flow is through the meter.

Ammeter shunt: A low-resistance conductor that is used to increase the range of an ammeter. It is shunted (placed in parallel) across the ammeter movement and carries the majority of the current.

Ampere (A): The unit of measurement for electrical current in coulombs (6.25 x 1018 electrons) per second. One ampere results in a circuit that has one ohm resistance when one volt is applied to the circuit. See Ohm's law.

Amplification: See Gain.

Amplifier: An electrical circuit designed to increase the current, voltage, or power of an applied signal.

Analog-to-Digital Conversion or Converter (ADC or A/D): The process of converting a sampled analog signal to a digital code that represents the amplitude of the original signal sample.

Audio and audio frequency (AF): The range of frequencies normally heard by the human ear; typically, about 20 to 20,000 Hz.

Beta (β): The current gain of a transistor when connected in a common emitter circuit, now more commonly called hfe.

Bias: In an electronic circuit, a voltage or current applied to an active device (transistor, diode, etc.) to set the steady-state operating point of the circuit.

Binary Coded Decimal (BCD): A binary numbering system in which any decimal digit is represented by a group of 4 bits. Each digit in a multi-digit number continues to be identified by its 4-bit group.

Binary digit (Bit): A digit in the binary number system whose value can be either 1 or 0.

Bipolar: A semiconductor device having both majority and minority carriers.

Bit: See Binary digit.

Block diagram: A system diagram which shows the relationship between the main functional units of the system represented by blocks.

Breakdown: The condition for a reverse-biased semiconductor junction when its high resistance, under the reverse bias, suddenly decreases, causing excessive current. Not necessarily destructive.

Bridge rectifier: A full-wave rectifier in which the rectifier diodes are connected in a bridge circuit to allow current to the load during both the positive and negative alternation of the supply voltage.

Capacitance (C): The capability to store charge in an electrostatic field. It can be expressed as equal to the charge Q in coulombs that is stored divided by the voltage E in volts that supplied the charge. Capacitance tends to oppose any change in voltage. The unit is farads.

Capacitive reactance (Xc): The opposition that a capacitor offers to a time changing signal or supplied voltage. Its value is Xc = 1 / 2πfc

Capacitor (C): A device made up of two metallic plates separated by a dielectric or insulating material. Used to store electrical energy in the electrostatic field between the plates.

Cathode (K): The negative electrode of a semiconductor diode.

Charge (Q): A measurable quantity of electrical energy representing the electrostatic forces between atomic particles. Electrons have a negative charge.

Choke: An inductance which is designed to pass large amounts of dc current. It usually is used in power supply filters to help reduce ripple; although, there are inductances called rf chokes (rfc) which prevent rf from feeding to a circuit.

Circuit: A complete path that allows electrical current from one terminal of a voltage source to the other terminal.

Circuit breaker: An electromagnetic switch used as a protective device. It breaks a circuit if the current exceeds a specified value.

Clock or Clock generator: An electronic circuit that generates accurate and precisely controlled, regularly occurring, synchronizing or timing signals called clock signals.

Clock rate: The frequency of oscillation of the master clock, or oscillator, in a system.

Coil: The component that is formed when several turns of wire are wound on a cylindrical form or on a metal core.

Collector (C): The element in a transistor that collects the moving electrons or holes, and from which the output usually is obtained. Analogous to the plate of a triode vacuum tube.

Color code: A system in which colors are used to identify the value of electronic components, or other variables, such as component tolerance.

Component: The individual parts that make up a circuit, a function, a subsystem or a total piece of equipment.

Conductor: A substance through which electrons flow with relative ease.

Contactor: A special relay for switching heavy currents at power line voltages.

Continuity: A continuous electrical path.

Controlled rectifier: A four-layer semiconductor device in which conduction is triggered ON by gate current and OFF by reducing the anode voltage below a critical value.

Coulomb (C): The unit of electrical charge, made up of a quantity of 6.25×10^{18} electrons.

Current (I): The flow of electrons, measured in amperes. One ampere results when one volt is impressed on a circuit that has a resistance of one ohm.

Decibel (db): The standard unit for expressing the ratio between powers P1 and P2. db = $10 \log 10 P1/ P2$, one tenth of a bel.

Dielectric: The non-conducting material used to separate the plates of a capacitor or for insulating electric contacts.

Digital signal: A signal whose level has only discrete values, like on or off, 1 or 0, + 5v or + 0.2v.

Digital to Analog Conversion (or Converter) (DAC or D/A): A circuit that accepts digital input signals and converts them to an analog output signal.

Diode: A device which has two terminals and has a high resistance to current in one direction and a low resistance to current in the other direction.

Direct Current (DC, dc): Current in a circuit in one direction only.

Drain: The element in a field-effect transistor which is roughly analogous to the collector of a bipolar transistor.

Effective value: The value of ac current that will produce the same heating effect in a load resistor as the corresponding value of dc current.

Electricity: A form of energy produced by the flow of electrons through materials and devices under the influence of an electromotive force produced electrostatically, mechanically, chemically or thermally.

Electrolytic capacitor: A capacitor whose electrodes are immersed in a wet electrolyte or dry paste.

Electromotive force (E): The force which causes an electrical current in a circuit when there is a difference in potential. Synonym for voltage.

Electron: The basic atomic particle having a negative charge that rotates around a positively charged nucleus of an atom.

Electrostatic field: The electrical field or force surrounding objects that have an electrical charge.

Emitter (E): The semiconductor material in a transistor that emits carriers into the base region when the emitter-base junction is forward biased.

Error: Any deviation of a computed, measured, or observed value from the correct value.

Farad (F): The basic unit for capacitance. A capacitor has a value of one farad when it has stored one coulomb of charge with one volt across it.

Field coil: An electromagnet formed from a coil of insulated wire wound around a soft iron core. Commonly used in motors and generators.

Field-Effect Transistor (FET): A 3-terminal semiconductor device where current is from source to drain due to a conducting channel formed by a voltage field between the gate and the source.

Filament: The heated element in an incandescent lamp or vacuum tube.

Filter: A circuit element or group of components which passes signals of certain frequencies while blocking signals of other frequencies.

Fluorescent: The ability to emit light when struck by electrons or other radiation.

Forward resistance: The resistance of a forward-biased junction when there is current through the semiconductor p-n junction.

Forward voltage (or bias): A voltage applied across a semiconductor junction in order to permit forward current through the junction and the device.

Frequency (F or f): The number of complete cycles of a periodic waveform during one second.

Gain (G): 1. Any increase in the current, voltage or power level of a signal. 2. The ratio of output to input signal level of an amplifier.

Ground (or Grounded): 1. The common return path for electric current in electronic equipment. Called electrical ground. 2. A reference point connected to or assumed to be at zero potential with respect to the earth.

Henry (H or h): The unit of inductance. The inductance of a coil of wire in henries is a function of the coils size, the number of turns of wire and the type core material.

Hertz (Hz): One cycle per second.

Impedance (Z): In a circuit, the opposition that circuit elements present alternating current. The impedance includes both resistance and reactance.

Inductance (L): The capability of a coil to store energy in a magnetic field surrounding it which results in a property that tends to oppose any change in the existing current in the coil.

Inductive reactance (XL): The opposition that an inductance offers when there is an ac or pulsating dc in a circuit. $X_L = 2\pi f_L$.

Input impedance: The impedance seen by a source when a device or circuit is connected across the source.

Integrated circuit (1C): A complex semiconductor structure that contains all the circuit components for a high functional density analog or digital circuit interconnected together on a single chip of silicon.

Junction: The region separating two layers in a semiconductor material, e.g. a p-n junction.

Junction transistor: A PNP or NPN transistor formed from three alternate regions of p and n type material. The alternate materials are formed by diffusion or ion implantation.

Leakage (or Leakage current): The undesired flow of electricity around or through a device or circuit. In the case of semiconductors, it is the current across a reverse biased semiconductor junction.

Linear amplifier: A class A amplifier whose output signal is directly proportional to the input signal. The output is an exact reproduction of the input except for the increased gain.

Load: Any component, circuit, subsystem or system that consumes power delivered to it by a source of power.

Loop: A closed path around which there is a current or signal.

Magnetic Field: The force field surrounding a magnet.

Magnetic lines of force: The imaginary lines called flux lines used to indicate the directions of the magnetic forces in a magnetic field.

Megohm (M): A million ohms. Sometimes abbreviated meg.

Microampere (mA): One millionth of an ampere.

Microfarad (mfd, MFD, or mfd): One millionth of a farad.

Milliampere (mA): One thousandth of an ampere.

Millihenry (mH): One thousandth of a henry.

Milliwatt (mW): One thousandth of a watt.

NPN Transistor: A bipolar transistor with a p-type base sandwiched between an n-type emitter, and an n-type collector. N-type semiconductor material (N): A semiconductor material in which the majority carriers are electrons, and there is an excess of electrons over holes.

Ohm (Ω): The unit of electrical resistance. A circuit component has a resistance of one ohm when one volt applied to the component produces a current of one ampere.

Ohms-per-volt: The sensitivity rating for a voltmeter. Also expresses the impedance (resistance) presented to a circuit by the meter when a voltage measurement is made. Open circuit: An incomplete path for current.

Operating point: The steady state or no signal operating point of a circuit or active device.

Operational amplifier (OP AMP): A high-gain analog amplifier with two inputs and one output.

Oscillation: A sustained condition of continuous operation where the circuit outputs a constant signal at a frequency determined by circuit constants and as a result of positive or regenerative feedback.

Pi (π): The mathematical constant which is equal to the ratio of the circumference of a circle to its diameter. Approximately 3.14.

Picofarad (pf): A unit of capacitance that is $1 \times 10\text{-}12$ farads or one millionth of a millionth of a farad.

Piezoelectric: A crystal property which causes a voltage to be developed across the crystal when mechanical stress is applied, or vice-versa.

PNP Transistor: A bipolar transistor with an n-type base sandwiched between a p-type emitter and a p-type collector.

Polarity: The description of whether a voltage is positive or negative with respect to some reference point.

Potential difference: The voltage difference between two points, calculated algebraically.

Power (P): The time rate of doing work.

Power (reactive): The product of the voltage and current in a reactive circuit measured in volt-amperes (apparent power).

Power (real): The power dissipated in the purely resistive components of a circuit measured in watts.

Power supply: A defined unit that is the source of electrical power for a device, circuit, subsystem or system.

P-type semiconductor material (P): A semiconductor material in which holes are the majority carriers and there is a deficiency of electrons.

Reactance (X): The opposition that a pure inductance or a pure capacitance provides to current in an ac circuit.

Rectification: The process of converting alternating current into pulsating direct current.

Relay: A device in which a set of contacts is opened or closed by a mechanical force supplied by turning on current in an electromagnet. The contacts are isolated from the electromagnet.

Resistance (R): A characteristic of a material that opposes the flow of electrons. It results in loss of energy in a circuit dissipated as heat.

Resistor (R): A circuit component that provides resistance to current in the circuit.

Reverse current: The current when a semiconductor junction is reverse biased.

Root-Mean-Square (RMS): See effective value. The RMS value of an ac sinusoidal waveform is 0.707 of the peak amplitude of the sine wave.

Semiconductor: One of the materials falling between metals as good conductors and insulators as poor conductors in the periodic chart of the elements.

Shunt: A parallel circuit branch, see Ammeter shunt.

Signal: In electronics, the information contained in electrical quantities of voltage or current that forms the input, timing, or output of a device, circuit, or system.

Silicon Controlled Rectifier (SCR): A semiconductor diode in which current through a third element, called the gate, controls turn-on, and the anode-to-cathode voltage controls turn-off.

Sine (sinusoidal) wave: A waveform whose amplitude at any time through a rotation of an angle from 0° to 360° is a function of the sine of an angle.

Step-down transformer: A transformer in which the secondary winding has fewer turns than the primary.

Step-up transformer: A transformer in which the secondary winding has more turns than the primary.

Transformer: A set of coils wound on an iron core in which a magnetic field couples energy between two or more coils or windings.

Transistor: A three-terminal semiconductor device used in circuits to amplify electrical signals or to perform as a switch to provide digital functions.

Turns ratio: The ratio of secondary winding turns to primary winding turns of a transformer.

Vector: A line representing the magnitude and time phase of some quantity, plotted on rectangular or polar coordinates.

Voltage (or Volt): The unit of electromotive force that causes current when included in a closed circuit. One volt causes a current of one ampere through a resistance of one ohm.

Voltage drop: The difference in potential between two points caused by a current through an impedance or resistance.

Watt (W): The unit of electrical power in joules per second, equal to the voltage drop (in volts) times the current (in amperes) in a resistive circuit.